THE ARTIST-GALLERY PARTNERSHIP

A Practical Guide to Consigning Art

•

Tad Crawford and Susan Mellon

INTRODUCTION BY

Daniel Grant

ALLWORTH PRESS
NEW YORK

Published by Allworth Press
An imprint of Allworth Communications
10 East 23rd Street, New York NY 10010

Cover design by Douglas Design Associates, New York, NY

Book design/typography by Sharp Designs, Inc., Lansing, MI

ISBN: 1-880559-92-7

Library of Congress Catalog Card Number: 98-70405

Printed in Canada.

Acknowledgments

.

For help with the first edition of this book the authors acknowledge with gratitude the invaluable assistance of Robert Anestis and Elena Canavier, the generous support of the National Endowment for the Arts, and the outreach efforts of The American Council for the Arts which published that edition. For help with this second edition, thanks are due to the staff at Allworth Press—Robert Porter, Ted Gachot, and especially Anne Hellman, who guided this expanded edition through the editorial process, and Nyier Abdou, who scrupulously reviewed and corrected the final draft. We are also appreciative for the assistance of Adria G. Kaplan of the Columbia Law School Center for Law and the Arts in locating appropriate research assistance and for the thorough research and contributions made by Laura Mankin.

•

Contents

· · · · · · · · · ·

PART III. APPENDIX

●

Introduction

.

by Daniel Grant

*I*f the arts are increasingly described as a business, why do so many artists and dealers refer to their relationship as a marriage? Similar to romantic link-ups, artists and dealers often claim to have met through mutual acquaintances; both talk of hand-holding, of being listened to or taken care of; they invite each other for dinners, parties, even vacations; their breakups are likened to a divorce. Supporting the entire affair is the sale of artworks. The art market is an odd mix of money and affection.

Relationships are what bring artists and dealers together, and relationships (artist-collector or dealer-collector) sell works of art. Some artists try to avoid the business of making individual connections with people by blindly sending slides of their work to galleries around the country or setting up a Web site for their work. Undoubtedly, there are success stories among those using these methods. However, almost all artists discover that they need to establish a personal relationship with a dealer or collector (or both) in order to achieve artistic recognition and financial success.

Business and personal elements of the artist-dealer relationship are frequently entwined. Rhona Hoffman, an art dealer in Chicago, noted that conversations with artists she represents "may start out strictly

business but switch onto personal things—restaurants, movies, families—then go back to business. It doesn't have to be clear what relationship you are specifically pursuing."

Both artists and dealers need to be clear as to the nature of the professional relationships they develop. How often and in what context will the artist's work be displayed? What sales commission will be paid to the dealer? How soon will an artist be paid following a sale? Who pays for framing, shipping, advertising, insurance, and catalogues? Is the dealer an exclusive agent for the artist? How long will this agreement be in effect? Tacit understandings and handshakes must give way to sometimes lengthy conversations and even legal contracts that detail how artist and dealer will work with each other. *The Artist-Gallery Partnership: A Practical Guide to Consigning Art* offers ground rules for these conversations, revealing applicable laws and legal concepts as well as ideas for resolving disputes and changing the terms of an agreement. The Standard Agreement is a highly flexible document that encourages dialogue. It should not frighten away those who are honest and well-intentioned.

When Jackson Pollock signed his first contract with collector and dealer Peggy Guggenheim in 1943, he was able to quit his job decorating ties to concentrate on painting. That first contract paid him a stipend of $150 per month, with guaranteed sales of $2,700 annually (if there were less than $2,700 in sales, Guggenheim would be paid the difference in paintings). His second contract with her two years later raised the stipend to $300 per month and gave Guggenheim ownership of Pollock's entire artistic output for the year with the exception of one painting that the artist could retain. The terms of those contracts might not satisfy artists nowadays, but they were beneficial to both Pollock and Guggenheim then, reflecting her trust in his talents and allowing him to work unencumbered by financial constraints. This was a true partnership.

Back in 1981, when *The Artist-Gallery Partnership* was first published, few artists and art dealers used written agreements. A growing number of artists have insisted on them since then, sometimes to the chagrin of their galleries. "In my experience, a conversation followed by a handshake tends to work just as well as a legal contract," said New York dealer Nancy Hoffman, who has written consignment agreements with some of the artists she represents but not with others, depending upon

the wishes of the individual artists. "If an artist I'm interested in wants a contract, we'll have a contract."

GETTING TO KNOW YOU

An artist-dealer relationship is frequently the outgrowth of other relationships, for instance, between a dealer and other artists he or she represents. "The artists whose work I'm most interested in seeing are those who are recommended by other artists I know and respect," said New York dealer Curt Marcus. Frequently, an artist in a gallery opens the door for other artists to be represented by the same dealer in this way. Hugh Kepets and Harriet Shorr, represented by New York's Fischbach Gallery, "spoke on my behalf," said Nancy Hagin, crediting her two friends with finding her a dealer. Similarly, Gregory Gillespie "definitely discussed Scott Prior" with Robert Fishko, director of New York's Forum Gallery, where Gillespie has been represented since the 1960s, and the outcome was Prior's joining the gallery.

The artist's recommendation does not ensure that the person he or she is promoting will be taken on by the dealer, but it does increase the likelihood that the person's work will be given a serious look. Still, the new artist's work must be suitable to the gallery, and a personal relationship needs to emerge between the artist and the dealer. Hagin said that an artist-friend at another gallery had "written a letter of introduction for me, but my meeting with the dealer there turned out to be a disaster. We didn't get along, he didn't really like my work. It was an embarrassment not only for me but for the artist who had written the letter." One notable instance of an artist throwing his weight around involved sculptor William King, who left dealer Virginia Zabriskie after she refused to give his then-girlfriend a show. He joined the gallery of dealer Terry Dintenfass, who also agreed to show the girlfriend's work, although King later regretted his actions. "Virginia told me at the time, 'You're one dumb cookie,' and she was right," he said.

There is no recognized etiquette for how artists and dealers select each other. Some dealers claim that they do not "take" an artist who is currently represented by another dealer, while there are those who regularly raid other galleries. Many artists will directly contact galleries in which they would like their work to be shown, while others believe

it demeaning to ask a dealer. "Dealers have the right to ask an artist to join a gallery," one artist noted, "When an artist asks a dealer, it puts the artist in a less-than-equal position with the dealer." Rules of conduct in the art world tend to be situational.

At times, dealers learn about artists from collectors, critics, museum curators and even other dealers whom they respect and trust. Artists and dealers work in insecure fields, offering to the world objects for which they alone may vouch for the intrinsic value and meaning, and endorsements matter. When sculptor Elyn Zimmerman brought an idea for an exhibition to a long-time friend of hers, Santa Monica, California dealer Fred Hoffman, "he said his space wasn't really suited for what I had in mind." But Hoffman contacted a friend of his, New York and Los Angeles dealer Larry Gagosian, who agreed to exhibit Zimmerman's work. After that show, there were two other shows and she joined his gallery.

Jeffrey Bergen, director of ACA Galleries in New York City, stated that he first learned about painter and sculptor Faith Ringgold through a documentary filmmaker, Linda Freeman, who "came to me about doing a film on Romare Bearden, an artist we represent. I asked to see her previous work, which included two films on Faith. I was very impressed with Faith's work and asked Freeman to introduce her to me."

Another relationship that sometimes leads to bigger things is the connection artists may make with gallery assistants. These salespeople, many of whom are young and ambitious, sometimes start their own galleries, often devoted to younger artists working in a certain style. Painter Don Eddy left the New York gallery French & Co. when Nancy Hoffman, an employee of the gallery, quit to start up her own. "I had a relationship with Nancy and felt that she understood and appreciated my work, and I didn't feel that as much with anyone else there," he said. While he has no written agreement with Nancy Hoffman, there had been a contract between the artist and French & Co., "and Nancy and I agreed verbally that we would use that as a baseline agreement for our relationship."

Similarly, Philip Evergood, Robert Gwathmey and Jacob Lawrence left ACA Galleries in New York when Terry Dintenfass stopped working there to establish her own gallery. "Gwathmey and Evergood were good friends of mine," Lawrence said. "When they decided to go with Terry, I thought I better do it, too."

Mark Tansey, a painter, noted that "I was never completely at ease

at the Grace Borgenicht Gallery, as Grace really worked with the artists of her time, who were a generation older than I am. But it was there that I met Curt Marcus, who was a gallery assistant. He worked with the younger artists at the gallery and, when he left to start up his own gallery, it seemed only natural to go with him."

Personnel changes at galleries, of course, not only create new opportunities but tensions; not all departures of employees result in new galleries, and galleries, new or old, are financially risky endeavors. When Aladar Marberger, the director of Fischbach Gallery, with whom Nancy Hagin had strong personal ties and "a more or less verbal understanding," died in 1988, there was a period of adjustment during which expectations needed to be realigned and renegotiated. "My understanding with Aladar was that for work that the gallery had kept for a while and returned to me, I could do with it as I like," she said. "After he died, I got in trouble for selling a work out of my studio." Under Lawrence diCarlo, Marberger's successor, differences were eventually ironed out, although Hagin's relationship with him has never been as close as with the previous gallery director.

Different gallery employees may have principal responsibility for working with specific artists, raising questions about the nature of the larger artist-gallery relationship when these assistants leave. Jeffrey Bergen noted that "at one point, I had a contemporary wing to the gallery, run by another director, and I had very little to do with it or with those artists. Then, that director left, and I took over the contemporary group. The transition wasn't easy. Some of the artists' work was more to my personal tastes, others less so. I remember saying to Leon Polk Smith, a minimalist—and I am not that interested in minimalism—'I respect what you do, but I'm not really passionate about your work. If I don't believe in it, I can't sell it effectively.' He left the gallery on amicable terms."

GETTING TO KNOW ALL ABOUT YOU

Some artists maintain an arm's-length relationship with their dealers—the one provides the artwork, the other sells it, and conversations do not veer far from business—but most strive for a much closer connection. "I have a friend who says, 'Dealers only exist to sell artwork,'

but I think of them as friends and treat them as I would any other friend," said conceptual artist John Baldessari. At times, the personal relationship grows to be quite strong, entailing dinner parties and invitations to weekend homes. Nancy Hagin rented and eventually bought her dealer's upstate New York summer home, while Curt Marcus noted that he has taken vacations with the artists he represents.

To many artists, the warmth of the friendship may seem to be the measure of the artist's standing with the dealer, while dealers may view the social relationship as an opportunity to develop their artist contacts. "Every dealer wants you to be their friend," said William King. "Dealers want you to invite them to your house, to your parties, so that they can be part of the milieu." His dealer, Terry Dintenfass, also noted that "some dealers socialize a lot with their artists in order to provide a social life for themselves or for their collectors."

The strength of the relationship is often revealed by the number of telephone calls that dealers make to artists on a weekly or monthly basis. "Artists want to hear regularly from their dealers," Curt Marcus said. "It's important that they know they are being thought about." Both Gregory Gillespie and Faith Ringgold said that they are called by their respective dealers at least once a week, relaying information on prospective buyers, past collectors, a new show, asking how's the work coming along, how's the family—the specific content may not be as important as the ongoing connection.

Painter Richard Haas has noted the state of one's relationship with a dealer may be measured in the frequency of phone calls and who's calling whom. "The dealer is calling you most of the time when you're in favor," he said. "When you find yourself calling the dealer most of the time, you're not in favor anymore. There are not enough phone calls, not enough visits to your studio; you don't get invited to dinner. You know you're at an end."

The relationship between artists and their dealers is deepened (or simply made more complicated) when cash advances or stipends are paid. Many dealers will take on the role of banker to their artists, providing money for the purchase of a house, the renovation of a studio, the purchase of expensive art materials, or even a medical emergency. Elyn Zimmerman's formal relationship with New York dealer Larry Gagosian began in 1991. "I had made some models for gallery-sized

work (she is otherwise known for her public sculptures) and was looking for someone who could help me fabricate them." Zimmerman explains, "Larry agreed to pay for the fabrication and show the pieces, and the costs would be deducted from sales. Larry has been my exclusive dealer ever since."

In most cases, these cash advances are applied directly to future sales, although the dealer may be repaid in actual artworks. Nancy Hoffman views advances as loans, for which she charges "a little interest," while other dealers consider them as part of the ongoing financial relationship. At times, artists repay the favor by deferring the payments for sales they are owed when their dealers are particularly strapped. "Sometimes, artists have lent me money in terms of not taking all the money they are owed in a given year," Terry Dintenfass said. "It's a two-way street, part of a friendship thing."

Stipends, a regular allowance paid monthly or annually by the dealer to the artist, also tightly bond the two in the expectation of a long-term relationship. Dealers recognize that in order to recoup their money, they must make every effort to promote and sell the artists' work, and artists see in the stipend a faith in, and commitment to, their artistic vision. This is one of the areas in which the professional and emotional sides of the artist-dealer relationship become entwined. William King's deal with Terry Dintenfass, for example, is a guaranteed $200,000 per year, "which has given me a very warm feeling about her."

Gregory Gillespie noted that "Forum Gallery has supported me for a long time with a monthly stipend, even during periods when nothing was selling. It is hard to put into words my feeling for my dealer because I know that without the stipend, I could not have been as freely creative over the years. I've never had to look for a job. I've never had to wonder where I stand with the dealer."

As the relationship between artists and their dealers develops over time, their assumptions about each other may grow, change or stay the same. In general, both sides expect the other to be honest and faithful to their agreements. Artists are expected to produce a certain quantity and quality of work, not making deals behind the backs of their dealers. Dealers are relied upon to exhibit, promote and sell the work, maintaining good records for sales and paying the artists promptly. As an artist's career advances, promoting his or her work may grow from

postcard and brochure announcements to newspaper and magazine advertisements, as well as the creation of a catalogue to accompany a show; the dealer may be expected to develop private commissions and print deals, arrange exhibitions elsewhere in the United States or abroad, even place work in museum collections. Often, the relationship between artist and dealer sours when the artist believes that he or she has outgrown the dealer or when the dealer finds that the market for the artist's work (or the artist's work itself) has not advanced sufficiently to maintain the investment. The two may need to sever their relationship, untying the many financial and emotional ties that have linked artist and dealer over the years in a process that many have likened to a marital divorce.

One trend that has emerged in the 1990s is for artists to reject an exclusive relationship with a particular dealer; opting instead for what painter Peter Halley called "a constellation of galleries that represent my work." Exclusivity means that all exhibitions and sales go through a particular dealer. Halley had exclusive relationships with the Sonnabend Gallery and Larry Gagosian, but left both in part because dealers elsewhere did not want to share sales commissions with New York galleries, resulting in lost sales. "Seventy-five percent of my market is in Europe," he said. "My collectors are not likely to come to New York to buy. Dealers in Europe chafe under the requirement that they pay half of the commission they earn to my New York dealer. Europeans like to buy from dealers they know and trust and with whom they have a personal relationship. For instance, I have found that German collectors will only buy from a German dealer. I found that I could do better establishing relationships with half a dozen dealers around the world than by participating in an exclusive relationship with a New York dealer."

Working with more than one dealer is certainly a complicating factor in an artist's life and career—each relationship requires its own recordkeeping in order to track sales and where one's art is—and it also requires an artist to be prolific enough to supply work for more than one gallery. John Baldessari prefers working under an exclusive arrangement as it means "they do the business, I make art." The benefit to nonexclusive artist-dealer relationships is flexibility and the ability of the artist to be in charge of his or her career decisions. Gallery owners exhibiting work by artists under an exclusive arrangement with another

dealer may not have much or any personal contact with these artists, resulting in a less than ardent pursuit of sales, and these galleries may also not receive the artist's best work. In 1992, Boston dealer Nina Nielsen and Gregory Gillespie had an argument so heated that she dismissed the artist from her gallery. The argument was a result of tensions arising from the degree to which New York's Forum Gallery—with which he has an exclusive agreement—was deciding which artworks would be shown in her gallery and what percentage of the commission she could keep. After a few years, the disagreement was patched up, and Gillespie began to show his work with Nielsen again.

Like Halley, painter and collage artist Nancy Spero, whose work is represented by five galleries around the United States, noted that not having an exclusive relationship has led to increased sales of her work. "When galleries know that they can earn all of the commission rather than share it," she said, "they will work harder to generate sales. Why work so hard just to pay some New York dealer half?" For her, the main drawback to working with so many galleries is that "it's not easy dealing with all these different personalities. You know, dealers are as temperamental as artists."

A written consignment agreement does not solve any of the problems that may arise between an artist and a dealer, but it clarifies the nature of their relationship and offers a mechanism by which disputes may be settled amicably. A good contract is dependent upon a sound understanding of the pertinent laws and what both artist and dealer are looking to do. In the ever-insecure world of the arts, there are endless opportunities for tensions to arise between artists and dealers; part of those tensions result from the fact that each side needs the other (one to produce, the other to sell). That need should be the basis not of ongoing antagonism but of a partnership, enabling artists to grow creatively within the relationship and earn money from the sale of their work. *The Artist-Gallery Partnership* provides a wide range of "talking points" for artists and dealers in negotiating their relationships. An up-to-date description of state art consignment laws throughout the United States in chapters 5 and 6 and the appendix offer ground rules that should minimize the likelihood of conflicts that lead to acrimony and lawsuits.

●

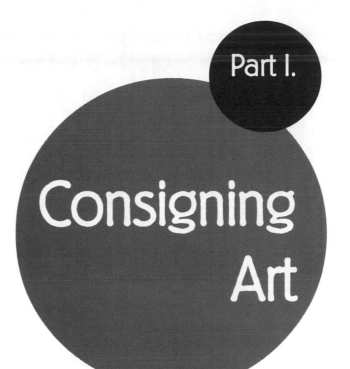

Part I.

Consigning Art

1

The Consignment Relationship

.

Artworks are commonly sold on consignment. In such an arrangement, the artist entrusts the artworks to a gallery (whether a cooperative, commercial or nonprofit gallery, an art consultant, a retail store, or another outlet), and is paid a portion of the price the gallery receives upon the sale of the artwork.

Both the gallery and the artist can benefit from this relationship. The artist, who is in the business of creating art, is not forced to go into the business of marketing it. By selling through a gallery, the artist avoids the expenses and the expenditure of time required in maintaining a retail shop. Artists promoted actively by established dealers stand to gain wider exposure than is ordinarily possible as a result of direct studio contacts. Craft artists who normally sell through fairs and wholesale markets may find that consignment in gallery outlets offers a special opportunity to create exhibition-type pieces for display to an art-conscious audience in a prestigious setting that tends to stimulate sales. Creative expression can be an intensely personal statement and many artists prefer dealing through galleries, rather than promoting their own work.

For the gallery, one clear benefit of consignment is the reduction in capital required: less of the gallery's funds are tied up in inventory. As

3

a result, the gallery can afford the risk of showing unique kinds of artwork for which no sure market exists, and it can introduce promising young artists to the buying public without a substantial financial investment. A gallery dealing mainly in consignment can spend a considerable sum on overhead expenses, yet still maintain a large stock of artworks and vary its displays frequently, factors which certainly enhance the likelihood of sales.

Each party in the consignment relationship makes a serious commitment to the other. Consigning artists give up a measure of control over their creations, entrusting them to an agent whose business is the marketing of artworks. Artists depend on galleries to promote them effectively, to care for the artworks properly, and to keep the works on public display. If consigned artworks do sell, the artist accepts that proceeds will be less than those from a direct studio sale.

The gallery taking artworks on consignment is making as strong a commitment. Although consignment limits its financial risks, the gallery depends on the sale of artworks for its survival. With limited space, the gallery is relying on the marketability of the artworks on hand and on receiving a continuing supply of works from the artists it represents. As agent for its artists, the gallery has a legal obligation to those artists and a responsibility for the safekeeping of the artworks in its possession.

Because of their interdependence, gallery and artist must depend on the integrity and high standards of professionalism of one another. Before entering into a consignment arrangement, therefore, the parties should first evaluate one another carefully, for the relationship between them should not be a matter of blind faith. Although in practice artists and galleries frequently begin their professional association in an extremely casual manner, it is far better for both to know as much as possible about the reputation for quality, reliability, honesty, and good will of their potential business partner.

The gallery might ask about the artist's training and professional background, finding out how long and how extensively the artist has been in business. It should know where the artist's work has been shown and through which other galleries the artist has been and is currently represented. The gallery should ask about the general scope of the artist's production and the level of output that can be expected in the

future, as well as the artist's typical price range. If the artist is interested in accepting special orders or commission work through the gallery, references of past performance are well worth checking; the gallery will be staking its reputation on the artist, relying on the artist's ability to deliver work of consistently acceptable quality in a timely manner. The gallery, accountable to its clients, must look for artists who act in a businesslike manner while creating art of quality.

The artist should evaluate the gallery with equal care. It can be particularly helpful to check with other artists who are familiar with the gallery, since news of any problem tends to travel rapidly. A look around the gallery is revealing in itself. Are the exhibitions attractively mounted and changed at regular intervals? Is there an alarm system or other protective device in evidence? Are the artworks treated carefully? Are the objects on display kept dusted or polished, and are they identified with the artists' names? Are the artworks compatible aesthetically with one's own works? The type of client the gallery attracts and the kind of market it reaches will be significant to the artist, as will be the manner in which the gallery relates to its clients and to art in general.

The artist should certainly ask whether the gallery deals only in consigned works. If a gallery owns a sizeable proportion of its stock outright, will it use every effort to promote the work of consigning artists, especially if the success of these efforts might mean one less sale from its own inventory? It is reasonable, too, for the artist to ask how long the gallery has been in operation, to confirm that the business is reasonably sound fiscally, and to ask something about the background and training of the key personnel to gain a clear idea of their professional qualifications.

Once both parties decide to proceed, it is important that they discuss the arrangement fully, outlining procedures and responsibilities. A written receipt for those works accepted on consignment, with a full description of the works, their retail price, the gallery's commission, its terms of payment, a statement that the work is on consignment, and a statement that the gallery assumes full responsibility for the artworks in its custody, is the absolute minimum written record that an artist should accept. (A sample of this type of receipt can be found in the appendix.) A much more detailed contract is preferable, however, to provide a clear-cut record of the terms to which the parties have agreed.

For this reason, the heart of this book is devoted to a provision-by-provision explanation of a model contract suitable for use—the Standard Art Consignment Agreement. This discussion is designed to point out many aspects of consignment of which artist and gallery should be aware.

Having once entered into the consignment relationship, the artist and the gallery should work toward strengthening their professional association. They should continue to communicate openly and frankly with each other. It is the responsibility of the artist to provide the gallery with useful information about the artworks, including all materials used and any special care requirements. The artist should also feel free to suggest to the gallery how to display the consigned artworks to advantage, although of course the final decision on display of the artworks is the gallery's. The artist should ask the gallery what its clients say about the work. Such comments can provide constructive criticism about the salability of the artworks which the artist would not otherwise hear. The gallery, in constant communication with potential buyers, may be able to pass on useful suggestions to the artist.

In the event of a disagreement, which is perfectly normal in any close and ongoing relationship, the dispute should be aired promptly and a solution sought without delay to minimize the effects of misunderstandings. By a willingness to share concerns and to work out differences, a truly amicable relationship can be nurtured. After all, people who create and those who sell art are both in business, but their connection to art is usually far more than just a financial one; it is aesthetic and often deeply personal. If, at the same time as the business relationship between gallery and artist develops, a friendship based on mutual respect can grow, both parties benefit.

●

2

Laws Governing the Consignment of Art

· ·

*B*efore going into the kinds of contractual arrangements that artist and gallery can make, it may be a good idea to look first at the law as it relates to the consignment of art.

In this country, business dealings in general, and the consignment relationship in particular, are governed primarily by case law and the Uniform Commercial Code (the UCC), a comprehensive statute that has been enacted by every state except Louisiana. (A sample UCC section can be found in section D of the appendix.) The function of the law is to establish legal parameters covering a range of situations that may arise in commerce. In the absence of a written contract between the parties involved, it details the obligations and responsibilities of each and sets certain guidelines to be followed in a court of law in the event of a dispute.

On the subject of consignment, the law does not usually differentiate among the types of goods being consigned, whether second-hand furniture, or horses, or original artworks placed on consignment by an artist. Herein lies a problem, for artists have less business experience than most people who deal regularly in consignment. In addition, artists are, generally speaking, in an unfavorable bargaining position when negotiating the terms of consignment with a gallery.

Also, the law, being a very general set of rules, is bound to seem arbitrary in some instances. In regard to the consignment of art, there are several important points about which artists and galleries should be aware. The first is that, unless the parties have agreed to the contrary, the *consignee* (the party taking goods on consignment—in this instance, the gallery) is responsible for loss or damage to the goods. However, the court decisions are not in agreement as to whether the gallery is liable regardless of the reason for the loss (*strictly liable*) or liable only in the event that its negligence causes the loss. Paragraph 6 of the Standard Agreement states that the gallery is to assume full responsibility for artworks while on consignment.

Another important provision of the UCC is that creditors of a consignee (i.e. a gallery) may seize the goods on hand to satisfy their claims, in spite of the fact that the consignee does not own them. In this case, not even a contractual arrangement between artist and gallery can protect the artist from the possibility that consigned works may be seized in the event of the gallery's indebtedness to someone else, because a creditor of the gallery is considered a "third party" who is therefore not bound by the terms of a contract made between artist and gallery.

The UCC does provide a means by which *consignors* (in this context, artists) can protect their goods against the possibility of seizure by creditors of the consignee, if they have followed certain procedures outlined in the UCC. These procedures will be discussed in detail under paragraph 8 of the Standard Agreement. But, as can be seen there, the protective procedures are exceedingly cumbersome. They place an unfair burden on the artist—if the artist is even aware of their existence before being confronted with the situation.

The legal climate, however, seems to be improving. At the state level, there has been legislative activity dealing specifically with art. Our state lawmakers have recognized the fact that artists, and original artworks, need to be better protected. More than half of the states have already enacted statutes dealing with the special problems involved in the consignment of art.

At the moment, though, the laws vary from state to state. To assist both artist and gallery, this book includes a thorough discussion of the state laws and their differences in chapter 5, "State Consignment Acts."

In addition, all of the state laws now in force are included in chapter 6, but it should be noted that what is in effect at the time of this writing may have since been amended. The artist should be sure to check on the current status of the laws. To obtain up-to-date information about the art consignment laws in effect in your own state, write to your local state arts agency; for that address, contact your state representative or senator.

Because of these variations, it makes sense to look at the kinds of provisions which these laws contain, rather than to go through each state's law separately. In this way, individual artists may gain a basic understanding of the degree of protection provided by the different statutes to help them as they study the specific laws in effect in their own states.

In general, art consignment laws provide that artwork left with a gallery is considered to be on consignment. It is not the property of the gallery unless it has been purchased and paid for. The laws also stipulate that the gallery is the agent of the artist, and must observe certain standards with respect to acting on the artist's behalf.

One feature common to several of the state laws is the requirement that there be a written contract between artist and gallery. The contract must contain some specific elements (although, of course, it may include additional provisions to which both parties agree). Looking at Connecticut's art consignment law, for example, one sees that the contract must include the minimum retail price for which the artworks may be sold, details as to the gallery's schedule of payments to the artist upon sale of the artworks, and an affirmation that the gallery accepts full responsibility for the safekeeping of consigned artworks in its custody. This law also requires a statement to the effect that the artworks may be used or displayed only with the permission of the artist and only with an acknowledgment that the artist created them.

In some states, the gallery's responsibility for the safekeeping of the artworks consigned to its custody is mandated by law, rather than through contract. Such laws state that the gallery is strictly liable to the artist in the event of loss or damage to the artworks, usually to their stated value. While artists dealing in states with a law of this kind do not need to incorporate the same provision in their own consignment

contracts to be sure of adequate protection, reiterating the point through written agreement certainly does no harm.

Another provision in some laws is the imposition of a *trustee* role on the gallery. As a trustee, the gallery is held to particularly high standards of fair dealing. It must act in ways which benefit and protect the artist. The money that the gallery receives for sale of the artworks, for example, is trust property until the artist has been paid in full. Until that time, it should be kept separately from the gallery's general funds. Money owed to the artist may not be applied to other uses, and it cannot be made subject to claims by creditors of the gallery.

One of the most significant aspects of the art consignment laws relates to the provision in the UCC which permits creditors of a consignee to seize goods on consignment in order to satisfy their claims. Some state laws now override that portion of the UCC, effectively eliminating any possibility that artworks or funds owing an artist can be taken by creditors of the gallery. Artists who deal through galleries in states with this level of legal protection need not bother with the preventive procedures outlined under paragraph 8 of the Standard Agreement. Lacking such a state statute, however, the artist should consider following those procedures to minimize the chance of losing consigned artworks following a gallery's insolvency.

The state laws are not perfect by any means. New York's law, for example, limits protection to "fine art," which it defines as "painting, sculpture, drawing, or works of graphic art, and print, but not multiples." The craft media are not covered. In Connecticut, the creditor clause of the UCC is not overridden by law. Instead, the consignor is encouraged to follow one of the procedures detailed in the UCC as a protective measure. Some state laws which impose gallery liability in the event of loss or damage to artworks create an ambiguity as to the amount owed the artist by using the term "stated value." This presumably means retail price, but retail price is more than the artist would ordinarily receive were the artwork to be sold through the gallery. Yet another weakness in some state laws is that, while a minimum selling price for artwork must be agreed to by artist and gallery, upper price limit has been left open. And many states fail to set forth specific penalties for noncompliance with provisions of their laws.

The inconsistency among the various state statutes creates con-

fusion. Nonetheless, these laws do represent a significant start at assuring basic legal protection to artists inexperienced in business dealings. If the consignment takes place in a state with such a consignment law, the relationship between artist and gallery will be regulated by its provisions. In states lacking special legislative protection, however, it is particularly important that the significant elements of the laws be incorporated into the agreement signed by artist and gallery, so that the parties can create through contract what has not been provided by law.

●

3

The Standard Art Consignment Agreement

· ·

It is not uncommon for galleries and artists to begin their consignment relationship with only a simple verbal agreement. In many cases, this understanding is confirmed with no more than a handshake and a receipt for the works accepted on consignment. To be sure, a detailed written contract cannot fill the vacuum that exists in the absence of trust and good will. But a number of states do require a written agreement between artist and gallery, and in any event such a document is highly desirable as a means of establishing formal guidelines by which the relationship will be governed.

Aside from its legal value, a contract allows both parties to define clearly their mutual responsibilities and their expectations of the other. By going through the give-and-take required to negotiate an agreement, the parties can begin to deal with one another as equal partners with a shared goal. Working out the terms of the contract help artist and gallery to clarify many aspects of the arrangement. Potential areas of conflict and ambiguity can be discussed in advance rather than after trouble develops. Each point that is agreed to in writing helps to eliminate the possibility of misunderstandings caused by lack of communication, and the signed document provides a permanent record of the agreement actually made by artist and gallery.

The Standard Art Consignment Agreement, shown in the appendix, is one contract suitable for use by artists and galleries. It is based on a model drawn up by the Artist/Craftsmen's Information Service of Washington, D.C.(A/CIS). The A/CIS draft was developed after extensive consultation with literally hundreds of individual artists and galleries and with lawyers familiar with artists' concerns and with consignment legislation. It incorporated elements from existing contracts as well as ideas from many people active in the field. As a preliminary draft, the model was disseminated by Artists Equity of Connecticut to its membership, and it was distributed by the Connecticut Commission on the Arts to selected galleries and artists within the state.

The Standard Art Consignment Agreement (referred to as the "Standard Agreement" in this book) is a refinement of that early model. It includes suggestions made by the Connecticut Commission on the Arts after that study was completed. In its present form, it can serve the needs of artists and galleries across the country. The Standard Agreement addresses the legalities of consignment; it conforms to art consignment laws which have been passed in some states, and it can help to protect artists in states with no such laws. It is designed with an eye to artists' basic rights as well as those of the galleries. It will help to point out issues about which artist and gallery should be aware, and areas that have been found troublesome in artist-gallery dealings.

The Standard Agreement is ready to use as is. The form included with this book may be photocopied freely. (The agreement is also available on the Allworth Press Web site, *www.allworth.com*.) Artist and gallery should fill out the form in duplicate, with both parties signing each copy. The contract is flexible enough to allow modification to suit individual circumstances; in fact, a significant portion of this book will be devoted to the different possibilities for modification.

To make modifications to the Standard Agreement, cross out those provisions which are not applicable and write in any changes. If additional provisions are necessary, they may be written in the space provided under paragraph 14. Should that space prove insufficient, make a notation in paragraph 14 to the effect that "An appended sheet contains additional provisions which form part of this Agreement." Write out the extra provisions on another sheet of paper and photocopy it, if possible. If not, write out an exact duplicate. Both parties should then

sign each sheet and attach one to each copy of the Agreement. A personalized version of the Standard Agreement may be created on a word processor and modified to the needs of the artist or gallery.

The discussion which follows "walks through" the Standard Agreement, point by point, in order to explain what each provision does and to suggest variations that may be applicable in certain circumstances. Whether or not one plans to use this particular contract, a reading of the text may prove helpful in gaining a better understanding of the legal issues, the common trade practices, general information relating to consignment, and a number of specific situations with which one may be confronted. The contract discussion will be followed by a short summary of what a contract does, legally, and what it does not do, and how disputes which arise may be resolved. The very act of formalizing the understanding between artist and gallery by means of such a document may itself help to prevent many disputes from developing.

As is noted at the top of the Standard Agreement, the name, address, and telephone number of both artist and gallery are to be written in full in the appropriate spaces. It is then the artist's responsibility to keep the gallery informed of any change in address. Though it might seem unnecessary to mention the importance of keeping this information up to date once the agreement has been signed, a number of galleries mention difficulties in contacting an artist whose work has been left there for a prolonged period but who no longer lives at the address on file. The gallery may need to get in touch with the artist on short notice when a question comes up about one of the artworks, and of course the gallery can only send payments and return artworks to the artist's last known address.

Similarly, it is the responsibility of the gallery to notify the artist of any change in its location or in ownership. At a new location, there may be a very different clientele, a factor that can affect the salability of the artist's work to a considerable extent. If the gallery itself changes hands, its new owner has the right to continue the consignment arrangement under the Standard Agreement only if the artist consents in writing to such a course. (This situation is detailed in paragraph 18 of the Standard Agreement.)

PARAGRAPH 1: AGENCY, PURPOSES

The Artist appoints the Gallery as agent for the works of art ("the Artworks") consigned under this Agreement, for the purpose of exhibition and sale. The Gallery shall not permit the Artworks to be used for any other purposes without the written consent of the Artist.

Agency is a legal term. An agency is the power one party is given to act for another. When exercising that power, the agent must act for the benefit of the party represented. In paragraph 1, the artist gives power of agency to the gallery; by signing the Standard Agreement, the gallery accepts its responsibilities in this role under the conditions agreed to by both parties. As agent, the gallery must act in good faith on the artist's behalf, trying to make advantageous transactions for the artist's benefit.

Inherent in the gallery-artist association is the fact that a gallery represents many artists simultaneously; it should be understood by the gallery, however, that it has an obligation to each artist individually. In addition, there are other areas of potential conflict in the gallery's role as agent for a consigning artist. If, for example, the gallery owns works by an artist who is also represented by consigned works, the gallery needs to assure the artist that it will promote the consigned works no less vigorously than those it owns outright. These kinds of situations do not prevent the gallery from being able to act effectively on the artist's behalf, but both parties should recognize that the potential for conflict does exist.

Paragraph 1 of the Standard Agreement stipulates that the artworks are consigned only for the purposes of exhibition and sale. If the artworks are to be consigned for other purposes, the written consent of the artist is required. There is no reason that artworks may not be consigned for other purposes, such as rentals, loans to a museum or for an exhibition in another location, and the making of reproductions, as long as the gallery has the capability to accomplish such purposes and the artist is willing to see the artworks used in these ways. It is essential, however, that these purposes be spelled out in detail; division of responsibility, duration, and any compensation due the artist should be clearly stated. The terms should be agreed to in writing by both par-

ties. (Additional provisions like this one can be made a part of the Standard Agreement following the procedures outlined under paragraph 14.)

Another feature of paragraph 1 is that it limits the gallery's role, as agent, to the works actually consigned; other works created by the artist are outside the scope of the gallery's agency and its right to receive a commission. In common practice, though, galleries often expect a larger role as representative for their artists. A gallery may require that the artist deal through it exclusively, within a limited or a broad geographical area; it may expect a commission on some or on all sales the artist makes directly from the studio; it may expect the artist to deliver a certain number of works within a set time period.

If the gallery wishes to impose conditions like these on the artist, it should discuss them with the artist rather than assuming that the practices are self-evident. To avoid misunderstandings, each party should be fully aware of the expectations of the other. Whatever conditions are agreed to should be in writing, signed by both parties. (Conditions of this type are discussed in more detail under paragraph 14, "Additional Provisions.")

PARAGRAPH 2: CONSIGNMENT

The Artist hereby consigns to the Gallery, and the Gallery accepts on consignment, those Artworks listed on the attached Inventory Sheet which is a part of this Agreement. Additional Inventory Sheets may be incorporated into this Agreement at such time as both parties agree to the consignment of other works of art. All Inventory Sheets shall be signed by Artist and Gallery.

Paragraph 2 of the Standard Agreement makes it clear that the artworks are being consigned rather than sold to the gallery. For however long the Agreement remains in effect, additional artworks accepted for consignment may also be made subject to the terms of the contract. Any such artworks should be listed on an inventory sheet (prepared in duplicate); the sheets should be signed by both parties, and one copy should be attached to each copy of the contract.

Even if the artist and the gallery do not use the Standard Agreement

or any other written contract to cover their responsibilities to one another, it is imperative that there be a written receipt for all works the artist consigns to the gallery. This document may be the only proof the artist has that the artworks are not the property of the gallery. For adequate protection, a receipt, such as that found in section B of the appendix, should be used. An artist who mails artworks to a gallery could enclose two signed receipts in the package, requesting that the gallery sign one copy and return it immediately.

The gallery should keep accurate and complete records of the transactions relating to every artwork in its custody. If works are subsequently returned unsold to the artist, the gallery should arrange to have the artist sign a receipt for the package, or acknowledge its safe return in writing or another manner, to eliminate any question of the gallery's ongoing responsibility.

PARAGRAPH 3: WARRANTY

The Artist hereby warrants that he/she created and possesses unencumbered title to the Artworks, and that their descriptions are true and accurate.

A *warranty* is a statement of fact that someone can rely on in entering into a contract. In paragraph 3, the gallery is given assurances that the artist created the works, that the artist owns them free and clear, and that the descriptions of these artworks are accurate and truthful. These assurances are not a matter of indifference to the gallery, for it must depend on the truthfulness of the artist's statements about the works. The gallery's promotion of a work of art is premised on the fact that the object was created by a certain artist, that the artist-owner has a clear title to it, and that the work is indeed what the artist claims it to be. If the gallery sells an artwork based on false information, it runs the risk of a lawsuit.

Consider, for example, if a craftsman-jeweler leaves a ring on consignment and tells the gallery that it is set with a genuine sapphire. A customer of the gallery purchases the ring, relying on this information, but later discovers that the stone is synthetic. Not only would the

reputation of the gallery be severely damaged, but the customer might sue the gallery. In that event, the gallery would have a legitimate claim against the artist because of the artist's breach of the warranty contained in the Standard Agreement.

PARAGRAPH 4: DURATION OF CONSIGNMENT

The Artist and the Gallery agree that the initial term of consignment for the Artworks is to be _____ (months), and that the Artist does not intend to request their return before the end of this term. Thereafter, consignment shall continue until the Artist requests the return of any or all of the Artworks or the Gallery requests that the Artist take back any or all of the Artworks with which request the other party shall comply promptly.

The Standard Agreement itself does not have a set term. The contract does not end until either the gallery or the artist chooses to terminate it. (See paragraph 15 for an explanation of the process and procedures for termination. Obviously, however, terminating the agreement means that the entire consignment relationship is being severed.) As long as the Standard Agreement remains in effect, it will continue to govern the terms of consignment. Artworks consigned even at a much later point may be made subject to the original Agreement, as has been mentioned in discussing paragraph 2.

Paragraph 4 does allow the artist and gallery to establish a definite initial term of consignment for specific artworks, however. The duration for this initial term of consignment has been left blank on the Standard Agreement, to encourage artist and gallery to discuss this point. The time may be very specific, if the artworks are being consigned only for a special exhibition, or less specific, if they are consigned for general display and sale.

Any plans the artist may have to remove the artworks during this initial term should be stated at the outset. The gallery needs to be able to count on having the artworks for the entire period, so that it can plan exhibition space accordingly and can promote the artworks effectively. If an emergency arises, the artist may request an earlier return of the

artworks than that specified for the initial term of consignment. As long as the reason is legitimate, the gallery understands the situation, and the removal of the artworks creates no hardship for the gallery, there should be no problem. (It should be remembered that the artist can terminate the entire relationship at any point by initiating the procedures outlined in paragraph 15; such an action would assure the return of all unsold artworks within thirty days.)

Ideally, after the initial term of consignment has ended, the gallery and the artist should establish regular extension periods for the artworks still on consignment, with a clear understanding that at the end of each interval unsold works could be returned promptly and new artworks submitted to the gallery. The mechanics for such extension periods are not specified in the Standard Agreement, however, for in reality few galleries have a systematic procedure for extending the initial consignment term.

Many galleries and artists say that they would prefer that these terms were more clearly defined, but many tend to leave them vague nonetheless. A busy gallery may not be able to take the time to contact each artist on a regular basis about the disposition of every artwork in its custody; it may also feel that if it returns artworks, the artist may infer that the gallery is no longer interested in marketing the artist's work, which can in turn discourage the artist from submitting new work. At the same time, artists often fail to take the initiative in approaching the gallery, perhaps not wishing to seem aggressive, ungrateful, or critical of the gallery's handling of the artworks.

Whatever the justification for not staying in touch, lack of communication does not foster a good working relationship. A periodic review of the association in general, with artist and gallery coming to specific decisions about extensions for works still on consignment, is always beneficial. Most galleries feel that the artist should be responsible for making periodic contact. The gallery might suggest a set interval—every three or six months, or at least once a year—at the end of which the artist would be expected to make contact. Once such a procedure is established, neither party need feel awkward about approaching the other.

The gallery should feel free to request new works at these regular intervals, in exchange for unsold artworks it returns to the artist; the

artist should recognize that a flow of fresh work may well stimulate sales. Promotion is a slow process; it may take considerable time for the gallery to create a demand for the artist's work. Neither artist nor gallery should give up the arrangement as long as both parties respect the talent and efforts of the other. It may be, however, that the gallery finds that the artist's work does not seem in line with what its clients are seeking, after having displayed the artworks for a prolonged period. In such a case, the gallery should express this view frankly to the artist rather than simply put the artworks in a back room. The gallery can suggest that the artist might profit by showing the artworks at another location. The artist should not take offense at this advice; as any retailer knows, there is no accounting for the tastes of the buying public.

A periodic review of the consignment relationship can prove to be productive in other ways, too. Meeting at a mutually convenient time (by appointment rather than when the artist happens to be in the neighborhood), artist and gallery can talk at leisure. The gallery may be able to pass along customer comments about the artworks which may explain why they sell, or don't sell. The gallery may also make suggestions about pricing. The artist may need to alter prices of works still on hand to reflect increases in the cost of materials. The artist may be able to point out special features of the artworks, which the gallery can then incorporate into subsequent promotional efforts. Any questions or hesitations which either party has about the arrangement can be aired at this point. By keeping the channels of communication open through regular meetings, disagreements can be worked out in a relaxed atmosphere.

Paragraph 4 does state that, after the end of the initial term of consignment, either party may request the return of the artworks. If and when the artist requests their return, it is the responsibility of the gallery to return the artworks promptly. But what if the gallery wishes to return artworks after they have remained on consignment for a prolonged period, and it cannot locate the artist?

This problem is not as uncommon as one would think. A number of galleries note that they have had to deal with abandoned artworks from time to time. One way to handle the matter would be for a gallery to add a provision to the Standard Agreement stating that it has the right to dispose of artworks left in its custody for an extended time after the

initial term of consignment has ended, if the artist fails to respond to a registered letter (sent by the gallery to the artist's last known address) notifying the artist that the gallery wishes to return the consigned artworks. Alternatively, the gallery might add a provision giving it the right to store such artworks at the artist's expense, if they remain unclaimed past a reasonable period after notification from the gallery as outlined above.

Whether or not there are such clauses in the agreement, and whether or not the artist and gallery decide to meet regularly, it is the artist's obligation as a responsible business partner to keep the gallery informed of address changes or plans for extended travel, so the gallery can count on being able to make contact at reasonably short notice whenever the need arises.

PARAGRAPH 5: TRANSPORTATION RESPONSIBILITIES

Packing and shipping charges, insurance costs, other handling expenses, and risk of loss or damage incurred in the delivery of Artworks from the Artist to the Gallery, and in the return to the Artist, shall be the responsibility of the _____ (specific Gallery or Artist).

The matter of who is to pay the costs of packing, shipping, insurance, and other handling expenses involved in the transportation of the artworks should be clearly understood ahead of time by both artist and gallery. If the artist lives close to the gallery, it is unlikely that transportation expenses will be an issue. Handling costs can be substantial for long-distance shipping or for large-scale artworks, however, and it is important in every case that one party be responsible for the safekeeping of artworks in transit.

Transportation expenses for shipment from the gallery to another point (a museum, a collector, or another purchaser) are normally borne by the gallery, but there is no fixed rule about which party pays for transporting the artworks from artist to gallery and gallery to artist. Many times, commercial galleries do absorb all transportation expenses. In other cases, the artist is expected to assume all costs incurred in the delivery of artworks, while the gallery pays for their return. Or, in the

case of a nonprofit institution that deals in consignment, the gallery may expect the artist to pay for transportation in both directions.

In the Standard Agreement, it is assumed that one party—either the artist or the gallery—will be responsible for all transportation costs. If this is the case, simply complete the blank in paragraph 5. If the costs are to be split, the Agreement may be modified easily. Write in the name of the party responsible for delivery costs in the blank provided. Strike out the words "and in their return to the Artist," then add the following the sentence: "The (Artist or Gallery) shall be responsible for all such expenses and risk of loss or damage incurred in the return of the Artworks to the Artist." Both parties should initial the change on each signed original agreement.

The gallery's responsibility for artworks in its custody is quite clear, but what about works in transit? If the gallery has accepted responsibility for the safe delivery and return of the artworks by agreeing to those terms in paragraph 5, it is obligated to pay the artist in the event of loss or damage in transit. If the artist is the party responsible for shipping costs, however, the situation is different.

Imagine that the artist has asked the gallery to have the artworks shipped back, at the artist's expense, and that they then arrive damaged or are lost in transit. Claims made against the carrier are ordinarily handled by the party sending the parcel. The gallery therefore initiates a claim on the artist's behalf, paying the artist the sum it receives from the carrier, less shipping charges if the artist had not paid them directly. There is a chance, however, that the carrier may not honor the claim, in whole or in part. The court decisions are unclear as to whether the gallery is strictly liable to make sure the artworks are returned to the artist intact, or liable only if its negligence causes loss or damage while in transit. Paragraph 5 permits the parties to determine who will bear the risk of loss or damage while the artworks are being transported.

The artist should consider this when sending work to and from the gallery. If the artwork is fragile by nature, or if its destruction or disappearance would be a major loss, is it worth taking the chance? In any case, the artist should specify the carrier to be used and the insurance value of the artwork, and should find out in advance whether the carrier has any limitations as to liability for breakage or loss, either as general policy or in its contract with the gallery.

PARAGRAPH 6: RESPONSIBILITY FOR LOSS
OR DAMAGE; INSURANCE COVERAGE

The Gallery shall be responsible for the safekeeping of all con-
signed Artworks while they are in its custody. The Gallery shall
be strictly liable to the Artist for their loss or damage (except
for damage resulting from flaws inherent in the Artworks), to
the full amount the Artist would have received from the Gallery
if the Artworks had been sold. The Gallery shall provide the Artist
with all relevant information about its insurance coverage for the
Artworks if the Artist requests this information.

Some states have enacted protective art consignment laws which
impose strict liability on the consignee (the party taking goods on
consignment) in the event of loss or damage to the consigned goods,
regardless of the cause of that damage. In states without these laws,
the gallery is usually held liable to the artist for loss or damage to the
consigned goods in its custody only upon a showing of negligence.

Strict liability provides better protection in these circumstances,
however. An artist who deals with galleries in states without special art
consignment statutes should realize this limitation of law and should
require that the gallery agree contractually to strict liability to protect
the artist fully in the event that the artworks are lost or damaged while
in the custody of the gallery. Paragraph 6 of the Standard Agreement
makes this point clear.

Those state laws which impose strict liability usually stipulate that
the consignee is responsible for the artworks "to their stated value." This
is an ambiguous term, however. If it means fair market value (retail
price), the artist would theoretically be due more for damaged work than
would be the case if the artworks were sold. The Standard Agreement
therefore limits gallery liability only to the price that the gallery would
ordinarily have paid the artist if the work had been sold—in other
words, retail price less commission. The artist would be owed this full
amount if the artworks were totally destroyed.

It is not uncommon that an artwork which is damaged can be restored
or repaired to its original or near-original condition. In such a case,
degree of damage and amount of compensation may be difficult to
assess fairly. A tear in the canvas might destroy a painting irreparably,

while deep scratches on a hand-wrought pewter bowl might be buffed out with relative ease. Paragraph 6 does not set specific procedures to be followed in the event of partial damage, since here a satisfactory resolution probably depends more on individual circumstances and on the good will and effort of the parties involved than on rigid rules. When working out compensation for partial damage, artist and gallery should discuss the problem and possible resolutions openly, calmly, and objectively.

The options should be talked through. Does the artist wish to repair the work for a reasonable fee? If so, the fee which the gallery is to pay for the service should be agreed to in advance, preferably in writing. In instances in which the artist claims that the work is totally destroyed and is paid in full by the gallery, does the gallery have the right to have it restored elsewhere, if this course seems feasible, then sell it? In their discussions, artist and gallery should keep in mind that accidents do happen, and what has happened cannot be changed. What is important, assuming that the artist wishes to continue dealing through the gallery, is that both parties agree on a fair resolution in order to put an unfortunate incident behind them.

Responsibility for damage due to flaws inherent in the material or in the manufacture of artworks is one area not covered by state laws on consignment. Yet blown glass cooled too quickly after it is formed may suddenly shatter months later; a certain batch of clay used for a baking dish may result in a fissure developing during normal use, even with the careful handling ceramic ware requires. Paragraph 6 takes note of the possibility that damage can be caused by such defects. Inherent flaws may be difficult to prove in many cases, but it is a matter of professional ethics that artists acknowledge responsibility for any problems of which they are aware and make whatever corrections— repair, substitution, or refund—are necessary.

The final provision in paragraph 6 concerns the gallery's insurance. At first glance, the kind of coverage a gallery maintains might seem irrelevant to a consigning artist, given that the Standard Agreement imposes strict liability on the gallery for the loss or damage of artworks in its custody, regardless of the extent of its insurance coverage. Consider, though, what would happen if the gallery should lose its entire inventory in a fire. Were it not adequately insured, the gallery

would probably not have the wherewithal to reimburse all of its artists and reopen for business.

The Standard Agreement does not require that the gallery carry insurance; it only stipulates that, when requested to do so, the gallery must give the artist any information about the coverage it does have for consigned works. In this manner,.the artist can weigh the potential risks involved in consigning artworks to the gallery's custody.

When reviewing an insurance policy, the gallery and the artist should consider the following points:

- What risks are covered? Risks might include fire, earthquake and other natural disasters; vandalism, accidental damage, damage due to frequent handling or carelessness; employee negligence or dishonesty and theft; and "mysterious disappearance," which, as the term implies, means loss without concrete evidence of forced entry. Even many so called all-risk policies do not cover mysterious disappearance. One should therefore look carefully at each policy and consider whether it may be worth added expense to have more extensive coverage.

- To what extent are consigned artworks covered? Are all media covered? Are the articles insured as a group to a set ceiling figure? Is this figure a realistic value for all of the goods on hand, year round? Are the artworks insured for retail price (fair market value), wholesale price, or a lesser amount? Is there a minimum deductible on each insured item? This is the case with many fine arts policies. If, for instance, the deductible is $250 per object, a $300 painting is not well covered, but, in this event, the gallery would be able to reimburse the artist for the loss of one work from cash on hand. However, should a major catastrophe affect its entire stock (and assuming there are many $300 objects in the inventory), the gallery might have difficulty making up the insurance shortfall. It might be better for the gallery to have a deductible amount for each event causing losses or a deductible amount for the year.

- When does coverage by the gallery begin and end? Are the artworks insured only when they are in the gallery itself, or are they covered for the entire period the gallery has custody of them?

Does the policy offer protection against damage sustained in transit? If so, is coverage limited to works transported by "common carrier" or does it include hand delivery? (These points may be particularly significant to an artist who has agreed to allow the gallery to lend out consigned artworks.)

The artist should recognize that insurance is costly, and that the gallery may elect to "self-insure" to some degree in order to keep its expenses down. On the other hand, the gallery has been entrusted with artworks belonging to someone else; unless it is financially strong, the gallery may not be able to survive a devastating loss whose consequences would affect the artist very directly. An artist consigning only a few artworks to any one gallery may not consider the loss of those works critical, but having a sizeable segment of one's production in a gallery with inadequate coverage is indeed cause for concern. Any risk should be measured in terms of whether one can afford the loss.

An artist may obtain insurance independently, of course, but should first be very sure that the policy allows payment for loss or damage up to the market value of the artworks, not just the cost of materials. (In the event of a claim, the artist will need to be able to prove actual market value of the artwork through sales of similar objects.)

If the artist is in a strong enough bargaining position with the gallery to be able to insist on the point, a provision might be added to the Standard Agreement requiring the gallery to insure all of the artworks consigned under this agreement for their full market value (less commission) against all risks of loss or damage, with coverage commencing when the artworks leave the artist's studio and continuing until such time as the artworks are delivered to a purchaser or returned to the artist. The artist might request in this event to be listed as beneficiary of the policy.

PARAGRAPH 7: FIDUCIARY RESPONSIBILITIES

Title to each of the Artworks remains in the Artist until the Artist has been paid the full amount owing him or her for the Artworks; title then passes directly to the purchaser. All proceeds from the

sale of the Artworks shall be held in trust for the Artist. The Gallery shall pay all amounts due the Artist before any proceeds of sales can be made available to creditors of the Gallery.

Paragraph 7 makes the point that a gallery never owns artworks on consignment to it, and that ownership passes directly from the artist to the purchaser. It must be noted, however, that while the Standard Agreement emphasizes that the artist must be paid in full before title to the artworks is relinquished, this provision is not legally binding on a purchaser of the artwork. Were the gallery never to pay the proceeds of the sale to the artist, the purchaser of the artwork could still claim ownership of it. If such a case came to court, the law would favor the purchaser as an innocent third party who had paid for the artwork, presumably with no knowledge of any arrangement made between artist and gallery.

For this reason, it is particularly important that a higher standard of legal obligation be placed on the gallery to pay its artists than would be the case without a contract. To this end, a number of states have enacted laws which include a provision to the effect that funds owing an artist are to be held *in trust* until the artist has been paid; a similar phrase is incorporated into paragraph 7 of the Standard Agreement in order to bind the gallery contractually even in states without protective legislation.

The term "in trust" is legal language. As used in this provision, it means that money the gallery has received for sales of the artist's work may not be used for other purposes (as, for example, paying the rent, paying for advertising, or paying other artists) until the artist has been paid. In a court of law, someone entrusted with such funds will be held to the highest standard of accountability if the funds are misused.

Paragraph 7 also makes it very clear that the gallery must pay all money owed to the artist before any of the proceeds of sales can be made available to its creditors. Once again, though, this provision is only binding between the gallery and the artist. Unless the consignment is governed by the laws of a state with protective art consignment legislation, it cannot guarantee absolute protection to the artist against the chance that the artworks might be seized by creditors to whom the gallery was indebted. As has been said earlier, the UCC permits creditors

of a consignee to seize consigned goods to satisfy their claims—notwith-standing any contractual arrangement between artist and gallery to the contrary.

Lacking a state law that protects consignors, the artist can only be assured of iron-clad protection by following certain procedures outlined in the UCC and described in the discussion of paragraph 8.

PARAGRAPH 8: NOTICE OF CONSIGNMENT

The Gallery shall give notice, by means of a clear and con-spicuous sign in full public view, that certain works of art are being sold subject to a contract of consignment.

It has been mentioned already that, according to the UCC, artworks on consignment can be seized by creditors of a gallery even though the artworks are not the gallery's property. The UCC does include several measures by which an artist consigning work to a gallery can prevent such a possibility. The artist may take the following actions:

- File UCC Form 1, indicating an ownership interest in the consigned artworks, with the county clerk or other local official and/or with the secretary of state (check with a lawyer as to which of these officials is appropriate in your state);
- Prove that the creditors of the gallery knew that the gallery was substantially engaged in selling artworks that belonged to people other than the gallery; or
- In states with an applicable law, post a sign in the gallery to notify the public (including any creditors) of the artist's ownership interest in the consigned artworks.

The UCC Form 1 is a simple enough form to complete and file. The effect of filing UCC Form 1 is to create a *lien*, which is a claim against property that restricts what the party possessing the property may do with it. However, this is an unrealistic measure because neither the artist nor the gallery is usually willing to go through the paperwork necessary to place the lien on the artwork and later remove it at the time of sale. An exception might be for those consignments of particularly expensive artworks.

The second measure by which the UCC offers protection to the consigning artist requires the artist to prove that creditors of the gallery were aware that the gallery sold artworks which were not its property. This point is a difficult one to prove in court, however, as many artists who have suffered substantial losses will confirm.

The third way to protect consigned artworks against the possibility of seizure by the gallery's creditors is by posting a sign in the gallery which alerts the public to the fact that the artworks are not the property of the gallery. This measure is a sure protection only in states with an "applicable law," such as in Connecticut, but in other states without adequate protective art consignment laws, the sign at least points out to the public that the gallery is engaged in selling artworks belonging to other people. The sign can help to show that the gallery's potential creditors may have been aware of the situation, thus providing partial proof of the type required by the second measure described above. For that reason, paragraph 8 of the Standard Agreement adopts this third course of action.

According to Connecticut's law, the burden of posting the sign, or tagging the artworks, is on each artist, a procedure that would be awkward if actually practiced. If every individual artist tacked up a clear and conspicuous sign stating that the artworks were on consignment, the gallery would present a very unkempt appearance. Paragraph 8 offers a more practical solution, by putting the burden of compliance on the gallery, since one sign can suffice to satisfy the requirement of the law. For convenience, a sign that is suitable for use is included in the appendix.

PARAGRAPH 9: REMOVAL FROM GALLERY

The Gallery shall not lend out, remove from the premises, or sell on approval any of the Artworks, without first obtaining written permission from the Artist.

It is the obligation of the gallery to obtain the artist's written permission before lending the artworks, selling them "on approval," or removing them from the gallery for any other reason. The artist may well agree to such requests by the gallery, when the purpose of the

arrangements is clearly to enhance sales. If the artist does approve the removal of an artwork from the gallery, both parties should agree in advance on the circumstances under which it is to be removed, who is responsible for loss or damage to the work, and how any rental fee or other compensation paid to the gallery will be shared.

PARAGRAPH 10: PRICING; GALLERY'S COMMISSION; TERMS OF PAYMENT

The Gallery shall sell the Artworks only at the Retail Price specified on the Inventory Sheet. The Gallery and the Artist agree that the Gallery's commission is to be ____ percent of the Retail Price of the Artwork. Any change in the Retail Price, or in the Gallery's commission, must be agreed to in advance by the Artist and the Gallery. Payment to the Artist shall be made by the Gallery within____days after the date of sale of any of the Artworks. The Gallery assumes full risk for the failure to pay on the part of any purchaser to whom it has sold an Artwork.

Pricing, commissions, and payment are at the heart of any agreement between gallery and artist. The price at which the artworks are to be marketed is the first decision to be made. The cost of materials, equipment, rent and other studio expenses, profit margin, the gallery's commission, and the special character of the individual objects are all factors to consider when setting a price on the artworks.

Paragraph 10 of the Standard Agreement expressly states that the gallery may sell artworks only at the retail price specified on the inventory sheet, unless another understanding has been agreed to by both parties. It is ordinarily up to the artist to set the retail price. Ideally, of course, the decision on how to price the artworks should be a joint one, with the artist recommending a figure at the time of submission, yet remaining open to any specific recommendations for changes by the gallery.

If the gallery feels that a work could realize a higher price than the artist had indicated, it should make this suggestion as part of its obligation to transact business to the artist's benefit. If the gallery believes that the artist's price is unrealistically high, it should say so.

(Remember that the gallery is accepting responsibility for the safe-keeping of the artworks. In the event of their loss or destruction, it must pay the full amount the artist would have received for their sale. Should the gallery's insurance company deem the work to have been over-valued, the gallery would still be liable to the artist and would have to make up the difference itself.)

The retail price finally agreed to by artist and gallery is to be noted on the inventory sheet. The gallery may not alter this price except with the prior approval of the artist. In practice, many artists do choose to allow the gallery a measure of flexibility in pricing—perhaps 10 percent above or below the retail price. If the gallery is to be allowed some discretion in pricing, the understanding should be clearly stated in writing. There are some situations in which the gallery may request permission from the artist to alter the stated price of an individual object, if this change may mean a sale that would otherwise not occur. For convenience, the gallery could contact the artist by telephone, but it would be prudent to follow this verbal agreement with a letter of confirmation.

There is a trade practice in some galleries to pay the artist a fixed net price when the artworks are sold, regardless of actual selling price. This procedure is not to the artist's advantage for a number of reasons, not the least of which is the mutual distrust that may be engendered between artist and gallery.

When artworks are sold at a very low price, the artist's ability to market similar works elsewhere at a higher level is jeopardized. At the other end of the scale, overpricing may be equally detrimental. Some state statutes stipulate that consigned artworks cannot be sold for less than the stated retail value, but no statute currently prevents a gallery from asking more than has been agreed upon. If retail price is not a fixed amount and the gallery does realize a very high price, however, the gallery may be tempted not to share the excess profit with the artist, and it may even be reluctant to divulge to the artist the amount for which the artwork sold. Even assuming that the gallery does share the extra profit with the artist, the practice of inflating prices may very well slow sales of the artist's work in general. The gallery may feel comfortable taking this calculated risk, but it is the artist, whose capital is tied up in inventory, who has more to lose. Accordingly, there should

be a firm understanding between artist and gallery as to allowable limits in the price the gallery asks for the artworks.

The matter of discounts is another trade custom which should be mentioned. Some galleries have a practice of making discounts to special customers, to interior designers and other professionals, or to museums. According to the Standard Agreement, the gallery would not be able to discount the artist's works without advance permission. In many instances such discounting might well be to the artist's advantage, but each case deserves to be considered on its merits. In every instance, artist and gallery must agree ahead of time on the price and on how the proceeds from the lower price should be divided.

The commission a gallery takes on the sale of consigned artworks is ordinarily a set percentage of the retail price at which the artwork sells. This rate varies, but it commonly ranges from around 30 percent to 50 percent, according to the gallery's location, its reputation, and its overhead. Nonprofit institutions generally charge a relatively low commission when consignment of artworks is considered one of their service functions; a prestigious commerical gallery may justify a higher rate in terms of gallery potential for sales and visibility.

As a rule, the gallery charges a set commission rate for all of its artists, though there are instances when a gallery might use a sliding scale (with a lower rate for objects that have a higher retail price) in order to encourage its artists to consign major pieces. An artist with a well-established reputation may be able to negotiate for a relatively high percentage of the proceeds realized from sales. Artists whose primary costs are in materials rather than labor might also be given terms more favorable than the gallery's standard commission because of the likelihood that a very steep gallery commission would price the object past the point of salability.

Paragraph 10 of the Standard Agreement provides only for commissions on sales of artworks consigned directly to the gallery and listed on the inventory sheet. It does not touch on one issue that is often a matter of conflict between artists and galleries: the question of commissions due on studio sales the artist may make to clients of the gallery.

To get around this issue, the gallery is likely not to divulge the names and addresses of purchasers of artworks to the artist, thus eliminating

the possibility that the artist might draw away the gallery's clientele and offer lower prices for studio sales. The gallery is also unlikely to reveal the address of an artist to its customers, lest they approach the artist directly in the hope of purchasing artworks at discounted prices.

The gallery and the artist can enjoy a more wholesome relationship if this mutual suspicion is eliminated. The best solution is for them to determine in advance under which circumstances a commission is appropriate, put this understanding in writing, then live up to the commitment made. If an artist makes a studio sale to a client referred by the gallery, for example, the gallery should in all fairness be entitled to a commission for that sale. If the gallery arranges for the artist to complete a special order, a similar arrangement would be reasonable, with the percentage rate depending on the degree of involvement by the gallery. When the gallery's promotion of an artist is clearly responsible for a sale, the gallery can expect to receive some compensation even if that sale takes place at the artist's studio. A provision to this effect might read as follows:

> The Gallery shall be entitled to a commission of ____ percent on Artworks sold directly by the Artist to a purchaser, when these sales were made through contacts established initially through the Gallery, and under the following other circumstances (specify):
>
> _____
>
> The Artist shall pay any such fees to the Gallery within ____ days of the date of final payment for the sale. In the event that the Artwork is subsequently returned by the purchaser to the Artist for a refund, the Gallery shall promptly return to the Artist any fee it had received.

The Standard Agreement provides that artists be paid all money owing them by the gallery within a set period from the date of sale of an artwork. The typical period is thirty days. This time period, or another agreed to by artist and gallery, should be written in.

There is no provision in the Standard Agreement for installment sales or deferred payment sales. Unless such a provision has been made, it is the gallery's responsibility to make full payment to the artist within

the prescribed period, regardless of when it receives the balance owed it for the artwork. If the artist is willing, the gallery may be given the right to structure its payments to the artist in line with the payments it receives from the purchaser. In such a case, a provision should be added to the contract to read:

> On installment sales, the Gallery shall pay the Artist in the following manner: In any such transactions, the Artist shall be paid the entire balance remaining within _____ days of that sale. The Gallery assumes full risk for the failure to pay on the part of any purchaser to whom it has sold an Artwork.

The final provision of paragraph 10 places the burden of risk for any nonpayment by the gallery's customers on the gallery rather than on the artist. The artist is not in a position to verify the creditworthiness of the purchasers and must therefore rely on the gallery's discretion.

PARAGRAPH 11: PROMOTION

> The Gallery shall use its best efforts to promote the sale of the Artworks. The Gallery agrees to provide adequate display of the Artworks, and to undertake other promotional activities on the Artist's behalf, as follows: _____
>
> _____
>
> The Gallery and the Artist shall agree in advance on the division of artistic control and of financial responsibility for expenses incurred in the Gallery's exhibitions and other promotional activities undertaken on the Artist's behalf. The Gallery shall identify clearly all Artworks with the Artist's name, and the Artist's name shall be included on the bill of sale of each of the Artworks.

The Standard Agreement requires that the Gallery use its best efforts to promote sales of the artist's work. "Best efforts" is a legal term, but its vagueness makes nonperformance difficult to prove. It is important, however, that the artist know exactly what the gallery plans by way of promotional activities.

The Agreement states that the gallery will provide "adequate display" of the artworks. The parties should discuss how the gallery plans to do this. The artist needs to understand that not all artworks can be on display all the time, yet the gallery must realize that the artist's work will not be sold if it is left in a closet or in a drawer. The artist might request an assurance that some of the artworks be on exhibition at all times, with all of them on public display periodically. If the gallery plans special exhibitions that do not include the artist's work and which will leave no room for general displays for prolonged periods, the artist should be told of these arrangements.

A blank space has been left in the Standard Agreement for a description of specific promotional activities planned by the gallery. These might include commitments to group or one-artist shows, with dates and mailings or advertisements to be sent out at certain intervals. The gallery might simply state that it will keep a specific minimum percentage of the artist's work on display at all times.

A gallery may ask for the artist's cooperation in its promotion, too. This assistance might take the form of occasional appearances, or perhaps a request for photographs of the artist or the artworks. These are reasonable requests, since such promotion may very well lead to sales. If a gallery functions as the artist's exclusive agent, it may also request that it be mentioned as the artist's representative on loans the artist makes to exhibitions and on reproductions of the artist's work to be shown in magazines. These latter expectations should be agreed to in writing by artist and gallery to prevent the chance of any misunderstanding. (The matter of exclusivity is discussed in some detail under paragraph 14.)

The last provision in paragraph 11 states that the gallery must identify the artworks by artist, and include the artist's name on the bill of sale. It may seem unnecessary to make this procedure a requirement, since it is a basic responsibility of the gallery to promote the artist, but artists, in the craft field particularly, have found that galleries are occasionally reluctant to give out the artists' names to purchasers of their work.

Paragraph 11 also draws attention to issues which the artist and gallery should consider in regard to exhibitions. In the case of major shows, the parties will do well to discuss these matters in some detail.

A provision relating to exhibitions might be added to the Standard Agreement to read:

> The Gallery and the Artist shall agree in advance on the division of financial responsibility and artistic control regarding special exhibitions of the Artist's work, including who is to be responsible for such aspects as advertisements, printing costs, framing, special installation expenses, traveling and transportation expenses, storage charges, photography, mailing costs, and other expenses relating to the exhibition. Neither the Gallery nor the Artist shall be entitled to reimbursement from the other for any expenses incurred by either party without the prior approval of the other.

Artistic control over the exhibition display can be handled according to the individual situation. In some instances, the artist has total control and manages the entire installation. In other cases, the gallery handles everything. In any event, the gallery should be receptive to suggestions from the artist, and should never force the artist to exhibit the artworks in a way that is incompatible with the artist's aesthetic sense. If the artist is interested in some measure of control over the quality of reproduction in advertisements, catalogues, and mailers, the degree of involvement and responsibility should be understood between the parties.

An artist and gallery with a good working relationship should not encounter insurmountable difficulties over artistic control. Expenses are more likely to present a problem, unless both parties understand from the outset who pays for what and how much is to be budgeted for the exhibition. It is a good idea to write down categories of expense, like those listed in the suggested provision above, and indicate whether artist or gallery is to be responsible for each item. In general, a gallery will bear all or a large proportion of these expenses, but it doesn't hurt to spell them out anyway. With the exhibition provision incorporated into the Standard Agreement, neither artist nor gallery would be entitled to reimbursement for expenses incurred without the prior approval of the other party.

One last matter which artist and gallery should agree about when

mounting an exhibition is who will ultimately own the frames, photographic negatives or transparencies, and the other materials used in preparation for the show.

PARAGRAPH 12: REPRODUCTION

The Artist reserves all rights to the reproduction of the Artworks except as noted in writing to the contrary. The Gallery may arrange to have the Artworks photographed to publicize and promote the Artworks through means to be agreed to by both parties. In every instance of such use, the Artist shall be acknowledged as the creator and copyright owner of the Artwork. The Gallery shall include on each bill of sale of any Artwork the following legend: "All rights to reproduction of the work(s) of art identified herein are retained by the Artist."

According to federal copyright law, the creator of "pictorial, graphic, and sculptural works" owns the right to do or authorize others to do the following: make copies, create derivative works (works based on an original work, such as prints derived from a painting), distribute the work, and display the work. These are *exclusive* rights of the artist. The main exceptions allow limited "fair uses," such as reproductions in reviews. The artist's rights do not pass to a purchaser of the artwork with its sale (except that a purchaser may display the work publicly), because ownership of a copyright is distinct from ownership of the object itself. Without a written transfer of copyright, therefore, an artist retains reproduction rights to the artwork even if the physical object is owned by someone else.

Paragraph 12 of the Standard Agreement is designed to point out these facts. The legend on the bill of sale serves to inform the gallery's customers of the artist's rights under the law. Should a purchaser be concerned about the possibility that the artist might later use the work commercially, the artist could agree contractually not to make specified types of reproductions of the work. If the purchaser should wish to have the work reproduced, the artist might be willing to sell reproduction rights limited to the intended use for an additional fee. (If the gallery is to be entitled to any commission on this fee, there should be a

statement to that effect added to the contract made between artist and gallery.)

On the subject of the purchaser's use of an artwork, it should be noted that even if the customer is only interested in reproducing the artwork for personal use (such as for a family Christmas card), the artist's permission is still required. The parties will have to agree as to whether a fee is appropriate. To assure continued copyright protection, the artist should require that the cards bear copyright notice as detailed below.

Notice of copyright should appear on all artworks and copies of artworks distributed by authority of the copyright owner, whether the artwork is "distributed" by sale, gift, or other transfer of ownership, or is just being displayed on loan. Otherwise, the copyright protection inherent in the artist's creation of the work may be diluted if infringers claim to have been "innocent" (i.e., to have infringed without knowledge of the artist's copyright).

The notice that should appear on all copies consists of three elements: first, the symbol ©, or the word "Copyright," or the abbreviation "Copr."; second, the first year when the artwork is distributed (although the year may be omitted in such instances as reproduction of the artwork on greeting cards, postcards, stationery, jewelry, dolls, toys, or any useful articles); third, the name of the artist, an abbreviation by which the name can be recognized, or a generally known alternative designation of the artist. The notice of copyright should be affixed to the artwork in a manner that is reasonably visible. The notice can go on the back of an artwork or on a frame to which the artwork is permanently attached.

In addition to the procedures outlined above, the artist would be wise to register the artwork with the Copyright Office to assure maximum copyright protection. Registration, which costs twenty dollars, must be made on Form VA, available from the Register of Copyrights, Library of Congress, Washington, DC 20559. The artist should keep in mind that it is possible to register a group of unpublished artworks for a single twenty-dollar fee. The Copyright Office also makes available a free Copyright Information Kit. This includes copies of Form VA and other Copyright Office circulars and is worth requesting. To expedite receiving forms or circulars, the Forms and Circulars Hotline number can be used:

(202) 707-9100. Artists with the proper software can download copyright forms from the Copyright Office home page (*lcweb.loc.gov/ Copyright*).

Paragraph 12 gives the gallery the right to have the artworks photographed for the purpose of promoting the artist's work. To avoid jeopardizing copyright protection, the artist should allow photographic reproduction of copyrighted artworks only on the condition that each copy be labeled with the copyright notice described above.

It is important that the gallery discuss with the artist how it plans to use the photographs; paragraph 12 indicates that the parties must agree on these uses. It is the gallery's obligation to acknowledge the artist as the creator of the artwork in any photograph it sends out to the press. (Magazines and newspapers do not always include such accompanying credits, though they certainly should be aware of their professional responsibilities in regard to copyright.)

One last point relating to photography is the matter of ownership of the negatives (or positives). Unless the photography is handled by the gallery in house, the photographer may retain rights to the original negatives. In such a case, the gallery should stipulate in its agreement with the photographer that subsequent use of the photographs be subject to its contract with the artist. It should attach a copy of paragraph 12 to its own contract with the photographer, including any restrictions on use to which artist and gallery had agreed.

PARAGRAPH 13: ACCOUNTING

A statement of accounts for all sales of the Artworks shall be furnished by the Gallery to the Artist on a regular basis, in a form agreed to by both parties, as follows: _____

(specify frequency and manner of accounting). The Artist shall have the right to inventory his or her Artworks in the Gallery and to inspect any books and records pertaining to sales of the Artworks.

One obligation of an agent is to account to the principal for funds received on the principal's behalf. The gallery must, therefore, account

to the artist for sales of the artworks. If the gallery is selling a substantial volume of work by an artist, the artist might wish to receive a detailed statement of accounts at regular intervals, including an itemized list of artworks sold, with inventory numbers, names of purchasers, sale price realized, and so on. If the volume of sales is very small, however, a complex statement may not be justified. In such a case, accounting might consist simply of copies of each bill of sale completed to include all pertinent information. The copies would be sent to the artist along with the gallery's regular payments.

The Standard Agreement is flexible as to manner of accounting. The important point is that the artist should be kept informed, without the gallery being burdened excessively. The parties should agree as to the form and frequency of accountings, and fill in the blank space provided for that purpose in paragraph 13.

In theory, the gallery should also furnish the artist with a statement of inventory on a regular basis, to confirm which artworks are still on hand. It is time-consuming, however, for a gallery with a large quantity of objects to check its entire stock against the artist's inventory sheets. As a result, a thorough check of individual items tends to be made only when the unsold artworks are finally returned to the artist.

For convenience, therefore, paragraph 13 makes individual artists responsible for checking on their own inventory, by giving them the rights to inventory their works in the gallery and to inspect the gallery's books and records pertaining to these artworks. The artist should notify the gallery ahead of time to set up an appointment for this purpose; the gallery should agree to meet as promptly as is mutually convenient.

There is one area of potential discord in regard to accounting that should be discussed by artist and gallery: the matter of revealing to the artist the names and addresses of purchasers of the artworks, a point already mentioned under paragraph 10 in the section relating to commissions. Some galleries are reluctant to disclose such information, perhaps out of fear that the artist may try to sell directly to its customers at a lower price. This reluctance can cause problems, for the artist may need to have the location of the artworks on record for such reasons as the planning of a retrospective exhibition or determining the provenance of a work.

If the gallery and artist have agreed to the conditions under which

the gallery would be owed a commission on sales made outside the gallery, and the gallery can rely on the artist to adhere to this understanding scrupulously, there is no reason why it should not reveal the names and addresses of purchasers to the artist. If such an accord cannot be reached and the information is of critical importance to the artist, a compromise might be for the gallery to agree to allow a third party to keep the records. The artist could then be given the necessary information upon legitimate request.

PARAGRAPH 14: ADDITIONAL PROVISIONS

Paragraph 14 of the Standard Agreement has been left blank in order that the artist and gallery may insert additional provisions into the Standard Agreement to fit the particular circumstances. Several of the variations already mentioned in relation to other provisions might be inserted here, such as those suggested for installment sales and exhibitions. In addition, there are other kinds of provisions which the gallery and artist might wish to consider.

Exclusivity. The degree of exclusivity the gallery may expect in its representation of the artist is one point which could be clarified here. According to the Standard Agreement, only those artworks described on an attached inventory sheet become subject to the terms of the contract. Certain other circumstances under which the gallery might be entitled to a commission have already been touched on under paragraph 10. In many instances, galleries assume a more or less exclusive professional relationship with the artist. In this event, the extent of the artist's obligation to the gallery should be discussed in detail and confirmed in writing.

The degree of exclusivity to which a gallery should be entitled would depend on its investment in the artist. A gallery which promotes the artist actively, by means of periodic group or individual shows, incurs considerable expense. It must pay for mailings, advertisements, and brochures. It has exhibition installation costs, as well as transportation, insurance, framing, and other expenses. Its own operating costs—staff, rent, utilities, and telephone—continue during the time the artist's work is being shown. A special exhibition also means that the gallery sacrifices the opportunity to show another artist's work. Not all galleries

operate on this scale, but, to the degree that they do make a financial commitment to the artist, they may feel that they should represent all of the artist's work, or at least a substantial portion of that work.

In the extreme, a gallery may expect to have an *exclusive agency.* This means that no other agent may sell the artist's work, although it does not keep the artist from making direct sales. Under this arrangement, the gallery would still be entitled to its regular commission if the artist sold a work of art through a second gallery, but it would receive no commission for work the artist sold at the studio. Alternatively, the gallery might demand an *exclusive sale* contract, which would entitle it to a commission in any event, whether the artworks were sold through another gallery or by the artist.

These kinds of arrangements may have some justification with an artist whose career is just beginning, since the gallery in this case can play a significant role in the artist's success through its promotional efforts. Many artists do feel reluctant about agreeing to such restrictions, however, and may wish to limit the degree of exclusivity to which the gallery is entitled. The artist may believe that the gallery should have an exclusive agency only in the city where the gallery is located, or within some other limited geographical area outside of which the gallery does not compete aggressively. The artist may request a time limitation on the gallery's exclusive representation, for example, a certain period after a special gallery exhibition of the artist's work. The agency can also be limited with respect to the different media in which an artist works, when the gallery does not specialize in selling these types of media. The artist could also limit the gallery's exclusive rights by stipulating a maximum number of artworks the gallery would be entitled to handle. If the gallery handles works by many artists and does not invest heavily in any one, it should not expect an exclusive agency.

The Standard Agreement as drafted simply grants the gallery a nonexclusive right to represent the artist. This arrangement leaves the artist free to contract with other galleries, each then being entitled to commissions only on the artworks it actually sells. Even in this instance, however, the gallery should be able to expect that the artist will not market similar works in galleries that are its direct competitors. A reasonable way to address this matter might be to insert the following clause in the Standard Agreement:

The Artist agrees that he/she will not market Artworks similar
to those on consignment under this Agreement in other galleries
within _____
(geographical area) without first giving notice to the Gallery.

Limited Editions. Another provision which could be added under this
paragraph concerns fine prints and other limited edition artworks. Such
a provision might read as follows:

> The Artist shall provide the Gallery with a warranty concerning
> each multiple Artwork, detailing the total number of copies in
> the edition, number of artist's and printer's proofs, restrikes, and
> other relevant information.

The gallery would then add to the bill of sale a legend stating: "This
work is one of a limited edition of ____ copies numbered as follows:
_____."

Arbitration. It may be desirable for the parties to agree in advance
that they will arbitrate any disputes that arise. This can avoid expensive
litigation and achieve a quicker and perhaps less acrimonious resolution
of disputes. Such a provision might exclude disputes over amounts of
money small enough to be sued for in small claims court. The names
of the arbitrators or arbitrating organization would have to be inserted
along with the place where arbitration would occur.

> All disputes arising under this Agreement shall be submitted to
> binding arbitration before _____ in
> the following location _____ and
> shall be settled in accordance with the rules of the American
> Arbitration Association. Judgement upon the arbitration award
> may be entered in any court having jurisdiction thereof.
> Notwithstanding the foregoing, either party may refuse to
> arbitrate when the dispute is for a sum of less than $____.

Terms of Sale. In paragraph 12 of the Standard Agreement, one con-
dition was imposed on the sale of artworks through a legend on the bill
of sale to the effect that the artist retains reproduction rights to the

artwork even after its sale. This statement reiterates a point of law and therefore merely alerts the purchaser to this fact.

Other conditions may be imposed on the purchaser of an artwork by the same mechanism. In order for a consigning artist to be able to place contractual restrictions on the purchaser, the artist's contract with the gallery should specify that the gallery "shall include on the bill of sale the following provision(s): _____." These restrictions might relate to the moral rights of the artist, such as the right to be given creative credit and the right to have the work not be mutilated, altered, or destroyed. For some art these rights may already exist pursuant to the federal Visual Artists Rights Act, which took effect on June 1, 1991, and is more fully discussed in *Legal Guide for the Visual Artist* by Tad Crawford (Allworth Press).

For example, the purchaser of an artwork would ordinarily have the right to destroy it. To prevent this possibility, the artist might stipulate that the gallery include on the bill of sale a legend stating:

> Purchaser agrees not to destroy the Artwork without first offering to return ownership of it to the Artist.

Another condition of sale could be included to protect the work against unauthorized alteration by the purchaser:

> Purchaser shall not distort, mutilate, or otherwise alter the work. In the event such distortion, mutilation, or other alteration occurs, whether by action of the purchaser or otherwise, the Artist shall have the right to disclaim having created it.

Or:

> In the event of damage to the Artwork, any restoration must be approved by the Artist.

If the artist has created a work in multiple parts, it can be important that the work be displayed as one unit. In such a case, artist and gallery may wish the purchaser to promise not to separate the parts. To accomplish this, the bill of sale should read:

Purchaser acknowledges that the Artwork is a single work consisting of _____ parts, and agrees to exhibit, sell, or otherwise transfer the work only in its entirety as a single work.

An artist can also assure the right to borrow back the artwork from the purchaser for exhibition purposes by stipulating that the gallery include on the bill of sale the following provision, drawn from attorney Robert Projansky's "Agreement of Original Transfer of Art":

The Artist may show the Artwork for up to 60 days once every five years at a nonprofit institution at no expense to the Purchaser, upon written notice given Purchaser no less than 120 days before the exhibition is scheduled to open and upon satisfactory proof of insurance and prepaid transportation.

Another significant provision of the Projansky contract concerns the artist's right to share in proceeds of future sales of the artwork. California has enacted a law which assures the artist this right. Were the artist to impose this kind of condition directly in the bill of sale, the provision might read:

On resale or other transfer of the Artwork, the Purchaser agrees to pay the Artist 5 percent of the gross sale price received, or, if the work is transferred other than by sale, 5 percent of the fair market value of the work as of the date of transfer.

It must be noted, however, that while this and other conditions of sale constitute a contractual agreement between the artist and the original purchaser of the artwork, they are not binding on subsequent purchasers of the artwork unless the same conditions are then incorporated into the terms of the later sales or are imposed by law. In addition, the artist should realize that some of these restrictions may conceivably jeopardize sales of the artworks and may also raise legal questions about enforceability.

PARAGRAPH 15: TERMINATION OF AGREEMENT

Notwithstanding any other provision of this Agreement, this Agreement may be terminated at any time by either the Gallery or the Artist, by means of written notification of termination from either party to the other. In the event of the artist's death, the estate of the Artist shall have the right to terminate the Agreement. Within thirty days of the notification of termination, all accounts shall be settled and all unsold Artworks shall be returned by the Gallery.

It has been mentioned earlier that the Standard Agreement has no set term. It simply remains in effect until terminated by one party or the other, following the straightforward procedures outlined above in the text of the Agreement. As long as the parties are satisfied with the arrangement, the artist can continue to consign artworks to the gallery under its terms. These additional artworks become subject to the conditions of the Agreement by artist and gallery signing the inventory sheets which describe them and attaching those sheets to the original contract.

If either party feels that its investment is too great to permit termination at will, that party may insist upon a fixed term. In such a case, the following clause might be substituted in place of the first sentence in paragraph 15 of the Standard Agreement:

This Agreement shall have a term of ____ years, after which it may be terminated by either party giving ____ days written notice to the other.

PARAGRAPH 16: PROCEDURES FOR MODIFICATION

Amendments to this Agreement must be signed by both Artist and Gallery and attached to this Agreement. Both parties must initial any deletions made on this form and any additional provisions written onto it.

The Standard Agreement is flexible enough to allow extensive modification. Any provision or portion of a provision may be deleted by striking it out, as long as both artist and gallery agree to the change.

Initialing the changes confirms this understanding. In a similar manner, the parties may add to the existing provisions and initial the additions. There is a blank space left under paragraph 14 for the incorporation of additional provisions.

If the space in paragraph 14 does not suffice for added provisions, they can be written out on a separate piece of paper. Make a notation in paragraph 14 to the effect that "An Appended Sheet contains additional provisions which form part of this Agreement." Write out the extra provisions in duplicate, have both parties sign the sheets, and attach one copy to each copy of the Agreement form.

This paragraph is intended to permit artist and gallery to insert any provisions they feel necessary to suit the particular situation. They should exercise this right freely, so the contract will cover exactly what is important to them. It is not necessary to use legal jargon. Just write out whatever terms are agreed to in simple, clear language.

PARAGRAPH 17: MISCELLANY

This Agreement represents the entire Agreement between the Artist and the Gallery. If any part of this Agreement is held to be illegal, void, or unenforceable for any reason, such holding shall not affect the validity and enforceability of any other part. A waiver of any breach of any of the provisions of this Agreement shall not be construed as a continuing waiver of other breaches of the same provision or other provisions hereof. This Agreement shall not be assigned, nor shall it inure to the benefit of the successors of the Gallery, whether by operation of law or otherwise, without the prior written consent of the Artist.

This paragraph contains a mixed bag of legalisms designed to satisfy lawyers. A brief translation: This document comprises everything that the artist and gallery have agreed to. If any portion of it should be found not to be valid for some reason, the remainder would still be in effect. And if, at some point, either gallery or artist should violate any provision of the agreement or permit an exception from any element in it, that action would not mean that a similar or different deviation would be allowed in the future.

Finally, the Agreement cannot be assigned, that is, taken over by another party. If the gallery changes hands or is bought out, the artist needs to be notified. The artist then has the right to decide whether to terminate the agreement or to continue the arrangement under the new conditions. For the agreement to remain in effect requires the artist's written consent.

PARAGRAPH 18: CHOICE OF LAW

This Agreement shall be governed by the laws of the State of _____.

Normally, and in the absence of an agreement between the parties to the contrary, the contract made between artist and gallery is governed by the law of the state in which the gallery is located. Choice of law may be a point which the parties wish to negotiate, however, particularly in light of the variations among state laws regarding the consignment of art. (See chapter 2, "Laws Governing the Consignment of Art," and copies of the state statutes in chapter 6.)

As long as either party has reasonable connections with a particular state, that state's law can be selected to govern the relationship. If, for example, the gallery is located in one state, the artist lives in another, and the contract between them is drawn up in a third state, any of these states is suitable for choice of law. One should check the current status of protective art consignment statutes in the different states to see which might be most advantageous. In the event of a dispute between artist and gallery, the state law selected would govern the court's decision, even if the case was handled in a different state.

SIGNING THE STANDARD AGREEMENT

The final step in completing the agreement is for artist and gallery to sign it. The title of the person who signs as authorized representative should be included, and the agreement should be dated as of the date it is signed.

Both artist and gallery should keep a copy of the agreement, along with all inventory sheets that have been made a part of their contract.

As additional works are consigned, inventory sheets describing those works should be prepared in duplicate, signed, and attached to the copies of the original agreement.

●

4

Legal Recourse in the Event of Disputes

. .

*H*aving studied a variety of conditions to which artist and gallery might agree in drawing up a consignment contract, one might ask at this point how effective the Standard Agreement—or any contract of this type—can be if conflicts arise between the parties.

There are certain things that no agreement, whether written or oral, can accomplish. The contract cannot create good will or make people honest. It cannot inspire an artist to create work of better quality nor give the gallery a greater ability to make sales. It cannot remove the potential for disputes, since no agreement can cover every conceivable issue, and reasonable people often disagree on matters of interpretation. In fact, an agreement cannot even prevent either party from breaching its provisions at will. It doesn't enforce itself; it merely offers legally binding guidelines.

The advantage of a written contract, of course, is that the nature of the parties' understanding is far clearer, far better documented. When an oral agreement is broken, the parties must testify as to their understanding. Lacking concrete proof of this, a resolution may have to be sought through common trade practices or general guidelines established by law. But whether an agreement is written or oral, a breach

of the agreement—a violation of any provision in it by either party—gives the other party the right to seek a remedy.

To be sure, an artist is not likely to take a gallery to court over such issues as whether the gallery is using its best efforts at promotion. An artist who feels that the gallery is not displaying the artworks to advantage can solve the problem by terminating the agreement. Where the breach of contract leads to monetary loss, however, the situation can be different. If an artist does not pay the gallery a commission on a studio sale, when the parties had agreed that the gallery was entitled to such a commission; if the gallery does not pay an artist the agreed-upon price for an artwork it had sold; if the artist finds that an artwork in the gallery's custody is unaccountably missing—if any of these circumstances occur, the party which has sustained the loss may be entitled to compensation.

Damages for a breach of contract are usually awarded as an amount of money. They generally include reasonable losses that have ensued from the breach, including lost profits and expenses. Normally an injured person must attempt to minimize the damages caused by the breach, however, and lost profits must be provable rather than speculative.

In certain instances, the gallery or the artist might bring action against the other for *specific performance*, that is, sue for artworks rather than money. If, for example, the gallery has paid for a work that the artist has completed but refuses to deliver, the gallery might sue to have that work given over to it. Or an artist might sue the gallery for the return of artworks which the gallery was keeping in breach of the provisions of their agreement.

Another legal remedy is *injunctive relief*, which generally prevents a party from taking certain actions. This measure might be invoked by a gallery or an artist in a dispute over ownership of an artwork. If, for example, either artist or gallery had planned to have the artwork shipped abroad, an injunction would prevent such action until a court could decide who was the rightful owner.

In states which have enacted artist-gallery consignment statutes, consequences for a breach of contract can be more serious than a simple liability for damages. The wrongful taking of trust funds may be a

criminal offense in some states. If so, such embezzlement might be punished by fines and imprisonment.

Given that there has been a significant breach of contract, one in which damages are clearly provable, how than does an injured party take legal action? If the amount in dispute is not over the limits of the small claims court in one's jurisdiction, this course is the simplest and the quickest.

Arbitration is a second means of solving the dispute, although finding qualified and willing arbitrators may be difficult. The parties might approach a local group of volunteer lawyers for the arts for assistance. The procedure involved in arbitration is for a neutral arbitrator or panel of arbitrators to hear the dispute and come to a reasonable decision. The disputing parties agree to be bound by this decision. Costs are moderate, but, since arbitration is by its nature a form of compromise, neither party may find the resolution entirely satisfactory. To be certain that arbitration can be used, the parties can stipulate that any disputes are subject to arbitration. This possibility is elaborated in the discussion of paragraph 14.

If the sums involved are substantial, the injured party may decide to bring a civil court action against the other. It should be remembered, however, that legal expenses can mount up rapidly and, needless to say, both parties lose in litigation. Even if one's financial loss is recouped in the process, "winning" does not make a litigant whole. The emotional frustrations and bitterness are likely to remain long after the case is closed, no matter which way the decision goes.

It is far better for the dispute to be worked out while a peaceable resolution can still be found, for it is easier to avoid trouble than to seek remedy after the fact. Both artist and gallery should keep in mind that any agreement is only as good as the individuals who make it. If they neither feel confident about the professionalism and integrity of each other nor sense a genuine spirit of cooperation from the beginning, there is little chance that their relationship will improve as time goes on.

A written agreement between artist and gallery is not so much an effective remedy in a court of law as it is a basic code of behavior—a set of formalized procedures which the parties agree will govern their

relationship. Negotiating its terms is a useful way to open the channels of communication. This process can give artist and gallery an opportunity to know each other and to see how future conflicts might be worked out. The parties who have established written guidelines are likely to feel a higher level of obligation to each other than might be the case in the absence of a contract. The fact that the Standard Agreement introduces topics which artist or gallery might not have considered beforehand may in itself help to eliminate some areas of confusion which tend to lead to misunderstandings. If the use of the Standard Agreement can prevent disputes between artist and gallery that might otherwise become irreconcilable, it will have served its purpose well.

●

State Consignment Laws

5

State Consignment Acts

by Laura Mankin

\mathcal{U}t is not uncommon in the art world for a dealer-consignee (herein referred to as "the gallery") and artist-consignor to seal an unwritten consignment agreement with nothing more than a handshake. Whether the parties are aware of it or not, in the absence of a state consignment statute, the UCC generally guides such transactions. UCC section 2-326, "Sale on Approval and Sale or Return; Consignment Sales and Rights of Creditors," (reproduced in section D of the appendix) contains the provisions for the consignment relationships considered in this text, and the problems that arise within this section will be examined in greater detail here. This UCC section recognizes the consignment relationship as separate from a contract of sale, but fails to provide the artist with sufficient protections against the claims of the gallery's creditors. In addition to inadequate protections, the artist must first convince a court that the transaction in question is in fact a consignment before he or she may even attempt to make use of the meager protections of section 2-326(3).[1] The UCC provides three alternative ways to protect consigned goods from the claims of the consignee's creditors. These protections are found within sections 2-326(3)(a), (b), and (c).

Section 2-326(3)(a) protects the goods from the claims of creditors

if the artist affixes a sign to the consigned work evidencing his or her interest. This provision, however, requires that the state within which the agreement is executed have independent consignment laws requiring that notice of a consignment arrangement be given to the public in the form of a sign. Absent such independent state legislation, this provision is useless. Two states, Connecticut and Florida, have included such "sign laws" in their statutes dealing with artist-gallery consignments. The Connecticut and Florida statutes state:

> Whenever a consignor delivers or causes to be delivered a work of fine art to a consignee, such consignor shall give notice to the public by affixing to such work of fine art a sign or tag which states that such work of fine art is being sold subject to a contract of consignment, or such consignor shall post a clear and conspicuous sign in the consignee's place of business giving notice that some works of fine art are being sold subject to a contract of consignment.[2]

Section 2-326(3)(b) can provide some protection to the artist. However, the burden still lies with the artist to prove that the gallery's dealings were known to the creditor and the gallery was in fact "substantially engaged in selling the goods of others." This may be difficult and costly to prove. It leaves open to question whether there is a significant difference between "partially engaged" and "substantially engaged," and this distinction could yield two very different outcomes in terms of the artist's works.

Section 2-326(3)(c) requires the artist to file UCC Form 1, discussed in chapter 3 under paragraph 8 of the Standard Agreement. This form is governed by article 9 of the UCC covering secured transactions. By filing UCC Form 1, the artist becomes a *secured creditor*. A secured creditor has rights against specific property of the debtor. These rights come ahead of the rights of *unsecured creditors*, who are only entitled to share what is left after the secured creditors have taken the property in which they had security interests.

Should the artist fail to file a security agreement pursuant to UCC section 9-114, the artist's works will be subject to the claims of the gallery's creditors. Section 9-114 requires that written notification of

the consignment be given to secured creditors of the gallery within five years before the gallery receives possession of the art. This notification must state that the goods are to be delivered on consignment and give a description of the goods. It is this provision that affords the artist the greatest protection under the UCC. Section 9 filing is, however, complicated and time consuming. In order to use it, the artist must see the need to protect the art and know about the appropriate UCC provisions.

These UCC provisions are not typically used, leaving most artists to rely solely on the honesty of their galleries. Difficulties will arise if the gallery goes bankrupt and its creditors attempt to claim the art on consignment or the proceeds from sales of the art held by the gallery. The UCC, firmly rooted in the traditional doctrines of ostensible ownership and good faith purchasers, clearly prefers these creditors in such a dispute. The artist will argue that title to the art was never tendered to the gallery, and therefore ownership rights could not pass to the creditor. To this the creditor will counter that it relied, reasonably and in good faith, on the gallery's possession of the goods as a sufficient indication of ownership.[3] In the absence of adequate state legislation, unless the artist comes within one of the section 2-326(3) exceptions, the goods will be subject to the claims of the creditor. The artist will be unable to recover the art and will simply be treated as another unsecured creditor of the gallery.

It is this result that prompted legislatures in thirty states and the District of Columbia to enact independent consignment laws. Although all of these statutes seek to protect essentially the same group of individuals within their respective states, the approach varies widely from state to state. There are some statutes which provide detailed and expansive protections for artists (New York, Oregon), while others afford little more protection than the UCC (New Mexico, Texas). The common provisions of the consignment laws can be grouped into ten categories:
1. Definitions
2. Acts constituting consignment
3. Gallery as agent for artist
4. Works of fine art as property held in trust for the artist
5. Proceeds from the sale of a work of fine art held in trust for the artist

6. Gallery liabilities
7. UCC provisions
8. Written agreements
9. Waiver Provisions
10. Penalties for violations

DEFINITIONS

The definition section is normally the first section of the statute and outlines its general application, defining what is considered an "artist," a "work of fine art," an "art dealer," etc. New York has over two pages of definitions which broaden the application of the statute. This contrasts with the narrower Massachusetts statute, which only defines five terms. States with stronger artist protections tend to have more detailed definitions, encompassing a larger portion of the art world and a greater variety of art forms. A court, in determining the type of art or artist protected by the consignment statutes, may look to these definitions for guidelines. In *Wesselmann* v. *International Images, Inc.*, the court determined that an artist who conceived an image, delivered it to the printer chosen by the publisher, and approved and signed final prints had delivered "prints of his own creation" to an art merchant.[4] By finding that the artist's actions fell within the scope of the definition "delivering prints of his own creation," the court could then extend to the artist the protections afforded by the state consignment law. The outcome of this case depended on judicial interpretation of statutory definitions and highlights their importance.

ACTS CONSTITUTING CONSIGNMENT

Generally, the second provision of the statute defines when an artist and gallery have entered into a consignment relationship. It appears in essentially the same form in all of the statutes, with a few exceptions. (Arizona, Maryland, New Hampshire, New Mexico, and North Carolina lack such a provision.) Kentucky's language is typical:

> Notwithstanding any custom, practice or usage of the trade to the contrary, whenever an artist delivers or causes to be

> delivered a work of fine art of the artist's own creation to an art dealer in the Commonwealth for the purpose of exhibition or sale, or both, on a commission, fee or other basis of compensation, the delivery to and acceptance of such work of fine art by the art dealer shall constitute a consignment, unless the delivery to the art dealer is pursuant to an outright sale for which the artist receives or has received full compensation for the work of fine art upon delivery, or will receive full compensation pursuant to an installment agreement executed prior to or upon delivery.[5]

This provision places the parties in a consignment relationship, whether or not they have intentionally entered one. In order to be deemed a consignment relationship, the artist must have created the work of fine art and then delivered it or caused it to be delivered to the gallery for the purpose of exhibition or sale. In return for such exhibition or sale services, the gallery receives a commission, fee or other compensation. Where these are the qualifications for forming a consignment agreement, it is relatively easy for the average participants in these types of arrangements to be classified as "consignors" and "consignees."

GALLERY AS AGENT FOR ARTIST

When it is deemed that a consignment relationship exists between the artist and the gallery, the gallery is then statutorily considered the agent of the artist. Found in nearly all of the state statutes, the "gallery as agent" provision is relatively simple, and yet it is a critical element of the consignment relationship. New Hampshire's statute contains the uncomplicated provision found in most statutes: "The art dealer shall be, with respect to that work of art, the agent of the artist."[6] This means that the gallery represents the interests of the artist in exhibiting and selling the works of art.

Some state statutes meld the "acts constituting consignment" and "gallery as agent for artist" provisions into a single clause. Florida's statute is one such example:

Whenever a consignor delivers, or causes to be delivered, a work of fine art to a consignee for the purpose of sale, or exhibition and sale, to the public on a commission, fee, or other basis of compensation, the delivery and acceptance thereof by the art dealer is deemed to be "on consignment"; and with respect to the work of art, such consignee shall thereafter be deemed to be the agent of such consignor.[7]

WORKS OF FINE ART AS PROPERTY HELD IN TRUST FOR THE ARTIST

This provision and the "proceeds held in trust" provision below are two of the most important elements of the consignment statutes. It is this provision which protects the artist's works from the claims of the gallery's creditors if the gallery goes bankrupt. Under the UCC, which governs in the absence of this type of statute, the works would not be adequately protected from these claims unless the artist had filed appropriately under Article 9.

This simple but essential clause is found in all of the thirty-one state statutes, and is illustrated by Idaho's provision that: "The work of fine art constitutes property held in trust by the consignee for the benefit of the consignor and is not subject to claim by a creditor of the consignee."[8] Insuring this type of protection for the artist's works was a primary impetus for the enactment of the legislation. At the very least, each of the statutes clearly states that if a consignment relationship exists, the works of art are held by the gallery in trust for the artist and are not subject to the claims of the gallery's creditors under any circumstances.

PROCEEDS FROM THE SALE OF WORK OF FINE ART HELD IN TRUST

The "proceeds held in trust for the artist" portion of these statutes is slightly more complicated than the "works of art held in trust for the artist" provision. Each state's statutory provision for proceeds falls into one of three categories:

1. A general provision for the proceeds to be held in trust and not be subject to the creditors of the consignees.
2. A provision for the proceeds to be held in trust and an additional

obligation on the part of the gallery to pay the artist within a specific time frame. This provision may give the artist an option to waive this payment schedule.

3. A provision for the proceeds to be held in trust and a second provision prohibiting a waiver of the trust provision.

Generally the proceeds provision reads as the Iowa statute does: "The proceeds from the sale of the work of fine art shall be held in trust by the consignee for the benefit of the artist. The proceeds shall first be applied to pay any balance due the artist unless the artist expressly agrees otherwise in writing."[9]

Alaska's statute specifically provides for the proceeds to be delivered directly to the artist within a prescribed time frame insuring the artist's receipt of payment: "proceeds from the sale of the work of art are trust funds in the hands of the art dealer for the benefit of the artist;" and "the dealer shall transmit the proceeds to the artist within 30 days of receipt by the dealer."[10] This is an important provision for an artist, as not only is the money protected from creditors' claims by the trust, but the thirty day provision insures the artist speedy receipt of the monies. The artist can, however, waive this right by expressly agreeing in writing to an alternate distribution of the proceeds. Arizona's statute requires that the proceeds be held in trust by the gallery until the amount due the artist from the sale is paid, but does not place specific time parameters on the transaction.

Connecticut and Florida follow the general provision: "The proceeds of the sale of work of fine art shall be held in trust by the consignee for the benefit of the consignor. Such proceeds shall be applied first in payment of any amount due to the consignor." However, unlike many other states (Arizona, California, Idaho, Georgia, Kentucky), Connecticut and Florida have an additional waiver restriction stating that: "any provision of a contract or agreement whereby the consignor waives any of the provisions of this section is void."[11]

In all thirty-one consignment statutes, the gallery has a responsibility to hold the art, as well as the proceeds from the sale of the art, in trust and a statutory obligation to pay the artist. Although liabilities, waiver provisions, written agreement requirements, and definitions vary from state to state, the trust provision is fundamental. It is critical that the

artist is aware of his or her ability or inability to waive portions of this provision.

GALLERY LIABILITIES FOR LOSS OR DAMAGE TO WORKS OF ART

Liability for loss or damage to works of art while in the gallery's possession varies from state to state. This liability may be waived under some of the statutes. Coverage can be grouped in three general categories.

The most protective for the artist are the statutes that hold the gallery strictly liable for the loss or damage of the work of art while it is in the gallery's control. As discussed previously, under strict liability, the gallery is responsible to the artist for any loss or damage to the art while it is in the gallery's possession, regardless of how the damage occurred. The gallery is liable for value established in the written contract between the artist and gallery. This type of provision may provide the fair market value in the absence of a written contract establishing the value. Some states also deduct the gallery's fee from its liability. This strict liability provision is found in Ohio, Illinois, Alaska, Arizona, New Hampshire, Washington, Wisconsin, and Colorado.

In *Eboigbe* v. *Zoological Soc. Of Cincinnati*, the court held that a determination of the fair market value of a wooden sculpture, which was damaged while on consignment and on display at the zoo, could be based upon substantial evidence that there was a market for the artist's artwork absent an actual offer to buy the sculpture.[12] In determining the fair market value the court was free to consider insurance figures, the artist's asking and selling prices, sales of lesser pieces, the artist's reputation in the art world, and expert opinion. This case is particularly interesting as the court looked to the fair market value despite the absence of a provision in the statute requiring this. The decision is positive for artists, as in the absence of a recorded fair market value, the court made this determination from various factors which indicated an elevated worth. It should also encourage galleries to insist upon determining with the artist a fair market value for individual works to be relied upon in the event of loss or damage. Keep in mind, of course, that this decision was rendered in Ohio and may not apply in other states.

Idaho's statute is an example of the second category, which is

somewhat nebulous: "The consignee is responsible for the loss of or damage to the work of fine art while in the possession of or on the premises of the consignee."[13] The Kentucky statute merely requires that the property be lost or damaged; there is no specific requirement that the work of fine art be in the gallery's possession or on the gallery's premises. Montana, Missouri, Georgia, Oregon, Minnesota, Pennsylvania, Florida, New Jersey, Tennessee, and Iowa all have provisions which award the artist damages for works of art lost or damaged while in the possession of or on the premises of the gallery. This also leaves open the question of fault. Must an artist prove that the damage was a result of negligent behavior on the part of the gallery? This question is not clearly addressed in statutes which include this type of provision for liability.

The third category provides little, if any, protection for the artist's works against loss or damage while in the gallery's possession. Arkansas provides for loss or damage, but only if the loss or damage is a result of the gallery's negligence, and even then the gallery's fee is still subtracted from the amount owed to the artist. Some statutes, however, have no liability provision at all. Among the states whose statutes are silent as to a gallery's liability are Michigan, Massachusetts, and Connecticut.

UCC PROVISIONS

Section 1-104 of the Uniform Commercial Code reads: "This Act being a general act intended as a unified coverage of its subject matter, no part of it shall be deemed to be impliedly repealed by subsequent legislation if such a construction can be reasonably avoided." This provision essentially protects the UCC from being repealed by legislation that does not specifically allow for exceptions to the UCC by exactly naming the sections it intends to invalidate. If a statute contains standard boilerplate language, as Arkansas law does ("notwithstanding any law to the contrary"), it is unlikely that a court will find this strong enough to preempt the UCC, seriously calling into question the application of the statute.

Connecticut and Florida require the artist to affix a sign to the consigned work of art giving notice to the public that the work is in fact

subject to a consignment agreement. This provision tracks UCC section 2-326(3)(a), which provides for effective protection from the gallery's creditors if notice of the consignment relationship is given by affixing a sign to the work. Given the realities of the art market, however, it is unlikely that a gallery will allow a work to be displayed with such a sign attached. Unless a sign is placed on the work of art, the work is not protected from the gallery's creditors, so these statutes have little effect. In contrast, Alaska and Arkansas have actually changed their UCCs to offer artists these protections. Within the text of Alaska's UCC, protection is provided for works of art on consignment from a gallery's creditors:

> Whenever an artist delivers or causes to be delivered a work of fine art of the artist's creation to an art dealer for the purpose of sale, or exhibition and sale to the public on a commission or fee or other basis of compensation, the work of fine art is not subject to the claims of the art dealer's creditors.

Alaska also has an independent statute for the protection of "Artists and Works of Art,"[14] which provides the same and additional protections, but section 2-326 of the state's UCC has been modified as well.

State statutes fall into one of two groups: (1) those that expressly repeal the relevant UCC sections in the text of the statute, and (2) those that do not expressly repeal it. This provision is crucial because absent explicit repeal, it is unlikely the state art consignment law will take effect. Statutes which fail to make this provision include Iowa and Maryland. The majority of statutes do include this provision, overriding the section 1-104 protections of the UCC.

The statute in Idaho which deals with "Artist and Art Dealers" specifically repeals UCC section 2-326: "This part of this chapter is not subject to the provisions of chapters 1 through 10, title 28, Idaho Code."[14] Maryland's statute fails to make any mention of the contradictory UCC provision, and Arkansas' preemption provision may not be specific enough to override it:

> A work of art delivered to an art dealer for the purpose of exhibition or sale and the proceeds from the sale of the work

by the dealer, whether to the dealer on his own account or to a third person, are not subject to the claims, liens, or security interests of the creditors of the art dealer, notwithstanding any law to the contrary.[15]

In the event that a state does not contain a UCC preemption provision, or the provision is not specific enough to repeal section 2-326, the artist may be forced to comply with one of the UCC provisions discussed earlier in order to protect art from the gallery's creditors.

WRITTEN AGREEMENTS

Roughly half of the consignment statutes specifically require a written agreement between the gallery and the artist. Some statutes require that the agreement include a list of specified elements, while Idaho and Montana merely require a written contract to be updated every three years. Pennsylvania requires only that a written contract be executed. States requiring written contracts include: Iowa, Connecticut, Florida, Ohio, Arizona, New Hampshire, Wisconsin, Washington, Oregon, and Missouri.

The written agreement usually includes four elements:
1. That the proceeds of the sale of the work of fine art be delivered to the artist on a schedule agreed to by the gallery.
2. That the gallery shall be responsible for the stated value of the work of fine art in the event of the loss of or damage to such work of fine art while it is in the possession of the gallery.
3. That a minimum sale price for the work of fine art be established between the artist and gallery.
4. The fee, commission, or other compensation basis of the gallery.

These provisions represent the most basic form of a consignment agreement, and, in drafting an agreement, it would be wise to include these compulsory provisions.

Most statutes which require a written agreement to be executed place the responsibility with the gallery, who is typically in a better position to see to it that such an agreement is understood and signed. In the event that the gallery fails to meet this responsibility, most statutes

provide, as Georgia's does, that: "If an art dealer violates this Code section, a court may, at the request of the artist, void the obligation of the artist to that art dealer or to a person to whom the obligation is transferred other than a holder in due course."[16] Essentially, an artist may be released from the consignment relationship if the gallery fails to perform this part of the gallery's obligations.

These agreements, regardless of how carefully they are drafted, have no effect on the creditor's claims. In order for the artist's works to be protected, the state statute must have provisions for the works and proceeds to be held in trust for the artist or the artist must comply with the filing requirements of Article 9 of the UCC.

WAIVER PROVISIONS

Waiver provisions allow the artist to waive or alter some or all of the statutory protections provided by the consignment statutes. If a waiver provision is included in the statute, it usually allows the artist to waive liability protections or payment schedule guarantees. Most statutes provide that the proceeds from the sale of a work of art shall constitute funds held in trust by the gallery for the benefit of the artist, and these proceeds shall first be applied to pay any balance due to the artist unless the artist expressly agrees otherwise in writing. If the artist is willing to structure a payment schedule in which the gallery is not obligated to first pay the artist, the artist should realize that he or she is giving up a statutory protection.

The majority of statutes provide for gallery responsibility for loss or damage to artwork while in the gallery's possession, and some states go as far as providing strict liability on the gallery's part for loss or damage. An artist, in many cases, may waive this protection as well. This waiver would directly follow the provision for liability, as in the Iowa statute:

> The consignee is responsible for the loss of or damage to the work of fine art, unless otherwise mutually agreed upon in writing between the artist and art dealer in which case the art dealer shall be required to exercise all due diligence and care with regard to the work of fine art. In case of a waiver, the burden

shall be on the dealer to demonstrate the waiver was entered into in good faith.[17]

Some states, such as Illinois, do not allow either party to waive any of its provisions: "Any portion of an agreement which waives any provision of this Act is void."[18] An artist, when considering entering into a consignment relationship, should consult the applicable state statute and determine its waiver provisions in terms of payment schedule and liability protections. He or she should not waive any of these protections inadvertently. The artist should know that if the statute contains a blanket non-waiver provision, any agreement, in writing or not, to waive rights protected under the statute will be void.

PENALTIES FOR VIOLATIONS

The penalties for violations of these statutes vary greatly from state to state. Some statutes, such as those of Massachusetts and Kentucky, contain no penalties sections, thus leaving the artist at a disadvantage. If the gallery violates the consignment agreement, the artist must then sue the gallery for breach of contract, and as these statutes provide no remedy for breach, the outcome will be highly unpredictable. New Mexico, Tennessee, Iowa, Minnesota, Maryland, Michigan, Idaho, and Montana also fail to include such a provision.

The majority of statutes provide, as Arkansas does, that:

> A violation by an art dealer of any of the provisions of this subchapter shall render the art dealer liable to the artist in an amount equal to fifty dollars ($50.00) plus the actual damages sustained by the artist, including incidental and consequential damages. In such actions, reasonable attorneys' fees and court costs shall be paid to the prevailing party.[19]

Some statutes differ in the dollar amount provided and the sections of the statute to which the penalties should be applied. Arizona finds the gallery liable to the artist for five hundred dollars, actual damages, and reasonable attorneys' fees for violations of the gallery's duty to obtain a written contract. If the gallery fails to transmit on a monthly

basis the monies for sales of fine art on consignment, the gallery is then liable to the artist in an amount equal to three times the amount due the artist. New Jersey merely provides that a gallery will be liable to the artist in a civil action for violations of the statute. Arizona, Colorado, Wisconsin, Georgia, Washington, and Arkansas all have similar penalty provisions.

Some states go further than awarding standard monetary awards, actual damages, and attorneys' fees. They provide for punitive damage awards within the penalties section. Missouri's statute reads: "Any art dealer or creditor of any art dealer who violates any provision of section 407.900 to 407.910 with intent to injure shall, in addition to the payment of all other damages and costs owed by him, pay to the artist involved punitive damages in an amount as may be determined by law and reasonable attorney's fees."[20] The Florida statute makes a violator of the statute "guilty of a misdemeanor of the second degree." The harshest punishment for violation of the consignment statute is, however, found in Oregon:

> It shall be unlawful for a consignee willfully and knowingly to secret[ly] withhold or appropriate a work of fine art or the proceeds from the sale thereof for the consignee's own use or the use of any person other than the consignor, except pursuant to a bona fide sale or as otherwise consistent with the terms of consignment. Violation of this section is a class C felony.[21]

Because the penalties vary from no provided remedy to those appropriate to class C felonies, it is essential that both gallery and artist are aware of the applicable state statute.

INDIVIDUAL STATE LAWS

The following section highlights some of the important provisions of the art consignment laws of those states which have enacted them. In most cases the actual wording of the statute has been used to describe the statutory provision or requirement. The full text of these provisions is found in chapter 6, "State Art Consignment Laws."

Alabama

- Alabama has not yet passed any state consignment legislation.

Alaska

- Alaska has included within the text of its UCC a protective provision for consignors and their art.
- The gallery is strictly liable for loss or damage to the art while the art is in the possession of the gallery for the value established by written agreement between the artist and gallery prior to the loss or damage. In the absence of a written agreement establishing the value of the art, the value is the fair market value of the work of art less the gallery's commission or fee.
- The gallery must transmit the proceeds from a sale to the artist within thirty days of receipt by the gallery; if the sale is on installment, the money from each installment must first be applied to pay any balance due the artist on the sale. The artist may waive this right and replace it with a percentage payment if this is agreed to expressly in writing.

Arizona

- The gallery is strictly liable for the loss of or damage to the work of fine art while it is in the gallery's possession for the value established in the written agreement between the artist and gallery prior to the loss or damage or, if no written agreement exists, the fair market value of the work of fine art.
- The gallery is required to obtain a written contract containing the following provisions:
 1. The value of the work of fine art.
 2. The time within which the proceeds of the sale are to be paid to the artist, if the work is sold.
 3. The minimum price for which the work is to be sold.
- The gallery is only to display the work of fine art if notice is given to users or viewers that the work is of the artist and the artist gives prior written consent to the particular use or display.
- The gallery is required to transmit funds from sales of the artist's work on a monthly basis.
- No waiver of any provision of the statute is permitted.

- Violations by the gallery can result in a five-hundred-dollar liability to the artist as well as actual damages and attorneys' fees. If the gallery fails to give notice that the work is by the particular artist or fails to obtain written consent before displaying the works, the gallery may be liable to the artist in an amount equal to three times the amount due the artist.

Arkansas

- The gallery is liable to the artist for fifty dollars and actual damages in the event of a violation of any provision of the statute. Reasonable attorneys' fees and court costs are paid to the prevailing party.
- Statute contains a possibly insufficient preemption of UCC section 104, stating only, "notwithstanding any law to the contrary."
- The gallery is only liable to the artist for negligent acts causing the loss of or damage to a work while it is in the gallery's possession. Value is established in a written agreement between the artist and gallery prior to the loss or damage. In the absence of a written agreement the value of the work is the fair market value less the gallery's commission or fee.

California

- The gallery is liable for the loss of or damage to the work of art. Nothing is said about the value for which the gallery is responsible, nor the circumstances (negligence) under which the gallery is liable.
- Proceeds from sale must first be applied to pay any balance due the artist unless the artist expressly agrees to waive this right in writing.
- It was held in *Pelletier* v. *Eisenberg* that the most accurate measure of damages to compensate an artist for his losses in an art gallery fire was the fair market value of the paintings destroyed or damaged, rather than the paintings' wholesale value, although the artist had agreed to pay the gallery owners a commission if the paintings were sold.[22]
- No waiver of the statute is permitted in any provision of an agreement.

- There is not a very strong preemption of the UCC. The statute fails to explicitly state the section of the UCC it intends to override. It reads: "The provision of this title shall prevail over any conflicting or inconsistent provisions of the Commercial Code affecting the subject matter of this title."[23]

Colorado

- The gallery is strictly liable for the loss of or damage to a work of fine art while it is in the gallery's possession. The value of the work of fine art is the value established in a written agreement between the artist and gallery executed prior to the loss or damage of the work. The statute fails to provide a way to set a value (either fair market value or fair market value less the gallery's commission or fee) for the work in the absence of a written agreement.
- Violations by a gallery of the provisions render the gallery liable for damages to the artist in the amount of fifty dollars plus actual damages. Reasonable attorneys' fees and court costs shall be paid to the prevailing party.
- Any provision, written or oral, which waives a provision of the statute shall be deemed to be against public policy and shall be void.

Connecticut

- Any provision of a contract or agreement where an artist waives any of the provisions of the statute is void.
- A written contract must be executed whenever a gallery accepts works of art on consignment. The agreement between the gallery and artist shall be written and include, but not be limited to, the following provisions:
 1. That the proceeds of the sale of the works be delivered to the artist on a schedule agreed upon by the gallery and artist.
 2. That the gallery is responsible for the stated value of the work of art in the event of the loss of or damage to such work while it is in the gallery's possession.
 3. The minimum amount for which the work should be sold.
 4. That the work may be used or displayed by the gallery or others only with prior written consent of the artist and only if the artist is acknowledged in such use or display.

Delaware
• Delaware has not yet passed any state consignment legislation.

District of Columbia
• The District of Columbia's statute contains very few specific provisions other than protecting the art and proceeds from the sale of the art from the gallery's creditors. It makes no provisions for gallery liability, written contracts, or penalties for violations.

Florida
• Any agreement whereby the artist waives any of the protective provisions of the statute is void.
• *Shuttie* v. *Festa Restaurant, Inc.* held that if the artist fails to comply with the provision of the statute with respect to posting notice of ownership, the innocent third party who takes security possession in the paintings (the creditors of the gallery) has superior possessory interest.[24]
• There must be a written contract between the artist and the gallery including the following provisions:
 1. That the proceeds of the sale of the art shall be delivered to the consignor at a schedule agreed upon by the gallery and artist.
 2. That the gallery shall be responsible for the stated value of the work of art in the event of the loss of or damage to such work of art while it is in the possession of such consignee.
 3. That the work of art shall only be sold by the consignee for an amount at least equal to the amount agreed upon by the consignor in writing.
 4. That the work of art can only be displayed by the gallery with the prior written consent of the artist.
 5. That the artwork delivered to the gallery by the artist for the purpose of exhibition or sale, and the artist's share of the proceeds of the sale of the work by the gallery (whether to the gallery on his or her own account or to a third person), shall create a priority in favor of the artist over the claims, liens, or security interests of the creditors of the gallery, notwithstanding any provisions of the UCC.

- Violation of the statute is a misdemeanor of the second degree, punishable as provided in Florida's penal code.
- The statute is only applicable to works of art priced over one hundred dollars.

Georgia

- A written contract must be entered into by the artist and gallery prior to the gallery's acceptance of art on a fee, commission or other compensation basis. This written agreement must establish:
 1. The value of the art.
 2. The time within which the proceeds of the sale are to be paid to the artist if the work of art is sold.
 3. The minimum price for the sale of the work of art.

 If a gallery violates the obligation to execute such an agreement, a court may, at the request of the artist, void the obligation of the artist to that gallery.
- The gallery is responsible for the loss of, or damage to, the work of art. There is nothing said of the amount for which the gallery is liable, a negligence requirement, or whether or not the work must be in the gallery's possession.
- The artist may waive the right to have the proceeds from the sale of the work of art applied first to any balance due. This waiver must be expressly agreed to in writing.
- An artist may only waive the gallery's liability for the loss of or damage to works of art when the gallery is a cooperative.
- In order to display the works on consignment:
 1. Notice must be given to the users or viewers that the work of art is that of the artist.
 2. The artist must give prior written consent to the particular use or display.
- A gallery who violates the statute is liable to the artist for fifty dollars, actual damages, and reasonable attorneys' fees.

Hawaii

- Hawaii has not yet passed any state consignment legislation.

Idaho

- The statute requires the consignment relationship to be defined in writing and renewed at least every three years by the gallery and artist. The statute makes no specific requirements as to what the agreement must include.
- It is the responsibility of the artist to identify clearly the work of art by attaching an identifying marking to or clearly signing the work of art.
- The gallery is responsible for the loss of or damage to the work of fine art while in the possession of or on the premises of the gallery.
- Proceeds from the sale of the work of fine art will first be applied to any balance due the artist, unless the artist expressly agrees otherwise in writing.
- Any waiver of any provision of the statute is void.

Illinois

- Any proceeds of the sale of a work of fine art, with the exception of customer deposits, are held in trust for the artist and must be paid to the artist within thirty days of receipt by the gallery unless the parties expressly agree otherwise in writing. Customer deposits shall be used to pay the amounts due the artist within thirty days after such deposits become part of the payment for the work.
- The gallery is strictly liable for the loss of or damage to the work of art while it is in the gallery's possession. The value is established in a written agreement between the gallery and artist executed prior to the loss or damage. If no written agreement exists, the value is the fair market value of the work. However, reimbursement to the artist from the gallery may not exceed the amount which would have been due the artist if the work had been sold at the stated purchase price in the agreement (the gallery's commission would be subtracted). The gallery is no longer held liable for loss or damage to the work of art if the artist fails to remove the work within a period of thirty days following the date agreed upon for removal of the work in a written contract. If no written agreement regarding removal exists, the gallery is no

longer liable after notice to remove the work of fine art is sent by registered mail to the artist's last known address.

- Artist and gallery must enter into a written agreement prior to, or within seven days of, acceptance of the work, including the following provisions:

 1. The value of the work.
 2. The time within which the proceeds of the sale are to be paid to the artist if the work is sold.
 3. The commission the gallery is to receive if the work is sold.
 4. The minimum price for the sale of the work and any discounts ordinarily given by the gallery in his regular course of business.

 If a gallery fails to comply with this requirement, an artist may seek relief in a court by having the artist's obligation to the gallery voided.

- Any portion of an agreement which waives any provision of the statute is void.
- Any gallery who violates the written contract requirement is liable to the artist for fifty dollars, actual damages, and reasonable attorneys' fees.

Indiana
- Indiana has not yet passed any state consignment legislation.

Iowa
- A contract must be entered into by the artist and gallery when the gallery accepts a work of fine art which includes the following provisions:

 1. That the amount of the proceeds due the artist from the sale of the work shall be delivered to the artist at a time agreed upon by the artist and gallery.
 2. That the gallery is responsible for the stated value of the work in the event of the loss of or damage to the work while it is in the possession of the gallery.
 3. That the work shall be sold by the gallery only for the amount agreed upon by the artist in the contract or agreement, and the gallery will take only the commission or fee agreed upon.
 4. That the work may be displayed or used by the gallery or other

person only with the prior written consent of the artist, and the artist may require that the artist be acknowledged in the use of the work.

- The gallery is responsible for the loss of or damage to the work, but the artist may agree to waive this liability in writing. If the artist chooses to do so, the gallery is still required to exercise all due diligence and care with regard to the work of fine art, and the burden is on the gallery to demonstrate that the waiver was entered into in good faith.
- Proceeds from the sale of the work shall be held in trust and first applied to pay any balance due the artist, unless the artist expressly agrees otherwise in writing.
- Any contractual provision of an agreement where the gallery waives a provision of the consignment statute is void.

Kansas
- Kansas has not yet passed any state consignment legislation.

Kentucky
- The gallery is responsible for the loss of, or damage to, the work of fine art. The statute fails to state the specific circumstances and amount for which the gallery is liable. Therefore, this should be clearly stated in a written agreement between the artist and gallery.
- Any provision of a contract or agreement whereby the artist waives any provision of the statute is void.

Louisiana
- Louisiana has not yet passed any state consignment legislation.

Maine
- Maine has not yet passed any state consignment legislation.

Maryland
- Maryland's statute contains very few specific provisions beyond protecting the art and proceeds from the sale of the art from the gallery's creditors. No provisions for gallery liability, written contracts, or penalties for violations are made.

Massachusetts

- The gallery is responsible for the loss of, or damage to, the work of fine art. The statute fails to state the specific circumstances and amount for which the gallery is liable. Therefore, this should be clearly stated in a written agreement between the artist and gallery.
- The proceeds from the sale of the work are held in trust by the gallery and must first be applied to any balance due the artist, unless the artist expressly agrees otherwise in writing.
- Any provision of an agreement whereby the artist waives any provision of the consignment statute is void.

Michigan

- A gallery may only accept works for a commission on consignment if, before the time of acceptance, the gallery gives the artist a written receipt describing the work delivered to the gallery and the consignment nature of the delivery.

Minnesota

- The gallery is responsible for the loss of, or damage to, the work of art. The statute fails to state the specific circumstances and amount for which the gallery is liable. Therefore, this should be clearly stated in a written agreement between the artist and gallery.
- The proceeds from the sale of the work are held in trust by the gallery and are to be applied first to any balance due to the artist, unless the artist expressly agrees otherwise in writing.

Mississippi

- Mississippi has not yet passed any state consignment legislation.

Missouri

- A written contract between the artist and gallery must be entered into and must include the following provisions:
 1. That the proceeds of the sale of the work must be delivered to the artist on a schedule agreed upon by the artist and gallery.
 2. That the gallery is responsible for the stated value of the work

in the event of loss of or damage to the work while it is in the possession of the gallery.

3. That the work can only be sold by the gallery for an amount at least equal to the amount agreed upon by the artist in writing.

4. That the work of fine art may be used or displayed by the gallery or others only with prior written consent of the artist.

- The proceeds from the sale of the work are held in trust by the gallery and are to be applied first to any balance due to the artist, unless the artist expressly agrees otherwise in writing. Such waiver must be clear, conspicuous, in writing, and signed by the artist.

- When a gallery buys the consigned art for itself, no waiver of the trust fund provision is permitted.

- Any gallery who violates the statute with intent to injure the artist shall be subject to additional damages to be determined by the court. Reasonable attorneys' fees will also be awarded to the artist.

Montana

- The consignment relationship must be defined in writing and renewed at least every three years by the gallery and artist. It is the responsibility of the artist to identify clearly each work of art by attaching an identifying marking to or clearly signing the work of art.

- The gallery is responsible for loss of or damage to the work while in the possession of or on the premises of the gallery.

- The proceeds from the sale of the work are held in trust by the gallery and must first be applied to pay any balance due the artist, unless the artist expressly agrees otherwise in writing.

- Any provision of a contract or agreement by which the artist waives any part of the statute is void.

Nebraska

- Nebraska has not yet passed any state consignment legislation.

Nevada

- Nevada has not yet passed any state consignment legislation.

New Hampshire

- The gallery is strictly liable for loss of or damage to the work while it is in the gallery's possession or control. The value of the work shall be the value established in the written contract between the artist and the gallery.
- A gallery may not accept work on consignment from an artist unless, prior to the time of acceptance, the gallery and artist enter into a written contract which contains all of the following provisions:
 1. The value of the work and whether it may be sold.
 2. The time within which the proceeds of the sale are to be paid to the artist, if the work is sold.
 3. The minimum price for the sale of the work of art.
 4. The fee or percentage of the sale price that is to be paid to the gallery for displaying or selling the work of art.
 5. An agreed-upon date for the removal of artwork and date for termination of the contract.

 If a gallery violates this section, a court, at the request of the artist, may void the obligation of the artist to that gallery.
- A gallery may not use or display a work on consignment unless notice is given to users or viewers that the work of art is the work of the artist and the artist gives prior written consent to the particular use or display.
- Any provision of a contract or agreement whereby the artist or gallery waives any of the provisions of the statute is void.
- A gallery who fails to execute a written contract with the artist with the necessary provisions or displays the works without proper consent and notice is subject to the following civil penalties:
 (a) One hundred dollars plus actual damages.
 (b) The artist's obligation for compensation to the gallery shall be voidable by the artist.

New Jersey

- The gallery must provide the artist with a written statement of the artist's rights as set forth in the statute. If a gallery fails to give such notice, it will be charged with disorderly conduct and shall

be subject, upon conviction, to the penalties set forth in New Jersey's penal code.

- The gallery shall not accept a work on consignment unless, prior to acceptance, the gallery conveys to the artist a written receipt describing the work delivered to the gallery and setting out the terms of the consignment agreement.
- The gallery is liable to the artist in a civil action for the loss of or damage to the works on consignment. The statute fails to state the specific circumstances and amount for which the gallery is liable. Therefore, this should be clearly stated in a written agreement between the artist and gallery.
- The artist may not waive rights under the statute unless the waiver is clear, conspicuous, and in writing.

New Mexico

- New Mexico's statute contains very few specific provisions beyond protecting the art and proceeds from the sale of the art from the gallery's creditors. No provisions for gallery liability, written contracts, or penalties for violations are made.

New York

- No waivers are permitted with the exception of the following provision: "Any proceeds from the sale of such work are trust funds in the hands of the dealer for the benefit of the artist."[25] A waiver of this section, however, shall not be valid with respect to:
 1. The first $2,500 of gross proceeds of sales received in any twelve-month period, commencing with the date of the execution of such a waiver.
 2. The proceeds of a work initially received on consignment but subsequently purchased by the gallery, directly or indirectly, for his own account.

Such a waiver may not benefit the gallery's creditors in any manner which might be inconsistent with the gallery's rights under the statute.

North Carolina

- North Carolina's statute contains very few specific provisions beyond protecting the art and proceeds from the sale of the art from the gallery's creditors. No provisions for gallery liability, written contracts, or penalties for violations are made.

North Dakota

- North Dakota has not yet passed any state consignment legislation.

Ohio

- The gallery cannot accept a work on consignment from an artist unless a written contract which contains the following provisions has been entered into by the gallery and artist:
 1. The value of the work of art and whether it may be sold.
 2. The time within which the proceeds of the sale are to be paid to the artist, if the work of art is sold.
 3. The minimum price for the sale of the work of art.
 4. The fee or percentage of the sale price that is to be paid to the gallery for displaying or selling the work of art.
- If the gallery violates any portion of the statute, a court, at the request of the artist, may void the obligation of the artist to that gallery.
- A gallery who accepts works on consignment must, prior to use or display of the work, give notice to users or viewers that the work of art is the artist's, and obtain written consent from the artist to the particular use or display.
- Any portion of an agreement or contract that waives any provision of the statute is void.
- A gallery who fails to either execute a written contract with the requisite provisions, notify the viewers of the work that it is the artist's, or obtain written and prior permission to display the work is liable to the artist for reasonable attorneys' fees and an amount equal to the greater of:
 (a) Fifty dollars, or,
 (b) The actual damages.

Oklahoma
- Oklahoma has not yet passed any state consignment legislation.

Oregon
- A gallery is liable to the artist for loss of or damage to an artwork in the gallery's possession if such loss or damage is caused by the gallery's failure to use the highest degree of care. In calculating damages, the artwork is given the value established in a written agreement between the artist and gallery prior to the loss or damage. If no written record of the value of the work of fine art exists, the artist's portion of its fair market value will be substituted.
- The gallery is no longer liable for the loss of or damage to work if the artist fails to remove the work within thirty days of the date agreed upon for removal in the contract or, in the absence of a written agreement, thirty days after the gallery sends notice to the artist's last known address by registered mail, or by certified mail with return receipt, ordering the removal of the work.
- A gallery must furnish the artist, upon demand, a list of the names, addresses, and dates of purchase of those individuals whose purchases of the artist's works total more than one hundred dollars. Failure to furnish this information entitles the artist to obtain an injunction prohibiting such conduct and in addition, money damages in an amount equal to three times the artist's portion of the retail value of the work.
- Section 359.210(b) contains what may be a typo, "The work of fine art, or the artist's portion of the proceeds from the sale of such work, shall not be subject to the claims of a creditor or consignee." This should probably read "claims of a creditor of consignee."
- The artist and gallery must enter into a written contract prior to the gallery's acceptance of the work. The contract must contain the following provisions:
 1. The retail value of the work.
 2. The time within which the proceeds of the sale are to be paid to the artist, if the work is sold.
 3. The fee, commission, or other compensation of the gallery.
- A gallery who accepts works on consignment must, prior to use

or display of the work, give notice to users or viewers that the work of art is the artist's, and obtain written consent from the artist to the particular use or display.

- Any provision of a contract or agreement whereby the artist waives any of the provisions of the statute is void.
- If a gallery knowingly and willfully violates the statute by withholding and using proceeds from a sale of the artist's work, it is a Class C felony.
- A gallery who fails to either execute a written contract with the requisite provisions, notify the viewers of the work that it is the artist's, or obtain written and prior permission to display the work is liable to the artist for one hundred dollars plus actual damages, and the artist's obligation for compensation to the gallery is voidable by the artist. The court may award reasonable attorneys' fees and costs to the prevailing party.

Pennsylvania

- A gallery accepting works on consignment must, prior to acceptance, issue the artist a written receipt describing the work delivered and setting out the terms of consignment. For terms which should be included in this type of contract, see chapter 3.
- The gallery is liable to the artist in a civil action for loss of or damage to the work.
- An artist may waive rights under the statute, provided the waiver is in writing.

Rhode Island

- Rhode Island has not yet passed any state consignment legislation.

South Carolina

- South Carolina has not yet passed any state consignment legislation.

South Dakota

- South Dakota has not yet passed any state consignment legislation.

Tennessee

- The gallery shall be responsible for the loss of or damage to the work of art. The statute fails to state the specific circumstances under and amount for which the gallery is liable. Therefore this should be clearly stated in a written agreement between the artist and gallery.
- The proceeds from the sale of the work are held in trust by the gallery and should first be applied to pay any balance due the artist, unless the artist expressly agrees otherwise in writing.
- With respect to cooperative galleries, the liability of the gallery for loss or damage to works of art may be waived. No other provision of the statute may be waived by the artist.

Texas

- Texas's statute contains very few specific provisions beyond protecting the art and proceeds from the sale of the art from the gallery's creditors. No provisions for gallery liability, written contracts, or penalties for violations are made.

Utah

- Utah has not yet passed any state consignment legislation.

Vermont

- Vermont has not yet passed any state consignment legislation.

Virginia

- Virginia has not yet passed any state consignment legislation.

Washington

- The gallery is strictly liable for the loss of or damage to artwork while it is in the gallery's possession. The value of the work is established between the artist and gallery in the written agreement entered into prior to the loss or damage. In the absence of a written agreement, the fair market value will be substituted.
- The gallery may only accept works on consignment from an artist if, prior to acceptance, the parties enter into a written contract which states:

1. The value of the work.
2. The fee, commission, or other compensation basis of the gallery.
3. The minimum price for the sale of the work.

- The gallery, prior to the display of the artist's work, must give notice to the viewers and users that the work is that of the artist, and obtain written consent to the particular use or display from the artist.
- Any portion of a contract which waives any provision of the statute is void.
- If a gallery violates the statute, the gallery is liable to the artist for fifty dollars plus actual damages. If the gallery fails to either execute a written contract with the requisite provisions, notify the viewers of the work that it is the artist's, or obtain written and prior permission to display the work, the artist's obligation for compensation to the gallery is voidable. The court may, at its discretion, award the artist reasonable attorneys' fees.

West Virginia
- West Virginia has not yet passed any state consignment legislation.

Wisconsin
- The gallery is strictly liable for the loss of or damage to the work while it is in the gallery's possession. The value of the work is established between the artist and gallery in the written agreement prior to the loss or damage. If no agreement regarding the value of the work exists, the measure will be the fair market value of the work.
- The gallery shall not accept a work on consignment from an artist unless a written contract has been entered into by the gallery and artist which contains the following provisions:
1. The value of the work.
2. The time within which the proceeds of the sale are to be paid to the artist, if the work is sold.
3. The minimum price for the sale of the work.
If a gallery violates this provision, a court may, at the request of the artist, void the obligation of the artist to that gallery.

- A gallery, prior to the display of the artist's work, must give notice to the viewers and users that the work is that of the artist, and obtain written consent to the particular use or display from the artist.
- Any portion of an agreement which waives any provision of the statute is void.
- If the gallery fails to either execute a written contract with the requisite provisions, notify the viewers of the work that it is the artist's, or obtain written and prior permission to display the work, the gallery is then liable to the artist for fifty dollars, actual damages, and reasonable attorneys' fees.

Wyoming

- Wyoming has not yet passed any state consignment legislation.

NOTES

1. Mark Marcone, *The UCC and Consignment: Making the Code Safe for Artists and Other "Little Fellows,"* 12 CARDOZO ARTS & ENT. L.J. 579, at 581(1994).
2. Connecticut Code, sec. 42-1161(b); Florida Code sec. 686.502(2).
3. Mark Marcone, *The UCC and Consignment: Making the Code Safe for Artists and Other "Little Fellows,"* 12 CARDOZO ARTS & ENT. L.J. 579, at 580(1994).
4. *Wesselmann* v. *International Images, Inc.,* 657 N.Y.S.2d.284.
5. Kentucky Revised Statutes, sec. 365.855.
6. New Hampshire Code, sec. 352.4.
7. Florida Code, sec. 686.502(1).
8. Idaho Code, sec. 28-11-103(2).
9. Iowa Code, sec. 556.D.3(4).
10. Alaska Statutes, sec. 45.65.200(2), (6).
11. Connecticut Code, sec. 42-1161(d); Florida Code, sec. 686.502(4).
12. *Eboigbe* v. *Zoological Society of Cincinnati,* 96 OH App. 3d 102.
13. Idaho Code, sec. 28-11-103(3).
14. Alaska Statutes, sec. 45.65.200.
15. Idaho Code, sec. 21-11-105(2).
16. Arkansas Code, sec. 4-73-207.
17. Georgia Statues, sec. 10-1-523(b).
18. Iowa Code, sec. 556D.3.3.

19. Illinois Compiled Statutes, sec. 320/6.

20. Arkansas Code, sec. 4-73-204.

21. Missouri Code, sec. 407.910.

22. Oregon Code, sec. 359.240.

23. *Pelletier* v. *Eisenberg*, 223 Cal. Rptr. 84, 177 Cal. App.3d 558.

24. California Code, sec. 1738.9.

25. *Shuttie* v. *Festa Restaurant, Inc.*, App. 3 Dist., 566 So.2d.554.

26. New York Code, sec. 12.01.

●

6

The State Art Consignment Laws

. .

Sec. 45.02.326 Sale on approval and sale or return; consignment sales and rights of creditors.

(a) Unless otherwise agreed, if delivered goods may be returned by the buyer even though they conform to the contract, the transaction is

 (1) a "sale on approval" if the goods are delivered primarily for use; and

 (2) a "sale or return" if the goods are delivered primarily for resale.

(b) Except as provided in (c) of this section, goods held on approval are not subject to the claims of the buyer's creditors until acceptance; goods held on sale or return are subject to such claims while in the buyer's possession.

(c) If goods are delivered to a person for sale and the person maintains a place of business at which the person deals in goods of the kind involved under a name other than the name of the person making delivery, then, with respect to claims of creditors of the person conducting the business, the goods are considered to be on sale or return. This subsection is applicable even though

an agreement purports to reserve title to the person making delivery until payment or resale or uses such words as "on consignment" or "on memorandum." However, this subsection is not applicable if the person making delivery

(1) complies with an applicable law providing for a consignor's interest or the like to be evidenced by a sign;

(2) establishes that the person conducting the business is generally known by the person's creditors to be substantially engaged in selling the goods of others; or

(3) complies with the filing provisions of AS 45.09.

(d) An "or return" term of a contract for sale is to be treated as a separate contract for sale within the statute of frauds section (AS 45.02.201), and as contradicting the sale aspect of the contract within the provisions on parol or extrinsic evidence (AS 45.02. 202).

(e) Whenever an artist delivers or causes to be delivered a work of fine art of the artist's creation to an art dealer for the purpose of sale, or exhibition and sale to the public on a commission or fee or other basis of compensation, the work of fine art is not subject to the claims of the art dealer's creditors. For the purposes of this subsection

(1) "art dealer" means a person other than a public auctioneer engaged in the business of selling works of fine art;

(2) "artist" means the creator of a work of fine art;

(3) "fine art" includes a painting, sculpture, drawing, photograph, or work of graphic art.

Sec. 45.65.200 Artists and art dealer relationships.

(a) When an artist delivers or causes to be delivered a work of art of the artist's own creation to an art dealer for the purpose of sale, or exhibition and sale, on a commission, fee, or other basis of compensation, the acceptance of the work of art by the art dealer is a consignment, and

(1) the art dealer is, with respect to the work of art, the agent of the artist;

(2) the work of art is trust property in the hands of the art dealer for the benefit of the artist;

(3) proceeds from the sale of the work of art are trust funds in the hands of the art dealer for the benefit of the artist;

(4) the art dealer shall return an unsold work of art on demand of the artist;

(5) the art dealer is strictly liable for loss or damage to a work of art while the work of art is in the possession of the art dealer; the value of a lost or damaged work of art is the value established by written agreement between the artist and art dealer before the loss or damage of the work of art; if no written agreement establishing the value of the work of art exists, the value is the fair market value of the work of art less the art dealer's commission or fee; and

(6) the dealer shall transmit the proceeds to the artist within 30 days of receipt by the dealer; if the sale is on installment, the money from each installment shall first be applied to pay any balance due the artist on the sale, unless the artist expressly agrees in writing that the proceeds on each installment are to be paid according to a percentage established by the consignment agreement.

(b) A work of art initially received as a consignment remains trust property notwithstanding the subsequent purchase of the artwork by the art dealer directly or indirectly for the art dealer's own account until the consignment price due to the artist is paid in full. The trusteeship continues until the fiduciary obligation of the art dealer with respect to the transaction is discharged in full.

Sec. 45.65.210 Waiver.

(a) A provision of a contract or agreement whereby the artist waives a provision of AS 45.65.200 is void except as provided in this subsection. An artist may waive the provisions of AS 45.65.200 if the waiver is clear, conspicuous, and agreed to in writing by the artist. A waiver under this subsection is not valid with respect to the proceeds of a work of art initially received as a consignment but subsequently purchased by the art dealer directly or indirectly for the art dealer's own account.

(b) A waiver under (a) of this section may not inure to the benefit of

the art dealer's creditors in a manner that is inconsistent with the artist's rights under AS 45.65.200.

Sec. 45.65.250 Definitions.

In AS 45.65.200–45.65.250, unless the context otherwise requires,

(1) "art dealer" means a person engaged in the business of selling works of art, other than a person exclusively engaged in the business of selling goods at public auction;

(2) "artist" means the creator of a work of art or, if deceased, the heirs or personal representatives of the creator;

(3) "consignment" means that no title to or estate in the goods or right to possession superior to that of the consignor vests in the consignee, notwithstanding the consignee's power or authority to transfer and convey, to third person, all of the right, title and interest of the consignor, in and to the goods;

(4) "creditor" has the meaning given in AS 45.01.201;

(5) "work of art" means an original or multiple original art work including:

(a) visual art such as a painting, sculpture, drawing, mosaic, or photograph;

(b) calligraphy;

(c) graphic art such as an etching, lithograph, offset print, or silk screen;

(d) craft work in clay, textile, fiber, wood, metal, plastic, or glass materials;

(e) mixed media such as a college or any combination of art media in this paragraph;

(f) art employing traditional native materials such as ivory, bone, grass, baleen, animal skins, wood and furs.

ARIZONA (ENACTED 1983)

§ 44-1771. Definitions

In this article, unless the context otherwise requires:

1. "Art dealer" means a person engaged in the business of selling works of fine art, other than a person exclusively engaged in the business of selling goods at public auction.

2. "Artist" means the creator of a work of fine art.

3. "On consignment" means delivered to an art dealer for the purpose of sale or exhibition, or both, to the public by the art dealer other than at a public auction.

4. "Work of fine art" means an original or multiple original art work which is:

 (a) A visual rendition, including a painting, drawing, sculpture, mosaic or photograph.

 (b) A work of calligraphy.

 (c) A work of graphic art, including an etching, lithograph, offset print or silk screen.

 (d) A craft work in materials, including clay, textile, fiber, wood, metal, plastic or glass.

 (e) A work in mixed media, including a collage or a work consisting of any combination of subdivisions (a) through (d).

§ 44-1772. Art dealer and artist; relationship

If an art dealer accepts a work of fine art, on a fee, commission or other compensation basis, on consignment from the artist who created the work of fine art:

1. The art dealer is, with respect to that work of fine art, the agent of the artist.

2. The work of fine art is trust property and the art dealer is trustee for the benefit of the artist until the work of fine art is sold to a bona fide third party or returned to the artist.

3. The proceeds of the sale of the work of fine art are trust property and the art dealer is trustee for the benefit of the artist until the amount due the artist from the sale is paid.

4. The art dealer is strictly liable for the loss of or damage to the work of fine art while it is in the art dealer's possession. The value of the work of fine art is, for the purpose of this section, the value established in a written agreement between the artist and art dealer prior to the loss or damage or, if no written agreement regarding the value of the work of fine art exists, the fair market value of the work of fine art.

§ 44-1773. Purchase or resale of consigned fine art by art dealer

A. If a work of fine art is trust property under § 44-1772 when initially received by the art dealer it remains trust property notwithstanding the subsequent purchase of the work of fine art by the art dealer directly or indirectly for the art dealer's own account until the purchase price is paid in full to the artist.

B. If the art dealer resells a work of fine art to which subsection A of this section applies to a bona fide third party before the artist has been paid in full, the work of fine art ceases to be trust property and the proceeds of the resale are trust funds in the hands of the art dealer for the benefit of the artist to the extent necessary to pay any balance still due to the artist. The trusteeship of the proceeds continues until the fiduciary obligation of the art dealer with respect to the transaction is discharged in full.

§ 44-1774. Trust property exempt from claims of art dealer's creditors

Notwithstanding title 47, no property which is trust property under § 44-1772 or 44-1773 is subject to the claims, liens or security interests of the creditors of the art dealer.

§ 44-1775. Art dealer required to obtain written contract

A. An art dealer may accept a work of fine art, on a fee, commission or other compensation basis, on consignment from the artist who created the work of fine art only if prior to or at the time of acceptance the art dealer enters into a written contract with the artist establishing:
 1. The value of the work of fine art.
 2. The time within which the proceeds of the sale are to be paid to the artist, if the work of fine art is sold.
 3. The minimum price for the sale of the work of fine art.

B. If an art dealer violates this section a court may, at the request of the artist, void the obligation of the artist to the art dealer or to a person to whom the obligation is transferred, other than a holder in due course.

§ 44-1776. Art dealer; duties

A. An art dealer who accepts a work of fine art, on a fee, commission

or other compensation basis, on consignment from the artist who created the work of fine art may use or display the work of fine art or a photograph of the work of fine art or permit the use or display of the work of fine art or a photograph of the work of fine art only if:

1. Notice is given to users or viewers that the work of fine art is the work of the artist.
2. The artist gives prior written consent to the particular use or display.

B. An art dealer who sells a work of fine art which is on consignment for the purpose of sale shall transmit all monies due the artist on a monthly basis.

§ 44-1777. Waiver voided

Any portion of an agreement which waives any provision of this article is void.

§ 44-1778. Civil penalty

A. Any art dealer who violates § 44-1775 or § 44-1776, subsection A is liable to the artist in an amount equal to:

1. Five hundred dollars.
2. The actual damages, if any, including the incidental and consequential damages, sustained by the artist by reason of the violation and reasonable attorney fees.

B. An art dealer who violates § 44-1776, subsection B is liable to the artist in an amount equal to three times the amount due the artist.

ARKANSAS (ENACTED 1987)

4-73-201 Title.

This subchapter may be cited as the "Artists' Consignment Act."

4-73-202 Definitions.

As used in this subchapter, unless the context otherwise requires:

(1) "Art" means a painting, sculpture, drawing, work of graphic art, pottery, weaving, batik, macrame, quilt, or other commonly recognized art form;

(2) "Artist" means the creator of a work of art or, if he is deceased, his estate;

(3) "Art dealer" means a person engaged in the business of selling works of art;

(4) "On consignment" means that no title to, or estate in, the goods or right to possession thereof superior to that of the consignor vests in the consignee, notwithstanding the consignee's power or authority to transfer and convey all of the right, title, and interest of the consignor in and to such goods to a third person.

4-73-203 Applicability of subchapter.

This subchapter shall not apply to any contract or arrangement in existence prior to July 4, 1983, nor to any extensions or renewals thereof; except that the parties to such contract or arrangement may thereafter elect to be governed by the provisions of this subchapter.

4-73-204 Liability of art dealer for violation of subchapter.

A violation by an art dealer of any of the provisions of this subchapter shall render the art dealer liable for damages to the artist in an amount equal to fifty dollars ($50.00) plus the actual damages sustained by the artist, including incidental and consequential damages. In such actions, reasonable attorneys' fees and court costs shall be paid to the prevailing party.

4-73-205 Waiver of subchapter's provisions void.

Any provision, whether oral or written, in or pertaining to the placing of a work of fine art on consignment whereby any provision of this subchapter is waived shall be deemed to be against public policy and shall be void.

4-73-206 Consigned artworks exempt from liens and security interests.

A work of art delivered to an art dealer for the purpose of exhibition or sale and the proceeds from the sale of the work by the dealer, whether to the dealer on his own account or to a third person, are not subject to the claims, liens, or security interests of the creditors of the art dealer, notwithstanding any law to the contrary.

**4-73-207 Delivery of work of fine art for exhibition or sale—Effects—
Liability of dealer for damage or loss.**

Notwithstanding any custom, practice, or usage of the trade or any
provision of law to the contrary:

(1) Whenever an artist delivers or causes to be delivered a work of
fine art of his own creation to an art dealer for the purpose of
exhibition or sale on a commission, fee, or other basis of
compensation, the delivery to, and acceptance thereof by, the art
dealer is deemed to place the work on consignment; and:

 (A) The art dealer shall thereafter, with respect to the work, be
 deemed to be the agent of such artist;

 (B) The work is trust property in the hands of the consignee for
 the benefit of the consignor; and

 (C) Any proceeds from the sale of the work are trust funds in the
 hands of the consignee for the benefit of the consignor;

(2) Notwithstanding the subsequent purchase of a work of fine art
by the consignee directly or indirectly for his own account, the
work initially received on consignment shall be deemed to remain
trust property until the price is paid in full to the consignor. If
the work is thereafter resold to a bona fide third party before the
consignor has been paid in full, the proceeds of the resale are
trust funds in the hands of the consignee for the benefit of the
consignor to the extent necessary to pay any balance still due to
the consignor, and the trusteeship shall continue until the
fiduciary obligation of the consignee with respect to the trans-
action is discharged in full;

(3) Notwithstanding any law to the contrary, no such trust property
or trust funds shall be subject to or subordinate to any claims,
liens, or security interests of the consignee's creditors;

(4) (A) An art dealer is liable for negligent acts causing the loss of
 or damage to a work of fine art while it is in his possession.

 (B) The value of the work of fine art is, for the purposes of this
 subsection, the value established in a written agreement
 between the artist and the art dealer prior to the loss or
 damage of the work or, if no written agreement regarding the
 value of the work exists, the fair market value of the work
 less the art dealer's commission or fee.

CALIFORNIA (ENACTED 1975)

§ 1738. Definitions

As used in this title:

(a) "Artist" means the person who creates a work of fine art or, if that person is deceased, that person's heir, legatee, or personal representative.

(b) "Fine art" means a painting, sculpture, drawing, work of graphic art (including an etching, lithograph, offset print, silk screen, or a work of graphic art of like nature), a work of calligraphy, or a work in mixed media (including a collage, assemblage, or any combination of the foregoing art media).

(c) "Art dealer" means a person engaged in the business of selling works of fine art, other than a person exclusively engaged in the business of selling goods at public auction.

(d) "Person" means an individual, partnership, corporation, limited liability company, association or other group, however organized.

(e) "Consignment" means that no title to, estate in, or right to possession of, fine art, superior to that of the consignor shall vest in the consignee, notwithstanding the consignee's power or authority to transfer and convey to a third person all of the right, title and interest of the consignor in and to such fine art.

§ 1738.5. Delivery to and acceptance by art dealer; effect

Notwithstanding any custom, practice or usage of the trade to the contrary, whenever an artist delivers or causes to be delivered a work of fine art of the artist's own creation to an art dealer in this state for the purpose of exhibition or sale, or both, on a commission, fee or other basis of compensation, the delivery to and acceptance of such work of fine art by the art dealer shall constitute a consignment, unless the delivery to the art dealer is pursuant to an outright sale for which the artist receives or has received full compensation for the work of fine art upon delivery.

§ 1738.6. Results of consignment; agency, property in trust, liability and proceeds

A consignment of a work of fine art shall result in all of the following:

(a) The art dealer, after delivery of the work of fine art, shall cons-

titute an agent of the artist for the purpose of sale or exhibition of the consigned work of fine art within the State of California

(b) The work of fine art shall constitute property held in trust by the consignee for the benefit of the consignor, and shall not be subject to claim by a creditor of the consignee.

(c) The consignee shall be responsible for the loss of, or damage to, the work of fine art.

(d) The proceeds from the sale of the work of fine art shall constitute funds held in trust by the consignee for the benefit of the consignor. Such proceeds shall first be applied to pay any balance due to the consignor, unless the consignor expressly agrees otherwise in writing.

§ 1738.7. Trust property

A work of fine art received as a consignment shall remain trust property, notwithstanding the subsequent purchase thereof by the consignee directly or indirectly for the consignee's own account until the price is paid in full to the consignor. If such work is thereafter resold to a bona fide purchaser before the consignor has been paid in full, the proceeds of the resale received by the consignee shall constitute funds held in trust for the benefit of the consignor to the extent necessary to pay any balance still due to the consignor and such trusteeship shall continue until the fiduciary obligation of the consignee with respect to such transaction is discharged in full.

§ 1738.8. Waiver by consignor as void

Any provision of a contract or agreement whereby the consignor waives any provision of this title is void.

§ 1738.9. Application of title

This title shall not apply to a written contract executed prior to the effective date of this title, unless either the parties agree by mutual written consent that this title shall apply or such contract is extended or renewed after the effective date of this title.

The provisions of this title shall prevail over any conflicting or inconsistent provisions of the Commercial Code affecting the subject matter of this title.

COLORADO (ENACTED 1982)

§ 6-15-101. Definitions

As used in this article, unless the context otherwise requires:

(1) "Art dealer" means a person engaged in the business of selling works of fine art, other than a person exclusively engaged in the business of selling goods at public auction.

(2) "Artist" means the creator of a work of fine art.

(3) "On consignment" means that no title to or estate in the goods or right to possession thereof superior to that of the consignor vests in the consignee, notwithstanding the consignee's power or authority to transfer and convey all of the right, title, and interest of the consignor, in and to such goods to a third person.

(4) "Work of fine art" or "work" means:

 (a) A work of visual art such as a painting, sculpture, drawing, mosaic, or photograph;

 (b) A work of calligraphy;

 (c) A work of graphic art such as an etching, a lithograph, an offset print, a silk screen, or any other work of similar nature;

 (d) A craft work in materials, including but not limited to clay, textile, fiber, wood, metal, plastic, or glass;

 (e) A work in mixed media such as collage or any combination of the art media set forth in this subsection (4).

§ 6-15-102. Art dealers and artists—consignment of works of fine art

(1) Notwithstanding any custom, practice, or usage of the trade and any of the provisions of section 4-2-326, C.R.S., to the contrary:

 (a) Whenever an artist delivers or causes to be delivered a work of fine art of his own creation to an art dealer for the purpose of exhibition or sale on a commission, fee, or other basis of compensation, the delivery to and acceptance thereof by the art dealer is deemed to place the work on consignment; and:

 (I) Such art dealer shall thereafter, with respect to the work, be deemed to be the agent of such artist;

 (II) Such work is trust property in the hands of the consignee for the benefit of the consignor; and

 (III) Any proceeds from the sale of the work are trust funds in the hands of the consignee for the benefit of the consignor.

(2) Notwithstanding the subsequent purchase of a work of fine art by the consignee directly or indirectly for his own account, the work initially received on consignment shall be deemed to remain trust property until the price is paid in full to the consignor. If such work is thereafter resold to a bona fide third party before the consignor has been paid in full, the proceeds of the resale are trust funds in the hands of the consignee for the benefit of the consignor to the extent necessary to pay any balance still due to the consignor, and such trusteeship shall continue until the fiduciary obligation of the consignee with respect to such transaction is discharged in full.

(3) Notwithstanding the provisions of the "Uniform Commercial Code—Sales," no such trust property or trust funds shall be subject to or subordinate to any claims, liens, or security interests of the consignee's creditors.

(4) An art dealer is strictly liable for the loss of or damage to a work of fine art while it is in his possession. The value of the work of fine art is, for the purposes of this subsection (4), the value established in a written agreement between the artist and the art dealer prior to the loss or damage of the work.

§ 6-15-103. Penalties

A violation by an art dealer of any of the provisions of this article shall render the art dealer liable for damages to the artist in an amount equal to fifty dollars plus the actual damages sustained by the artist, including incidental and consequential damages. In such an action reasonable attorney fees and court costs shall be paid to the prevailing party.

§ 6-15-104. Applicability

(1) This article shall not apply to any contract or arrangement in existence prior to March 25, 1982, nor to any extensions or renewals thereof; except that the parties to such contract or arrangement may thereafter elect to be governed by the provisions of this article.

(2) Any provision, whether oral or written, in or pertaining to the placing of a work of fine art on consignment whereby any

provision of this article is waived shall be deemed to against public policy and shall be void.

CONNECTICUT (ENACTED 1978)

§ 42-116k. Definitions

As used in this chapter:

(a) "Artist" means the creator of a work of fine art.

(b) "Art dealer" means a person, partnership, firm, association, limited liability company or corporation other than a public auctioneer who undertakes to sell a work of fine art.

(c) "Consignor" means an artist or any person, partnership, firm, association, limited liability company or corporation who delivers a work of fine art to an art dealer for the purpose of sale, or exhibition and sale, to the public on a commission or fee or other basis of compensation.

(d) "Consignee" means an art dealer who receives and accepts a work of fine art from a consignor for the purpose of sale, or exhibition and sale, to the public on a commission or fee or other basis of compensation.

(e) "Fine art" means (1) a work of visual art such as a painting, sculpture, drawing, mosaic or photograph; (2) a work of calligraphy; (3) a work of graphic art such as an etching, lithograph, offset print, silk screen or other work of similar nature; (4) crafts such as crafts in clay, textile, fiber, wood, metal, plastic, glass or similar materials; and (5) a work in mixed media such as a collage or any combination of the foregoing art media.

§ 42-116l. Consignment relationship. Notice. Proceeds of sales held in trust. Contract requirements

(a) Whenever a consignor delivers or causes to be delivered a work of fine art to a consignee for the purpose of sale, or exhibition and sale, to the public on a commission, fee or other basis of compensation, the delivery to and acceptance thereof by the art dealer is deemed to be "on consignment" and such consignee shall thereafter with respect to the said work of fine art be deemed to be the agent of such consignor.

(b) Whenever a consignor delivers or causes to be delivered a work of fine art to a consignee, such consignor shall give notice to the public by affixing to such work of fine art a sign or tag which states that such work of fine art is being sold subject to a contract of consignment, or such consignor shall post a clear and conspicuous sign in the consignee's place of business giving notice that some works of fine art are being sold subject to a contract of consignment.

(c) The proceeds of the sale of a work of fine art shall be held in trust by the consignee for the benefit of the consignor. Such proceeds shall be applied first in payment of any amount due to the consignor.

(d) Any provision of a contract or agreement whereby the consignor waives any of the provisions of this section or section 42-116m is void.

§ 42-116m. Contract provisions

Whenever a consignee accepts a work of fine art for the purpose of sale or exhibition and sale to the public on a commission, fee or other basis of compensation, there shall be a written contract or agreement between the consignor and consignee which shall include but not be limited to the following provisions: (a) That the proceeds of the sale of the work of fine art shall be delivered to the consignor at a schedule agreed upon by the consignor and consignee; (b) that the consignee shall be responsible for the stated value of the work of fine art in the event of the loss of or damage to such work of fine art while it is in the possession of such consignee; (c) that the work of fine art shall only be sold by the consignee for an amount at least equal to the amount agreed upon by the consignor in writing; (d) that the work of fine art may be used or displayed by the consignee or others only with prior written consent of the consignor and only if the artist is acknowledged in such use or display.

§§ 42-116n, 42-116o. Reserved for future use

DISTRICT OF COLUMBIA (ENACTED 1985)

s 28:9-114 Consignment.

(1) A person who delivers goods under a consignment which is not a security interest and who would be required to file under this article by section 28:2-326(3)(c) has priority over a secured party who is or becomes a creditor of the consignee and who would have a perfected security interest in the goods if they were the property of the consignee, and also has priority with respect to identifiable cash proceeds received on or before delivery of the goods to a buyer, if:

(a) the consignor complies with the filing provision of the article on sales with respect to consignments (section 28:2-326(3)(c)) before the consignee receives possession of the goods; and

(b) the consignor gives notification in writing to the holder of the security interest if the holder has filed a financing statement covering the same types of goods before the date of the filing made by the consignor; and

(c) the holder of the security interest receives the notification within five years before the consignee receives possession of the goods; and

(d) the notification states that the consignor expects to deliver goods on consignment to the consignee, describing the goods by item or type.

(2) In the case of a consignment which is not a security interest and in which the requirements of the preceding subsection have not been met, a person who delivers goods to another is subordinate to a person who would have a perfected security interest in the goods if they were the property of the debtor.

(3) (a) In this subsection, the following words have the meanings indicated:

(i) "Art dealer" means an individual, partnership, firm, association, or corporation, other than a public auctioneer, that undertakes to sell a work of fine art created by another.

(ii) "Artist" means the creator of a work of fine art.

(iii) "On consignment" means delivered to an art dealer for the purpose of sale or exhibition, or both, to the public by the art dealer other than at a public auction.

(iv) "Work of fine art" means an original art work which is:

 (A) a visual rendition including a painting, drawing, sculpture, mosaic, or photograph;

 (B) a work of calligraphy;

 (C) a work of graphic art including an etching, lithograph, offset print, or silk screen;

 (D) a craft work in materials including clay, textile, fiber, wood, metal, plastic, or glass; or

 (E) a work in mixed media including a collage or a work consisting of any combination of works included in this subsection.

(b) If an art dealer accepts a work of fine art on a fee, commission, or other compensation basis on consignment from the artist, then the following shall apply:

 (i) the art dealer is, with respect to that work of fine art, the agent of the artist;

 (ii) the work of fine art is trust property and the art dealer is trustee for the benefit of the artist until the work of fine art is sold to a bona fide third party; and

 (iii) the proceeds of the sale of the work of fine art are trust property and the art dealer is trustee for the benefit of the artist until the amount due the artist from the sale is paid.

(c) Notwithstanding the purchase of the work of fine art by the art dealer directly or indirectly for the art dealer's own account, a work of fine art that is trust property when initially accepted by the art dealer remains trust property until the purchase price is paid in full to the artist.

(d) Property that is trust property under this section is not subject to the claims, liens, or security interests of the creditors of an art dealer.

FLORIDA (ENACTED 1986)

686.501. Definitions

As used in ss. 686.501-686.506:

(1) "Art" means a painting, sculpture, drawing, work of graphic art, pottery, weaving, batik, macrame, quilt, print, photograph, or

craft work executed in materials including, but not limited to, clay, textile, paper, fiber, wood, tile, metal, plastic, or glass. The term shall also include a rare map which is offered as a limited edition or a map 80 years old or older; or a rare document or rare print which includes, but is not limited to, a print, engraving, etching, woodcut, lithograph, or serigraph which is offered as a limited edition, or one 80 years old or older.

(2) "Artist" means the creator of a work of art or, if she or he is deceased, the artist's heirs or personal representative.

(3) "Art dealer" means a person engaged in the business of selling works of art, a person who is a consignee of a work of art, or a person who, by occupation, holds herself or himself out as having knowledge or skill peculiar to works of art or rare documents or prints, or to whom such knowledge or skill may be attributed by her or his employment of an agent or broker or other intermediary who, by occupation, holds herself or himself out as having such knowledge or skill. The term "art dealer" includes an auctioneer who sells works of art, rare maps, rare documents, or rare prints at public auction as well as the auctioneer's consignor or principal. The term "art dealer" does not include a cooperative which is totally owned by artist members.

(4) "Creditor" means a "creditor" as defined in s. 671.201.

(5) "Person" means an individual, partnership, corporation, or association.

(6) "Author" or "authorship" refers to the creator or creation of a work of art or to the period, culture, source, or origin with which the creation of the work is identified in the description of the work.

(7) "Counterfeit" means a work of art made or altered with intent to deceive in such a manner that it appears to have an authorship which it does not in fact possess. The term "counterfeit" includes any work of art made, altered, or copied in such a manner that it appears to have an authorship which it does not in fact possess, even though the work may not have been made with intent to deceive.

(8) "Written instrument" means a written or printed agreement, bill of sale, or any other written or printed note or memorandum of the sale or exchange of a work of art by an art dealer, and includes

a written or printed catalog or other prospectus of a forthcoming sale as well as any written or printed corrections or amendments thereof.

(9) "Consignor" means an artist or any person, partnership, firm, association, or corporation which delivers a work of art to an art dealer for the purpose of sale, or exhibition and sale, to the public on a commission, fee, or other basis of compensation.

(10) "Consignee" means an art dealer who receives and accepts a work of art from a consignor for the purpose of sale, or exhibition and sale, to the public on a commission, fee, or other basis of compensation

686.502. Consignment relationship; notice; proceeds of sales held in trust; contract requirements

(1) Whenever a consignor delivers, or causes to be delivered, a work of art to a consignee for the purpose of sale, or exhibition and sale, to the public on a commission, fee, or other basis of compensation, the delivery to and acceptance thereof by the art dealer is deemed to be "on consignment"; and, with respect to the work of art, such consignee shall thereafter be deemed to be the agent of such consignor.

(2) Whenever a consignor delivers or causes to be delivered a work of art to a consignee, such consignor shall give notice to the public by affixing to such work of art a sign or tag which states that such work of art is being sold subject to a contract of consignment, or such consignee shall post a clear and conspicuous sign in the consignee's place of business giving notice that some works of art are being sold subject to a contract of consignment.

(3) The proceeds of sale of a work of art shall be held in trust by the consignee for the benefit of the consignor. Such proceeds shall be applied first in payment of any amount due to the consignor.

(4) Any provision of a contract or agreement whereby the consignor waives any of the provisions of this section is void.

686.503. Contract provisions

Whenever a consignee accepts a work of art for the purpose of sale, or exhibition and sale, to the public on a commission, fee, or other basis of compensation, there shall be a written contract or agreement between the consignor and consignee which shall include, but not be limited to, the following provisions:

(1) The proceeds of the sale of the work of art shall be delivered to the consignor at a schedule agreed upon by the consignor and consignee.

(2) The consignee shall be responsible for the stated value of the work of art in the event of the loss of or damage to such work of art while it is in the possession of such consignee.

(3) The work of art shall only be sold by the consignee for an amount at least equal to the amount agreed upon by the consignor in writing.

(4) The work of art may be used or displayed by the consignee or others only with the prior written consent of the consignor and only if the artist is acknowledged in such use or display.

(5) A work of art delivered to an art dealer by an artist for the purpose of exhibition or sale and the artist's share of the proceeds of the sale of the work by the dealer, whether to the dealer on his or her own account or to a third person, shall create a priority in favor of the artist over the claims, liens, or security interests of the creditors of the art dealer, notwithstanding any provisions of the Uniform Commercial Code.

686.504. Warranties by art dealers; written statement; terminology

Any provision in any other law to the contrary notwithstanding:

(1) When an art dealer, in selling or changing a work of art, furnishes to a buyer of such work who is not an art dealer a written instrument which, in describing the work, identifies it with any authorship, the description shall be presumed to be part of the basis of the transaction and shall create an express warranty of the authenticity of the authorship as of the date of the sale or exchange. The warranty shall not be negated or limited because the art dealer in the written instrument did not use formal words such as "warrant" or "guarantee," because the art dealer did not

have a specific intention or authorization to make the warranty, or because any statement relevant to authorship is, reports to be, or is capable of being, merely the art dealer's opinion.

(2) In construing the degree of authenticity of authorship warranted, due regard shall be given to the terminology used in describing the authorship and the meaning accorded to such terminology by the customs and usage of the trade at the time and in the locality where the sale or exchange took place. A written instrument delivered pursuant to a sale which took place in this state which, in describing the work, states, for example:

 (a) That the work is by a named author or has a named authorship without any other limiting words: means unequivocally that the work is by the named author or has the named authorship.

 (b) That the work is attributed to a named author: means a work of the period of the author, attributed to her or him, but not with certainty by her or him.

 (c) That the work is of a school of a named author: means a work of the period of the author, by a pupil or close follower of the author but not by the author.

 (d) That the rare map, rare print, sculpture, drawing, or other work of art is of the authorship or from the period or date attributed to the work of art.

686.505. Construction of language

Words relevant to the creation of an express warranty of authenticity of authorship of a work of art and words tending to negate or limit warranty shall be construed where reasonable as consistent with each other by parol or extrinsic evidence; negation or limitation is inoperative to the extent that the construction is unreasonable. Subject to the limitations hereinafter set forth, the construction shall be deemed unreasonable in any of the following cases:

(1) The language tending to negate or limit the warranty is not conspicuous, written, and contained in a provision separate and apart from any language relevant to the creation of the warranty, in words which would clearly and specifically apprise the buyer that the seller assumes no risk, liability, or responsibility for the

authenticity of the authorship of a work of art. Words of general disclaimer like "all warranties, express or implied, are excluded" are not sufficient to negate or limit express warranty of authenticity of the authorship of a work of art created under s. 686.504 or otherwise.

(2) The work of art is proved to be a counterfeit, and this was not clearly indicated in the description of the work.

(3) The work of art is unqualifiedly stated to be the work of a named author or authorship, or date or period or limited edition, and it is proved that, as of the date of sale or exchange, the statement was false, mistaken, or erroneous.

686.506. Rights and liabilities, additional; merchant's liability

(1) The rights and liabilities created by ss. 686.501-686.506 shall be construed to be in addition to and not in substitution, exclusion, or displacement of other rights and liabilities provided by law, including the law of principal and agent except where the construction would, as a matter of law, be unreasonable.

(2) An art dealer who, as buyer, is excluded from obtaining the benefits of an express warranty under ss. 686.501-686.506 shall not be deprived of the benefits of any other provisions of law.

(3) An art dealer whose warranty of authenticity of authorship was made in good faith shall not be liable for damages beyond the return of the purchase price which he or she received, together with any attorney's fees and costs incurred by reason of the art dealer's refusal to comply with ss. 686.501-686.506

(4) Any person who violates ss. 686.501-686.506 is guilty of a misdemeanor of the second degree, punishable as provided in s. 775.082 or s. 775.083.

(5) Nothing in ss. 686.501-686.506 shall apply to any work of art, when offered for sale or sold at wholesale or retail, framed or unframed, at a price of $100 or less.

(6) Nothing in ss. 686.501-686.506 shall apply to works of art sold by artists who produce the same directly to a consumer, without the intervention of a wholesale or retail art dealer.

GEORGIA (ENACTED 1981)

10-1-520 Short title.

This article shall be known and may be cited as the "Georgia Consignment of Art Act."

10-1-521 Definitions.

As used in this article, the term:

(1) "Art dealer" means a person engaged in the business of selling works of art, other than a person exclusively engaged in the business of selling goods at public auction, and other than a nonprofit organization.

(2) "Artist" means the person who creates a work of art, or, if such person is deceased, such person's heir, legatee, or personal representative.

(3) "Consignment" means that no title to, estate in, or right to possession of the work of art superior to that of the consignor shall vest in the consignee, notwithstanding the consignee's power or authority to transfer and convey to a third person all of the right, title, and interest of the consignor in and to such work of art.

(4) "Cooperative" means an association or group of artists which:

 (A) Engages in the business of selling only works of art which are produced or created by such artists;

 (B) Jointly owns, operates, and markets such business; and

 (C) Accepts such works of art from its members on consignment.

(5) "Person" means an individual, partnership, corporation, association, entity, or other group, however organized.

(6) "Value of the work of art" means an amount agreed upon by written contract as the monetary worth of a work of art which amount shall be used in determining damages in the instance of a violation of this article by an art dealer and shall not be used for any other purpose.

(7) "Work of art" means an original art work which is:

 (A) A visual rendition, including a painting, drawing, sculpture, mosaic, or photograph;

 (B) A work of calligraphy;

 (C) A work of graphic art, including an etching, lithograph, offset print, or silk screen;

(D) A craft work in materials, including clay, textile, fiber, wood, metal, plastic, or glass; or

(E) A work in mixed media, including a collage or a work consisting of any combination of subparagraphs (A) through (D) of this paragraph.

10-1-522 Delivery of artwork to dealer for exhibition or sale in exchange for commission, fee, or other compensation constituting consignment.

Notwithstanding any custom, practice, or usage of the trade to the contrary, whenever an artist delivers or causes to be delivered a work of art of the artist's own creation to an art dealer in this state for the purpose of exhibition or sale, or both, on a commission, fee, or other basis of compensation, the delivery to and acceptance of such work of art by the art dealer shall constitute a consignment, unless the delivery to the art dealer is pursuant to an outright sale for which the artist receives or has received full compensation for the work of art upon delivery.

10-1-523 Written contract required for consignment of work of art; violation by art dealer rendering artist's obligation voidable.

(a) An art dealer may accept a work of art on a fee, commission, or other compensation basis on consignment from the artist who created the work of art only if prior to or at the time of acceptance the art dealer enters into a written contract with the artist establishing:

(1) The value of the work of art;

(2) The time within which the proceeds of the sale are to be paid to the artist if the work of art is sold; and

(3) The minimum price for the sale of the work of art.

(b) If an art dealer violates this Code section, a court may, at the request of the artist, void the obligation of the artist to that art dealer or to a person to whom the obligation is transferred other than a holder in due course.

10-1-524 Effects of consignment.

A consignment of a work of art shall result in all of the following:

(1) The art dealer, after delivery of the work of art, shall constitute

an agent of the artist for the purpose of sale or exhibition of the consigned work of art within this state;

(2) The work of art shall constitute property held in trust by the consignee for the benefit of the consignor and shall not be subject to claim by a creditor of the consignee;

(3) The consignee shall be responsible for the loss of, or damage to, the work of art; and

(4) The proceeds from the sale of the work of art shall constitute funds held in trust by the consignee for the benefit of the consignor. Such proceeds shall first be applied to pay any balance due to the consignor, unless the consignor expressly agrees otherwise in writing.

10-1-525 Art received as consignment to remain trust property; art received as consignment not subject or subordinate to claims, liens, or security interests.

(a) A work of art received as a consignment shall remain trust property, notwithstanding the subsequent purchase thereof by the consignee directly or indirectly for the consignee's own account, until the price is paid in full to the consignor. If such work is thereafter resold to a bona fide purchaser before the consignor has been paid in full, the proceeds of the resale received by the consignee shall constitute funds held in trust for the benefit of the consignor to the extent necessary to pay any balance still due to the consignor and such trusteeship shall continue until the fiduciary obligation of the consignee with respect to such transaction is discharged in full.

(b) No such trust property or trust funds shall be or become subject or subordinate to any claims, liens, or security interests of any kind or nature whatsoever of the consignee's creditors, anything in Code Section 11-2-326 or any other provision of Title 11 to the contrary notwithstanding.

10-1-526 Contractual waiver of liability for works of art consigned to cooperative.

Any cooperative may contract with its members to waive liability for the loss of or damage to works of art consigned to such cooperative.

Any other provision of a contract or an agreement whereby the consignor purports to waive any provision of this article is void.

10-1-527 Use or display of work of art or photograph thereof.
An art dealer who accepts a work of art on a fee, commission, or other compensation basis on consignment from the artist who created the work of art may use or display the work of art or a photograph of the work of art or permit the use or display of the work of art or a photograph of the work of art only if:
(1) Notice is given to users or viewers that the work of art is the work of the artist; and
(2) The artist gives prior written consent to the particular use or display.

10-1-528 Applicability to contracts executed prior to July 1, 1995.
This article shall not apply to a written contract executed prior to July 1, 1995, unless either the parties agree by mutual written consent that this article shall apply or such contract is extended or renewed after July 1, 1995.

10-1-529 Liability for violations by art dealers.
Any art dealer who violates this article is liable to the artist in an amount equal to:
(1) Fifty dollars; and
(2) The actual damages, if any, including the incidental and consequential damages sustained by the artist by reason of the violation and reasonable attorney's fees.

IDAHO (ENACTED 1987)

28-11-101 Definitions.
As used in this chapter, unless the context requires otherwise, the following definitions apply:
(1) "Art dealer" means a person engaged in the business of selling works of fine art, other than a person exclusively engaged in the business of selling goods at public auction.
(2) "Artist" means a person who creates a work of fine art or, if the

person is deceased, the person's heir, devisee, or personal representative.

(3) "Consignment" means that no title to, estate in or right to possession of fine art superior to that of the consignor vests in the consignee, notwithstanding the consignee's power or authority to transfer and convey to a third person all of the right, title and interest of the consignor in and to the fine art.

(4) "Fine art" means a painting, sculpture, drawing, work of graphic art, including an etching, lithograph, signed limited edition offset print, silk screen, or a work of graphic art of like nature; a work of calligraphy, photographs, original works in ceramics, wood, metals, glass, plastic, wax, stone or leather or a work in mixed media, including a collage, assemblage, or any combination of the art media mentioned in this subsection.

(5) "Person" means an individual, partnership, corporation, association, or other group, however organized.

28-11-102 Artist-art dealer relationship.

Notwithstanding any custom, practice or usage of the trade to the contrary, whenever an artist delivers or causes to be delivered a work of fine art of the artist's own creation to an art dealer in this state for the purpose of exhibition and sale on a commission, fee, or other basis of compensation, the delivery to and acceptance of the work of fine art by the art dealer constitutes a consignment, unless the delivery to the art dealer is pursuant to an outright sale for which the artist receives upon delivery or has received prior to delivery full compensation for the work of fine art.

28-11-103 Agency relationship—Trust property.

A consignment of a work of fine art results in the following:

(1) The art dealer, after delivery of the work of fine art, is an agent of the artist for the purpose of sale or exhibition of the consigned work of fine art within the state of Idaho. This relationship shall be defined in writing and renewed at least every three (3) years by the art dealer and the artist. It is the responsibility of the artist to identify clearly the work of art by securely attaching identifying marking to or clearly signing the work of art.

(2) The work of fine art constitutes property held in trust by the consignee for the benefit of the consignor and is not subject to claim by a creditor of the consignee.

(3) The consignee is responsible for the loss of or damage to the work of fine art while in the possession of or on the premises of the consignee.

(4) The proceeds from the sale of the work of fine art constitute funds held in trust by the consignee for the benefit of the consignor. The proceeds shall first be applied to pay any balance due to the consignor, unless the consignor expressly agrees otherwise in writing.

28-11-104 Subsequent sale—Payment to consignor.

A work of fine art received as a consignment remains trust property, notwithstanding the subsequent purchase thereof by the consignee directly or indirectly for the consignee's own account until the price is paid in full to the consignor. If the work is resold to a bona fide purchaser before the consignor has been paid in full, the proceeds of the resale received by the consignee constitute funds held in trust for the benefit of the consignor to the extent necessary to pay any balance due to the consignor and the trusteeship continues until the fiduciary obligation of the consignee with respect to the transaction is discharged in full.

28-11-105 Waiver void—Exemption from UCC.

(1) Any provision of a contract or agreement by which the consignor waives any provision of this part of this chapter is void.

(2) This part of this chapter is not subject to the provisions of chapters 1 through 10, title 28, Idaho Code.

28-11-106 Application.

This part of this chapter does not apply to a written contract executed prior to July 1, 1987, unless:

(1) The parties agree that this part of this chapter will apply; or

(2) The contract is extended or renewed after July 1, 1987.

ILLINOIS (ENACTED 1985)

320/0.01. Short title

§ 0.01. Short title. This Act may be cited as the Consignment of Art Act.

320/1. Definitions

§ 1. As used in this Act, unless the context otherwise requires:

(1) "Art dealer" means a person engaged in the business of selling works of fine art, other than a person exclusively engaged in the business of selling goods at public auction.

(2) "Artist" means the creator of a work of fine art or, if such person is deceased, the creator's heir, legatee, or personal representative.

(3) "On consignment" means that no title to, estate in, or right to possession of the work of fine art superior to that of the consignor shall vest in the consignee, notwithstanding the consignee's power or authority to transfer and convey all of the right, title, and interest of the consignor in and to such work of fine art to a third party.

(4) "Commission" means the fee, compensation, or percentage of the actual selling price of a work of fine art agreed upon by the artist and art dealer which the art dealer may retain after the sale of the artist's work to a third party.

(5) "Creditor" includes, but is not limited to, those persons embraced by the definition of "creditor" in Section 1-201 of the "Uniform Commercial Code", approved July 31, 1961, as amended.

(6) "Bona fide purchaser" means a person who in good faith makes a purchase without notice of any outstanding rights of others.

(7) "Work of fine art" means:
 (a) A visual rendition including, but not limited to, a painting, drawing, sculpture, mosaic, videotape, or photograph.
 (b) A work of calligraphy.
 (c) A work of graphic art including, but not limited to, an etching, lithograph, serigraph, or offset print.
 (d) A craft work in materials including, but not limited to, clay, textile, fiber, wood, metal, plastic, or glass.
 (e) A work in mixed media including, but not limited to, a

collage, assemblage, or work consisting of any combination of paragraphs (a) through (d).

320/2. Consignment—Effect

§ 2. Any custom, practice, or usage of the trade notwithstanding:

(1) Whenever an artist delivers or causes to be delivered a work of fine art of the artist's own creation to an art dealer in this State for the purpose of sale, exhibition, or both, on a commission, the delivery to and acceptance of the work of fine art by the art dealer is deemed to place the work of fine art on consignment, unless the delivery is pursuant to an outright sale for which the artist receives or has received full compensation for the work of fine art upon delivery.

(2) Such art dealer shall thereafter, with respect to the work of fine art, be deemed the agent of the artist.

(3) Such work of fine art is trust property and the art dealer is trustee for the benefit of the artist until the work of fine art is sold to a bona fide purchaser or returned to the artist.

(4) The proceeds of the sale of a work of fine art are trust property and the art dealer is trustee for the benefit of the artist until the amount due the artist from the sale is paid in full. Except for customer deposits, these trust funds shall be paid to the artist within 30 days of receipt by the art dealer unless the parties expressly agree otherwise in writing. If the sale of the work of fine art is on installment, the funds from the installment shall first be applied to pay any balance due to the artist on the sale, unless the parties expressly agree in writing that the proceeds on each installment shall be paid according to a percentage established by the consignment agreement. Customer deposits shall be used to pay the amounts due the artist within 30 days after such deposits become part of the payment for the work. Any agreement entered into pursuant to this subsection (4) must be clear and conspicuous.

(5) The art dealer shall be strictly liable for the loss of or damage to the work of fine art while it is in the art dealer's possession. The value of the work of fine art is, for purposes of this subsection, the value established in a written agreement between the

artist and art dealer prior to the loss or damage or, if no written agreement regarding the value of the work of fine art exists, the fair market value of the work of fine art. Any reimbursement due the artist from the dealer as a result of the loss of or damage to a work of fine art shall not exceed the amount which would have been due to the artist if the work had been sold at the stated purchase price in the agreement.

(6) The art dealer shall not be held liable for loss or damage to the work of fine art if the artist fails to remove the work of fine art within a period of 30 days following the date agreed upon for removal of the work of fine art in a written contract between the artist and art dealer or, if no written agreement regarding a removal date exists, 30 days after notice to remove the work of fine art is sent by registered mail to the artist's last known address.

320/3. Works of fine art as trust property

§ 3.(1) If a work of fine art is trust property under Section 2 when initially received by the art dealer, it remains trust property notwithstanding the subsequent purchase of the work of fine art by the art dealer directly or indirectly for the art dealer's own account until any balance due to the artist from the sale is paid in full.

(2) If the art dealer resells a work of fine art to which subsection (1) applies to a bona fide purchaser before the artist has been paid in full, the work of fine art ceases to be trust property and the proceeds of the resale are trust funds in the hands of the art dealer for the benefit of the artist to the extent necessary to pay any balance due to the artist. The trusteeship of any of the proceeds continues until the fiduciary obligation of the art dealer with respect to the transaction is discharged in full.

320/4. Trust property—Creditors of dealer

§ 4. No property which is trust property under Section 2 or Section 3 is subject to the claims, liens or security interests of the creditors of the art dealer.

320/5. Commission on consignment

§ 5.(1) An art dealer may accept a work of fine art for commission on consignment from an artist only if prior to or within seven days of acceptance the art dealer enters into a written contract with the artist which shall include but not be limited to the following provisions:

 (a) The value of the work of fine art.

 (b) The time within which the proceeds of the sale are to be paid to the artist if the work of fine art is sold.

 (c) The commission the art dealer is to receive if the work of fine art is sold.

 (d) The minimum price for the sale of the work of fine art, and any discounts ordinarily given by the art dealer in his regular course of business.

(2) An art dealer who accepts a work of fine art for commission on consignment from an artist may use or display the work of fine art or a photograph of the work of fine art or permit the use or display of the work of fine art or a photograph of the work of fine art only if notice is given to users or viewers that the work of fine art is the work of the artist.

(3) If an art dealer violates this Section 5, the artist may seek relief in a court of competent jurisdiction by having the obligation of the artist voided with respect to that art dealer or to his successors or assigns.

320/6. Waivers

§ 6. Any portion of an agreement which waives any provision of this Act is void.

320/7. Violations—Liability

§ 7. Any art dealer who violates Section 5 is liable to the artist in an amount equal to:

(1) $50; and

(2) The actual damages, if any, including the incidental and consequential damages, sustained by the artist by reason of the violation and reasonable attorneys' fees.

320/8. Application and construction of Act

§ 8.(1) This Act shall not apply to a written contract executed prior to the effective date of this Act, unless either the parties agree by mutual written consent that this chapter shall apply or such contract is extended or renewed after the effective date of this Act.

(2) The provisions of this Act shall prevail over any conflicting or inconsistent provisions of the "Uniform Commercial Code", approved July 31, 1961, as amended, affecting the subject matter of this Act.

IOWA (ENACTED 1986)

556D.1. Definitions

As used in this chapter, unless the context requires otherwise:

1. "Art dealer" means a person engaged in the business of selling works of fine art, in a shop or gallery devoted in the majority to works of fine art, other than a person engaged in the business of selling goods of general merchandise or at a public auction.

2. "Artist" means the person who creates a work of fine art or, if such person is deceased, the person's personal representative.

3. "Consignment" means a delivery of a work of fine art under which no title to, estate in, or right to possession superior to that of the consignor vests in the consignee, notwithstanding the consignee's power or authority to transfer and convey to a third person all of the right, title, and interest of the consignor in and to the fine art.

4. "Fine art" means a painting, sculpture, drawing, mosaic, photograph, work of graphic art, including an etching, lithograph, offset print, silk screen, or work of graphic art of like nature, a work of calligraphy, or a work in mixed media including a collage, assemblage, or any combination of these art media which is one of a kind or is available in a limited issue or series. "Fine art" also means crafts which include work in clay, textiles, fiber, wood, metal, plastic, glass, or similar materials which is one of a kind or is available in a limited issue or series.

5. "Stated value" means the amount agreed to be paid to the consignor.

556D.2. Consignment

If an artist delivers or causes to be delivered a work of fine art of the artist's own creation to an art dealer in this state for the purpose of exhibition or sale on a commission, fee, or other basis of compensation, the delivery to and acceptance of the work of fine art by the art dealer is a consignment, unless the delivery to the art dealer is an outright sale for which the artist receives or has received full compensation upon delivery.

When an art dealer accepts a work of fine art for the purposes of sale or exhibition and sale to the public on a commission, fee, or other basis of compensation, there shall be a contract or agreement between the artist and art dealer which shall include the following provisions:

1. That the amount of the proceeds due the artist from the sale of the work of fine art shall be delivered to the artist at a time agreed upon by the artist and the art dealer.

2. That the art dealer shall be responsible for the stated value of the work of fine art in the event of the loss of or damage to the work of fine art while it is in the possession of the art dealer.

3. That the work of fine art shall be sold by the art dealer only for the amount agreed upon by the artist in the contract or agreement and that the art dealer will take only the commission or fee agreed upon.

4. That the work of fine art may be used or displayed by the art dealer or any other person only with the prior written consent of the artist. The artist may require that the artist be acknowledged in the use of the work of fine art.

556D.3. Conditions of consignment

The following apply to consignment:

1. The art dealer, after delivery of the work of fine art, becomes an agent of the artist for the purpose of sale or exhibition of the consigned work of fine art.

2. The work of fine art shall be held in trust by the consignee for the benefit of the consignor and is not subject to claim by a creditor of the consignee.

3. The consignee is responsible for the loss of or damage to the work of fine art, unless otherwise mutually agreed upon in

writing between the artist and art dealer in which case the art dealer shall be required to exercise all due diligence and care with regard to the work of fine art. In case of a waiver, the burden shall be on the dealer to demonstrate the waiver was entered into in good faith.

4. The proceeds from the sale of the work of fine art shall be held in trust by the consignee for the benefit of the artist. The proceeds shall first be applied to pay any balance due the artist unless the artist expressly agrees otherwise in writing.

556D.4. Consignment—trust arrangement

A consignment remains trust property, even if purchased by the art dealer, until the price is paid in full to the artist. If the work is resold to a bona fide purchaser before the artist has been paid in full, the proceeds of the resale received by the art dealer constitute funds held in trust for the benefit of the artist to the extent necessary to pay any balance still due to the artist and the trusteeship continues until the fiduciary obligation of the art dealer with respect to the transaction is discharged in full.

556D.5. Waiver provision void

A provision of a contract or agreement where the art dealer waives a provision of this chapter is void.

KENTUCKY (ENACTED 1986)

365.850 Definitions

As used in KRS 365.855 to 365.875:

(1) "Artist" means the person who creates a work of fine art or, if such person is deceased, such person's heir, legatee, or personal representative;

(2) "Fine art" shall include, but is not limited to, a painting, sculpture, drawing, work of graphic or photographic art, including an etching, lithograph, offset print, silk screen, or work of graphic art of like nature, a work of calligraphy, a work of folk art or craft, or a work in mixed media including a collage, assemblage, or any combination of the foregoing art media;

(3) "Art dealer" means a person engaged in the business of selling, as either a primary or supplemental source of income, works of fine art, other than a person exclusively engaged in the business of selling goods at public auction;

(4) "Person" means an individual partnership, corporation, association or other group, however organized; and

(5) "Consignment" means a delivery of a work of fine art under which no title to, estate in, or right to possession of, fine art, superior to that of the consignor shall vest in the consignee, notwithstanding the consignee's power or authority to transfer and convey to a third person all of the right, title and interest of the consignor in and to such fine art.

365.855 Acts Constituting Consignment

Notwithstanding any custom, practice or usage of the trade to the contrary, whenever an artist delivers or causes to be delivered a work of fine art of the artist's own creation to an art dealer in the Commonwealth for the purpose of exhibition or sale, or both, on a commission, fee or other basis of compensation, the delivery to and acceptance of such work of fine art by the art dealer shall constitute a consignment, unless the delivery to the art dealer is pursuant to an outright sale for which the artist receives or has received full compensation for the work of fine art upon delivery, or will receive full compensation pursuant to an installment agreement executed prior to or upon delivery.

365.860 Rules Constituting Consignment

The following provisions shall apply to consignment of a work of fine art:

(1) The art dealer, after delivery of the work of fine art, shall constitute an agent of the artist for the purpose of sale or exhibition of the consigned work of fine art;

(2) The work of fine art shall constitute property held in trust by the consignee for the benefit of the consignor, and shall not be subject to claim by a creditor of the consignee. Should the consignee initiate or be forced into bankruptcy proceedings, the consignor shall have the continuing authority to claim physical possession of the work of fine art;

(3) The consignee shall be responsible for the loss of, or damage to, the work of fine art; and

(4) The proceeds from the sale of the work of fine art shall constitute funds held in trust by the consignee for the benefit of the consignor. Such proceeds shall first be applied to pay any balance due the consignor, unless the consignor expressly agrees otherwise in writing.

365.865 Work of Art Consigned Remains Trust Property until Payment Received by Consignor

A work of fine art received as a consignment shall remain trust property, notwithstanding the subsequent purchase thereof by the consignee directly or indirectly for the consignee's own account until the price is paid in full to the consignor or upon agreement to an installment sales contract. If an installment sales contract has not been agreed to and such work is thereafter resold to a bona fide purchaser before the consignor has been paid in full, the proceeds of the resale received by the consignee shall constitute funds held in trust for the benefit of the consignor to the extent necessary to pay any balance still due to the consignor and such trusteeship shall continue until the fiduciary obligation of the consignee with respect to such transaction is discharged in full.

365.870 Waiver of Provisions of KRS 365.855 to 365.875 Prohibited

Any provision of a contract or agreement whereby the consignor waives any provision of KRS 365.855 to 365.875 is void.

365.875 Application and Effect of KRS 365.855 to 365.870

(1) The provisions of KRS 365.855 to 365.870 shall not apply to a written contract executed prior to July 15, 1986, unless either the parties agree by mutual consent that the provisions of KRS 365.855 to 365.870 shall apply or such contract is extended or renewed after July 15, 1986.

(2) The provisions of KRS 365.855 to 365.870 shall not affect the remedies at law available to a party to a consignment contract upon breach of the contract, where such remedies are not in opposition to the provisions of KRS 365.855 to 365.870.

(3) The provisions of KRS 365.855 to 365.870 shall prevail over any conflicting or inconsistent provisions of KRS Chapter 355.

MARYLAND (ENACTED 1983)

s 11-8A-01 Definitions.

(a) In general.—In this subtitle, the following words have the meanings indicated.

(b) Art dealer.—"Art dealer" means an individual, partnership, firm, association, or corporation, other than a public auctioneer, that undertakes to sell a work of fine art created by someone else.

(c) Artist.—"Artist" means the creator of a work of fine art.

(d) On consignment.—"On consignment" means delivered to an art dealer for the purpose of sale or exhibition, or both, to the public by the art dealer other than at a public auction.

(e) Work of fine art.—"Work of fine art" means an original art work which is:

 (1) A visual rendition including a painting, drawing, sculpture, mosaic, or photograph;

 (2) A work of calligraphy;

 (3) A work of graphic art including an etching, lithograph, offset print, or silk screen;

 (4) A craft work in materials including clay, textile, fiber, wood, metal, plastic, or glass; or

 (5) A work in mixed media including a collage or a work consisting of any combination of works included in this subsection.

s 11-8A-02 Art dealer as bailee of artist; work of fine art and proceeds of sale as bailment property.

If an art dealer accepts a work of fine art on a fee, commission, or other compensation basis, on consignment from the artist:

 (1) The art dealer is, with respect to that work of fine art, the bailee of the artist;

 (2) The work of fine art is bailment property in which the art dealer has no legal or equitable interest until the work is sold to a bona fide third party; and

(3) The proceeds of the sale of the work of fine art are bailment property in which the art dealer has no legal or equitable interest until the amount due the artist from the sale, minus the agreed commission, is paid.

s 11-8A-03 Period during which work of fine art remains bailment property.

Notwithstanding the subsequent purchase of the work of fine art by the art dealer directly or indirectly for the art dealer's own account, a work of fine art that is bailment property when initially accepted by the art dealer remains bailment property until the purchase price, minus the agreed upon commission, is paid in full to the artist.

s 11-8A-04 Bailment property not subject to claims of art dealer's creditors.

Property that is bailment property under this subtitle is not subject to the claims, liens, or security interests of the creditors of an art dealer.

MASSACHUSETTS (ENACTED 1978)

§ 1. Definitions

As used in this chapter, the following words shall, unless the context clearly requires otherwise, have the following meanings:

"Artist", the person who creates a work of fine art or, if such person is deceased, such person's heir, legatee, or personal representative.

"Fine art", a painting, sculpture, drawing, work of graphic art, including an etching, lithograph, offset print, silk screen, or work of graphic art of like nature, a work of calligraphy, or a work in mixed media including a collage, assemblage, or any combination of the foregoing art media.

"Art dealer", a person engaged in the business of selling works of fine art, other than a person exclusively engaged in the business of selling goods at public auction.

"Person", an individual partnership, corporation, association or other group, however organized.

"Consignment", a delivery of a work of fine art under which no title to, estate in, or right to possession of, fine art, superior to that of the

consignor shall vest in the consignee, notwithstanding the consignee's power or authority to transfer and convey to a third person all of the right, title and interest of the consignor in and to such fine art.

§ 2. Delivery and acceptance constituting consignment

Notwithstanding any custom, practice or usage of the trade to the contrary, whenever an artist delivers or causes to be delivered a work of fine art of the artist's own creation to an art dealer in the commonwealth for the purpose of exhibition or sale, or both, on a commission, fee or other basis of compensation, the delivery to and acceptance of such work of fine art by the art dealer shall constitute a consignment, unless the delivery to the art dealer is pursuant to an outright sale for which the artist receives or has received full compensation for the work of fine art upon delivery.

§ 3. Incidents of consignment

The following provisions shall apply to consignment of a work of fine art:

(a) The art dealer, after delivery of the work of fine art, shall constitute an agent of the artist for the purpose of sale or exhibition of the consigned work of fine art.

(b) The work of fine art shall constitute property held in trust by the consignee for the benefit of the consignor, and shall not be subject to claim by a creditor of the consignee.

(c) The consignee shall be responsible for the loss of, or damage to, the work of fine art.

(d) The proceeds from the sale of the work of fine art shall constitute funds held in trust by the consignee for the benefit of the consignor. Such proceeds shall first be applied to pay any balance due the consignor, unless the consignor expressly agrees otherwise in writing.

§ 4. Trust

A work of fine art received as a consignment shall remain trust property, notwithstanding the subsequent purchase thereof by the consignee directly or indirectly for the consignee's own account until the price is paid in full to the consignor. If such work is thereafter resold

to a bona fide purchaser before the consignor has been paid in full, the proceeds of the resale received by the consignee shall constitute funds held in trust for the benefit of the consignor to the extent necessary to pay any balance still due to the consignor and such trusteeship shall continue until the fiduciary obligation of the consignee with respect to such transaction is discharged in full.

§ 5. Waiver of provisions
Any provision of a contract or agreement whereby the consignor waives any provision of this chapter is void.

§ 6. Application of chapter
The provisions of this chapter shall not apply to a written contract executed prior to its effective date, unless either the parties agree by mutual consent that the provisions of this chapter shall apply or such contract is extended or renewed after the effective date of this chapter. The provisions of this chapter shall prevail over any conflicting or inconsistent provisions of chapter one hundred and four and chapter one hundred and six.

MICHIGAN (ENACTED 1971)

442.311. Definitions
Sec. 1. As used in this act:
(a) "Art dealer" means a person engaged in the business of selling works of fine art, other than a person exclusively engaged in the business of selling goods at public auction.
(b) "Artist" means the creator of a work of fine art or, if the creator is deceased, the creator's heirs or personal representatives.
(c) "Bona fide purchaser" means a person who in good faith makes a purchase without notice of any outstanding rights of others.
(d) "Commission" means the fee, compensation, or percentage of actual selling price of a work of fine art, agreed upon by the artist and art dealer, which the art dealer may retain after sale of the artist's work of fine art to a third party.
(e) "Consignor" means a person who delivers or causes to be delivered a work of fine art to an art dealer on consignment.

(f) "Fine art" means an original art or craft work which is:
 (i) A visual rendition including, but not limited to, a painting, drawing, sculpture, mosaic, video tape, or photograph.
 (ii) A work of calligraphy.
 (iii) A work of graphic art including, but not limited to, an etching, lithograph, offset print, or silk screen.
 (iv) A craft work in materials including, but not limited to, clay, textile, fiber, wood, metal, plastic, glass, stone, or leather.
 (v) A work in mixed media including, but not limited to, a collage or a work consisting of any combination of subparagraphs (i) to (iv).

(g) "On consignment" means that no title to or estate in the fine art or right to possession of the fine art superior to that of the consignor vests in the consignee, except that the consignee has the power or authority to transfer and convey, to a third person, all of the right, title, and interest of the consignor, in and to the fine art.

(h) "Person" means an individual, partnership, corporation, association, or other group, however organized.

442.312. Consignment; trust property and funds; creditors' claims

Sec. 2. Any custom, practice, or usage of the trade to the contrary notwithstanding:

(a) When an artist or other person delivers or causes to be delivered a work of fine art to an art dealer for the purpose of sale on a commission, the delivery to and acceptance of the work of fine art by the art dealer is considered to be on consignment and the art dealer shall thereafter, with respect to the work of fine art, be considered to be the consignee of the work of fine art.

(b) The work of fine art is trust property in the hands of the consignee for the benefit of the consignor.

(c) Any proceeds due the artist or other consignor from the sale of the work of fine art are trust funds in the hands of the consignee for the benefit of the consignor.

(d) A work of fine art initially received on consignment shall be considered to remain trust property notwithstanding the subsequent purchase of the work of fine art by the consignee directly

or indirectly for the consignee's own account until the terms of purchase are completed. If the work is thereafter resold to a third party who is a bona fide purchaser before the consignor has been paid in full, the work of fine art ceases to be trust property and the proceeds of the resale are trust funds in the hands of the consignee for the benefit of the consignor to the extent necessary to pay any balance still due to the consignor. The trusteeship relating to proceeds of the resale shall continue until the fiduciary obligation of the consignee with respect to a transaction is discharged in full.

(e) Property or funds which are trust property or trust funds pursuant to this section are not subject to the claims, liens, or security interest of the creditors of the art dealer, notwithstanding any other section of this act.

442.312a. Acceptance of fine art works on consignment; receipt

Sec. 2a. (1) An art dealer may accept a work of fine art for a commission on consignment only if before or at the time of acceptance the art dealer delivers to the consignor a written receipt describing the works of fine art delivered to the art dealer and the consignment nature of the delivery.

(2) Except as provided in this subsection, this section applies to a work of fine art accepted on consignment on and after the effective date of this section. If a work of fine art is accepted under a contract in existence before the effective date of this section, this section is applicable to that work of fine art, the proceeds of sale from that work of fine art, and the art dealers involved in the transaction, only to the extent that the provisions of this act do not conflict with that contract.

442.314. Existing contracts or arrangements, extensions, renewals

Sec. 4. This act does not affect any written or oral contract or arrangement in existence before January 1, 1971, nor to any extensions or renewals of a contract except by the mutual written consent of the parties.

442.315. Effective date

Sec. 5. This act shall take effect on January 1, 1971.

MINNESOTA (ENACTED 1983)

324.01. Definitions

Subdivision 1. Scope. For the purposes of sections 324.01 to 324.05, the following terms have the meanings given them.

Subd. 2. Artist. "Artist" means the creator of a work of art or, if that person is deceased, the heirs or personal representatives of the creator of a work of art.

Subd. 3. Art. "Art" means a painting, sculpture, drawing, work of graphic art, photograph, weaving, or work of craft art.

Subd. 4. Art dealer. "Art dealer" means a person engaged in the business of selling works of art, other than a person exclusively engaged in the business of selling goods at public auction.

Subd. 5. Person. "Person" means an individual, partnership, corporation, association, or other group, however organized.

Subd. 6. Consignment. "Consignment" means the delivery of possession of an art work by an artist to an art dealer by which no title to, estate in, or right to possession of, art, superior to that of the artist vests in the art dealer, notwithstanding the art dealer's power or authority to transfer and convey to a third person all of the right, title, and interest of the artist in and to that work of art.

324.02. Delivery to and acceptance by art dealer

Notwithstanding any custom, practice, or usage of the trade to the contrary, if an artist delivers or causes to be delivered a work of art of the artist's own creation to an art dealer in this state for the purpose of exhibition or sale, or both, on a commission, fee, or other basis of compensation, the delivery to and acceptance of the work of art by the art dealer constitutes a consignment, unless the delivery to the art dealer is pursuant to an outright sale for which the artist receives or has received full compensation for the work of fine art upon delivery.

324.03. Results of consignment; artist–art dealer relationships

A consignment of a work of fine art results in all of the following:

(1) the art dealer, after delivery of the work of art, is an agent of the artist for the purpose of sale or exhibition of the consigned work of art within the state of Minnesota;

(2) the work of art is property held in trust by the consignee for the

benefit of the consignor and is not subject to claim by a creditor of the consignee;

(3) the consignee is responsible for the loss of, or damage to, the work of art; and

(4) the proceeds from the sale of the work of art must be held in trust by the consignee for the benefit of the consignor. The proceeds must first be applied to pay any balance due to the consignor, unless the consignor expressly agrees otherwise in writing.

324.04. Trust property

A work of art received as a consignment remains trust property until the consignor has been paid in full, notwithstanding the subsequent purchase of it by the consignee directly or indirectly for the consignee's own account. If the work is thereafter resold to a bona fide purchaser before the consignor has been paid in full, the proceeds of the resale received by the consignee constitute funds held in trust for the benefit of the consignor to the extent necessary to pay any balance still due to the consignor. The trusteeship continues until the fiduciary obligation of the consignee with respect to this transaction is discharged in full.

324.05. Application

Sections 324.01 to 324.05 do not apply to a written contract executed prior to August 1, 1983, unless either the parties agree by mutual consent that sections 324.01 to 324.05 apply, or the contract is extended or renewed after August 1, 1983.

The provisions of sections 324.01 to 324.05 prevail over any conflicting or inconsistent provisions of chapter 336 affecting the subject matter of these sections.

MISSOURI (ENACTED 1984)

407.900. Definitions

As used in sections 407.900 to 407.910:

(1) The term "art dealer" means a person engaged in the business of selling fine arts. The term "art dealer" does not include any person engaged exclusively in the business of selling goods at public auction;

(2) The term "artist" means a person who creates fine art or, if such

person is deceased, such person's heir, legatee, or personal representative;

(3) The term "consignment" means a transfer of the physical possession of fine art by the artist creating the fine art as consignor in which no title to, estate in, or right to possession of the fine art superior to that of the artist who is the consignor shall vest in the consignee, notwithstanding the consignee's power or authority to transfer and convey the title, and all of the rights and interests of the artist who is the consignor in and to such fine art to a third person;

(4) The term "creditors" includes, but is not limited to, those persons included in the definition of "creditor" in section 400.1-201, RSMo;

(5) The term "fine arts" includes:

(a) Visual art such as paintings, sculptures, drawings, mosaics, or photographs;

(b) Calligraphy;

(c) Graphic art such as etchings, lithographs, offset prints, silk screens, and other works of a similar nature;

(d) Crafts, including any item made by an artist or craftsman through the use of clay, textiles, fibers, wood, metal, plastic, glass, ceramics, or similar materials;

(e) Works in mixed media such as collages or any combination of the art forms or media listed in paragraph (a), (b), (c), or (d) of this subdivision.

407.902. Art delivered to art dealer for sale or exhibition deemed consignment, when, exception—written contract required, contents

1. Notwithstanding any custom, practice, or usage of the trade to the contrary, whenever an artist delivers, or causes to be delivered, a work of fine art of the artist's own creation to an art dealer in this state for the purpose of exhibition or sale, or both, on a commission, fee, or other basis of compensation, the delivery to and acceptance of such work of fine art by the art dealer from the artist shall constitute a consignment unless the delivery to the art dealer is pursuant to an outright sale for which

the artist has received or receives, either prior to or upon delivery, full compensation for the work of fine art.

2. Whenever a consignee accepts a work of fine art from an artist for the purpose of sale or exhibition and sale to the public on a commission, fee, or other basis of compensation, there shall be a written contract or agreement between the artist who is the consignor and consignee which shall include, but need not be limited to, provisions that:

 (1) The proceeds of the sale of the work of fine art shall be delivered to the artist who is the consignor at a schedule agreed upon by the artist who is the consignor and consignee;

 (2) The consignee shall be responsible for the stated value of the work of fine art in the event of the loss of or damage to such work of fine art while it is in the possession of such consignee;

 (3) The work of fine art shall only be sold by the consignee for an amount at least equal to the amount agreed upon by the artist who is the consignor in writing;

 (4) The work of fine art may be used or displayed by the consignee or others only with prior written consent of the artist who is the consignor.

407.904. Consignment, effect

A consignment of a work of fine art shall result in all of the following:

(1) The art dealer, after receipt of the work of fine art, shall constitute an agent of the artist for the purpose of sale or exhibition of the consigned work of fine art within the state of Missouri;

(2) The work of fine art shall constitute property held in trust by the consignee for the benefit of the artist who is the consignor and shall not be subject to claim by a creditor of the consignee;

(3) The proceeds from the sale of the work of fine art shall constitute funds held in trust by the consignee for the benefit of the artist who is the consignor, and such proceeds shall first be applied to pay any balance due to the artist who is the consignor, unless the artist who is the consignor expressly agrees otherwise in writing.

407.905. Art dealer is agent of artist—work of art and sale proceeds held in trust for artist, not subject to creditor of consignee

A work of fine art received as a consignment from the artist who created the work of fine art shall remain trust property, notwithstanding the subsequent purchase thereof by the consignee directly or indirectly for the consignee's own account until the price is paid in full to the artist who is consignor. If such work is thereafter resold to a bona fide purchaser before the artist who is consignor has been paid in full, the proceeds of the resale received by the consignee shall constitute funds held in trust for the benefit of the artist who is consignor to the extent necessary to pay any balance still due to the artist who is consignor and such trusteeship shall continue until the fiduciary obligation of the consignee to the artist who is the consignor with respect to such transaction is discharged in full.

407.907. Waiver of proceeds in trust by artist, requirements

An artist who is a consignor may lawfully waive the provisions of subdivision (3) of section 407.904 if such waiver is clear, conspicuous, in writing, and signed by the artist who is the consignor. No waiver shall be valid with respect to the proceeds of a work of fine art initially received "on consignment" but subsequently purchased by the consignee directly or indirectly for his own account. No waiver shall inure to the benefit of the consignor's creditors in any manner which might be inconsistent with the rights under sections 407.900 to 407.910 of the artist who is the consignor.

407.908. Contracts, prior to August 13, 1984, not affected, exceptions

Sections 407.900 to 407.910 shall not apply to a written contract executed prior to August 13, 1984, unless either the parties agree by mutual written consent that sections 407.900 to 407.910 shall apply or such contract is extended or renewed after August 13, 1984. The provisions of sections 407.900 to 407.910 shall prevail over any conflicting or inconsistent provisions of chapter 400, RSMo, affecting the subject matter of sections 407.900 to 407.910.

407.910. Violations—punitive damage and costs authorized

Any art dealer or creditor of an art dealer who violates any provision

of sections 407.900 to 407.910 with intent to injure shall, in addition to the payment of all other damages and costs owed by him, pay to the artist involved punitive damages in an amount as may be determined by law and reasonable attorney's fees.

MONTANA (ENACTED 1985)

22-2-501. Definitions

As used in this part, unless the context requires otherwise, the following definitions apply:

(1) "Art dealer" means a person engaged in the business of selling works of fine art, other than a person exclusively engaged in the business of selling goods at public auction.

(2) "Artist" means a person who creates a work of fine art or, if the person is deceased, the person's heir, devisee, or personal representative.

(3) "Consignment" means that no title to, estate in, or right to possession of fine art superior to that of the consignor vests in the consignee, notwithstanding the consignee's power or authority to transfer and convey to a third person all of the right, title, and interest of the consignor in and to such fine art.

(4) "Fine art" means a painting, sculpture, drawing, work of graphic art (including an etching, lithograph, signed limited edition offset print, silk screen, or a work of graphic art of like nature), a work of calligraphy, photographs, original works in ceramics, wood, metals, glass, plastic, wax, stone, or leather, or a work in mixed media (including a collage, assemblage, or any combination of the art media mentioned in this subsection).

(5) "Person" means an individual, partnership, corporation, association, or other group, however organized.

22-2-502. Artist-art dealer relationship

Notwithstanding any custom, practice, or usage of the trade to the contrary, whenever an artist delivers or causes to be delivered a work of fine art of the artist's own creation to an art dealer in this state for the purpose of exhibition and sale on a commission, fee, or other basis of compensation, the delivery to and acceptance of such work of fine

art by the dealer constitutes a consignment, unless the delivery to the art dealer is pursuant to an outright sale for which the artist receives upon delivery or has received prior to delivery full compensation for the work of fine art.

22-2-503. Agency relationship—trust property

A consignment of a work of fine art results in the following:

(1) The art dealer, after delivery of the work of fine art, is an agent of the artist for the purpose of sale or exhibition of the consigned work of fine art within the state of Montana. This relationship must be defined in writing and renewed at least every 3 years by the art dealer and the artist. It is the responsibility of the artist to identify clearly the work of art by securely attaching identifying marking to or clearly signing the work of art.

(2) The work of fine art constitutes property held in trust by the consignee for the benefit of the consignor and is not subject to claim by a creditor of the consignee.

(3) The consignee is responsible for the loss of or damage to the work of fine art while in the possession of or on the premises of the consignee.

(4) The proceeds from the sale of the work of fine art constitute funds held in trust by the consignee for the benefit of the consignor. The proceeds must first be applied to pay any balance due to the consignor, unless the consignor expressly agrees otherwise in writing.

22-2-504. Subsequent sale—payment to consignor

A work of fine art received as a consignment remains trust property, notwithstanding the subsequent purchase thereof by the consignee directly or indirectly for the consignee's own account, until the price is paid in full to the consignor. If the work is resold to a bona fide purchaser before the consignor has been paid in full, the proceeds of the resale received by the consignee constitute funds held in trust for the benefit of the consignor to the extent necessary to pay any balance due to the consignor and the trusteeship continues until the fiduciary obligation of the consignee with respect to the transaction is discharged in full.

22-2-505. Waiver void—exemption from U.C.C.

(1) Any provision of a contract or agreement by which the consignor waives any provision of this part is void.

(2) This part is not subject to the provisions of Title 30, chapters 1 through 9.

NEW HAMPSHIRE (ENACTED 1988)

§ 352:3 Definitions.

In this subdivision:

I. "Art dealer" means a person, including an individual, partnership, firm, association, or corporation, engaged in the business of selling works of art, other than a person exclusively engaged in the business of selling goods at a public auction.

II. "Artist" means the creator of a work of art, or, if the artist is deceased, the artist's personal representative, heirs or legatees.

III. "On consignment" means delivered to an art dealer for the purpose of sale or exhibition, or both, to the public by the art dealer other than at a public auction.

IV. "Work of art" means an original artwork that is any of the following:

(a) A visual rendition including, but not limited to, a painting, drawing, sculpture, mosaic, or photograph.

(b) A work of calligraphy.

(c) A work of graphic art, including, but not limited to, an etching, lithograph, offset print, silk screen, or other work of similar materials.

(d) A craft work in materials, including, but not limited to, clay, textile, fiber, wood, metal, plastic, glass, or similar materials.

(e) A work in mixed media, including, but not limited to, a collage or a work consisting of any combination of the items listed in subparagraphs (a) through (d) of this paragraph.

§ 352:4 Art Dealer and Artists; Relationship.

If an art dealer accepts a work of art, on a fee, commission, or other compensation basis, on consignment from the artist who created the work of art, the following consequences shall attach:

I. The art dealer shall be, with respect to that work of art, the agent of the artist.

II. The work of art shall be trust property and the art dealer shall be a trustee for the benefit of the artist until the work of art is sold to a bona fide third party or returned to the artist.

III. The proceeds of the sale of the work of art shall be trust property and the art dealer shall be a trustee for the benefit of the artist until the amount due the artist from the sale is paid.

IV. The art dealer shall be strictly liable for the loss of, or damage to, the work of art while it is in the art dealer's possession or control. The value of the work of art shall be, for the purpose of this subdivision, the value established in the written contract between the artist and art dealer entered into pursuant to RSA 352:7.

§ 352:5 Purchase or Resale of Consigned Art by Art Dealer.

I. If a work of art is trust property under RSA 352:4 when it is initially received by the art dealer, it shall remain trust property, notwithstanding the subsequent purchase of the work of art by the art dealer directly or indirectly for the art dealer's own account, until the purchase price specified pursuant to RSA 352:7 is paid in full to the artist.

II. If an art dealer resells a work of art that he purchased for his own account to a bona fide third party before the artist has been paid in full, the work of art shall cease to be trust property and the proceeds of the resale shall be trust funds in the possession or control of the art dealer for the benefit of the artist to the extent necessary to pay any balance still due to the artist. The trustee-ship of the proceeds shall continue until the artist is paid in full under the contract entered into pursuant to RSA 352:7. A separate trust account for each artist shall not be required under this subdivision.

§ 352:6 Trust Property Exempt from Claims of Art Dealer's Creditors.

Notwithstanding any other provision of law, a work of art that is trust property or the artist's portion of the proceeds from the sale of such

work under RSA 352:4 or 352:5 shall not be subject to the claims, liens, or security interests of the creditors of the art dealer.

§ 352:7 Art Dealer Required to Obtain Written Contract.

I. An art dealer shall not accept a work of art, on a fee, commission, or other compensation basis, on consignment from the artist who created the work of art unless, prior to or at the time of acceptance, the art dealer enters into a written contract with the artist that contains all of the following:

(a) The value of the work of art and whether it may be sold;

(b) The time within which the proceeds of the sale are to be paid to the artist, if the work of art is sold;

(c) The minimum price for the sale of the work of art;

(d) The fee or percentage of the sale price that is to be paid to the art dealer for displaying or selling the work of art;

(e) An agreed upon date for removal of artwork and date for termination of contract.

II. If an art dealer violates this section, a court, at the request of the artist, may void the obligation of the artist to that art dealer or to a person to whom the obligation is transferred, other than a holder in due course.

§ 352:8 Art Dealer Duties; Condition for Display of Work or Photograph.

An art dealer who accepts a work of art, on a fee, commission, or other compensation basis, on consignment from the artist who created the work of art, shall not use or display the work of art or a photograph of the work of art, or permit the use or display of the work of art or a photograph of the work of art, unless the following occur:

I. Notice is given to users or viewers that the work of art is the work of the artist;

II. The artist gives prior written consent to the particular use or display.

§ 352:9 Waivers Void.

Any provision of a contract or agreement whereby the artist or art dealer waives any of the provisions of this subdivision shall be void.

§ 352:10 Civil Penalty.

Any art dealer who violates RSA 352:7 or 352:8 shall be liable to the artist for his reasonable attorney's fees plus:

I. One hundred dollars, plus the actual damages, if any, including the incidental and consequential damages, sustained by the artist by reason of the violation.

II. If an art dealer violates any provisions of this subdivision, the artist's obligation for compensation to the art dealer shall be voidable by the artist.

§ 352:11 Exemption from U.C.C.

The provisions of this subdivision shall prevail over conflicting or inconsistent provisions of RSA 382-A, the Uniform Commercial Code.

§ 352:12 Application.

This subdivision shall not apply to a written contract executed prior to January 1, 1989, unless:

I. The parties agree that this subdivision shall apply; or

II. The contract is extended or renewed on or after January 1, 1989.

NEW JERSEY (ENACTED 1987)

12A:2-329. Short title

This act shall be known and may be cited as the "Artworks Consignment Act."

12A:2-330. Definitions

As used in this act:

(1) "Art dealer" means a person engaged in the business of selling crafts and works of fine art, other than a person exclusively engaged in the business of selling goods at public auction.

(2) "Artist" means an individual who is the creator of a craft or work of fine art.

(3) "Commission" means a fee, compensation or percentage of the actual selling price of a craft or work of fine art, which has been agreed upon by the artist and an art dealer, and to which the art

dealer is entitled after completion of the sale of the craft or work of fine art to a third party.

(4) "Consignee" means a person who accepts a craft or work of fine art delivered to the person on consignment.

(5) "Consignor" means a person who delivers, or causes the delivery, of a craft or work of fine art to an art dealer on consignment.

(6) "Craft" means an artistic rendition created using any medium, including, but not limited to, a collage and other works consisting of any combination of painting, drawing, sculpture, photography and manual creation in clay, textile, fiber, wood, metal, plastic, glass, stone, leather or similar materials.

(7) "Fine art" means an original work of visual or graphic art created using any medium, including but not limited to, a painting, drawing or sculpture.

(8) "On consignment" means delivered into the possession and control of a person in whom title to the delivered object does not vest but who, by agreement with the consignor, is authorized to convey the consignor's right, title and interest in the object to a third person.

12A:2-331. Consignment arrangement resulting from delivery to art dealer for sale on commission

When an artist or an artist's representative delivers or causes the delivery of a craft or work of fine art to an art dealer to be sold by the art dealer for a commission, the transfer to and acceptance by the art dealer of the craft or work of fine art shall be on consignment.

12A:2-332. Consignor's protection against consignee's creditors; conditions; written statement of rights

(1) Notwithstanding the provision of N.J.S. 12A:2-326, the consignor may be protected against the creditors of the consignee where:

(a) the consignee or consignor places a sign on the craft or work of fine art which states that the item is on consignment; or

(b) the consignor establishes that the consignee is generally known by his creditors to be substantially engaged in selling the goods of others; or

(c) the consignor complies with the filing provisions of chapter 9 of this title (Uniform Commercial Code-Secured Transactions), thereby perfecting a security interest in the craft or work of fine art.

(2) At the time the craft or work of fine art is placed on consignment, the consignee shall provide the consignor with a written statement of consignor's rights as set forth in subsection (1) of this section. A consignee who fails to give such notice shall be a petty disorderly person and shall be subject, upon conviction, to the penalties set forth in N.J.S. 2C:43-3.

(3) A craft or work of fine art initially received on consignment shall remain the property of the consignor upon compliance with the provisions of subsection (1) of this section, notwithstanding the subsequent purchase of the craft or work of fine art by the consignee, directly or indirectly, for the consignee's own account, until the terms of the purchase are completed.

12A:2-333. Freedom of art on consignment from claims, liens or security interests of consignee's creditors

Crafts or works of fine art placed on consignment in compliance with the provisions of subsection (1) of section 4 are not subject to the claims, liens or security interests of the creditors of the consignee or art dealer.

12A:2-334. Acceptance of craft or art for commission on consignment; written receipt, terms

An art dealer shall not accept a craft or work of fine art for a commission on consignment unless, before the time of acceptance, the art dealer conveys to the consignor a written receipt describing the craft or work of fine art delivered to the art dealer and setting out the terms of the consignment agreement.

12A:2-335. Liability of art dealer for loss or damage to craft or art

An art dealer who accepts a craft or work of fine art on consignment shall be liable in a civil action brought by the consignor for the loss of or damages to the craft or work of fine art.

12A:2-336. Consignor's waiver of rights

A consignor may not waive his rights under this act unless the waiver is clear, conspicuous and in writing.

NEW MEXICO (ENACTED 1979)

56-11-1 Short title.

Sections 1 through 3 [56-11-1 to 56-11-3 NMSA 1978] of this act may be cited as the "Artists' Consignment Act."

56-11-2 Definitions.

As used in the Artists' Consignment Act [56-11-1 to 56-11-3 NMSA 1978]:

A "art" means a painting, sculpture, drawing, work of graphic art, pottery, weaving, batik, macrame or quilt containing the artist's original handwritten signature on the work of art;

B. "artist" means the creator of a work of art, or, if he is deceased, the artist's heirs or personal representative;

C. "art dealer" means a person primarily engaged in the business of selling works of art;

D. "creditor" means a "creditor" as defined in Section 55-1-201 NMSA 1978; and

E. "person" means an individual, partnership, corporation or association.

56-11-3 Art consignment; priority of claims, liens or security interests.

A work of art delivered to an art dealer by an artist for the purpose of exhibition or sale, and the artists' [artist's] share of the proceeds from the sale of the work by the dealer, whether to the dealer on his own account or to a third person, shall create a priority in favor of the artist over the claims, liens or security interests of the creditors of the art dealer, notwithstanding any provision of the Uniform Commercial Code [Chapter 55 NMSA 1978].

NEW YORK (ENACTED 1983)

§ 11.01. Definitions

As used in this title:

1. "Artist" means the creator of a work of fine art or, in the case of multiples, the person who conceived or created the image which is contained in or which constitutes the master from which the individual print was made.

2. "Art merchant" means a person who is in the business of dealing, exclusively or non-exclusively, in works of fine art or multiples, or a person who by his occupation holds himself out as having knowledge or skill peculiar to such works, or to whom such knowledge or skill may be attributed by his employment of an agent or other intermediary who by his occupation holds himself out as having such knowledge or skill. The term "art merchant" includes an auctioneer who sells such works at public auction, and except in the case of multiples, includes persons, not otherwise defined or treated as art merchants herein, who are consignors or principals of auctioneers.

3. "Author" or "authorship" refers to the creator of a work of fine art or multiple or to the period, culture, source or origin, as the case may be, with which the creation of such work is identified in the description of the work.

4. "Creditors" means "creditor" as defined in subdivision twelve of section 1-201 of the uniform commercial code.

5. "Counterfeit" means a work of fine art or multiple made, altered or copied, with or without intent to deceive, in such manner that it appears or is claimed to have an authorship which it does not in fact possess.

6. "Certificate of authenticity" means a written statement by an art merchant confirming, approving or attesting to the authorship of a work of fine art or multiple, which is capable of being used to the advantage or disadvantage of some person.

7. "Conservation" means acts taken to correct deterioration and alteration and acts taken to prevent, stop or retard deterioration.

8. "Craft" means a functional or non-functional work individually designed, and crafted by hand, in any medium including but not limited to textile, tile, paper, clay, glass, fiber, wood, metal or

plastic; provided, however, that if produced in multiples, craft shall not include works mass produced or produced in other than a limited edition.

9. "Fine art" means a painting, sculpture, drawing, or work of graphic art, and print, but not multiples.

10. "Limited edition" means works of art produced from a master, all of which are the same image and bear numbers or other markings to denote the limited production thereof to a stated maximum number of multiples, or are otherwise held out as limited to a maximum number of multiples.

11. "Master" when used alone is used in lieu of and means the same as such things as printing plate, stone, block, screen, photographic negative or other like material which contains an image used to produce visual art objects in multiples, or in the case of sculptures, a mold, model, cast, form or other prototype, other than from glass, which additional multiples of sculpture are produced, fabricated or carved.

12. "On consignment" means that no title to, estate in, or right to possession of, the work of fine art or multiple that is superior to that of the consignor vests in the consignee, notwithstanding the consignee's power or authority to transfer or convey all the right, title and interest of the consignor, in and to such work, to a third person.

13. "Person" means an individual, partnership, corporation, association or other group, however organized.

14. "Print" in addition to meaning a multiple produced by, but not limited to, such processes as engraving, etching, woodcutting, lithography and serigraphy, also means multiples produced or developed from photographic negatives, or any combination thereof.

15. "Proofs" means multiples which are the same as, and which are produced from the same masters as, the multiples in a limited edition, but which, whether so designated or not, are set aside from and are in addition to the limited edition to which they relate.

16. "Reproduction" means a copy, in any medium, of a work of fine art, that is displayed or published under circumstances that,

reasonably construed, evinces an intent that it be taken as a representation of a work of fine art as created by the artist.

17. "Reproduction right" means a right to reproduce, prepare derivative works of, distribute copies of, publicly perform or publicly display a work of fine art.

18. "Sculpture" means a three-dimensional fine art object produced, fabricated or carved in multiple from a mold, model, cast, form or other prototype, other than from glass, sold, offered for sale or consigned in, into or from this state for an amount in excess of fifteen hundred dollars.

19. "Signed" means autographed by the artist's own hand, and not by mechanical means of reproduction, after the multiple was produced, whether or not the master was signed or unsigned.

20. "Visual art multiples" or "multiples" means prints, photographs, positive or negative, sculpture and similar art objects produced in more than one copy and sold, offered for sale or consigned in, into or from this state for an amount in excess of one hundred dollars exclusive of any frame or in the case of sculpture, an amount in excess of fifteen hundred dollars. Pages or sheets taken from books and magazines and offered for sale or sold as visual art objects shall be included, but books and magazines are excluded.

21. "Written instrument" means a written or printed agreement, bill of sale, invoice, certificate of authenticity, catalogue or any other written or printed note or memorandum or label describing the work of fine art or multiple which is to be sold, exchanged or consigned by an art merchant.

§ 12.01. Artist-art merchant relationships

1. Notwithstanding any custom, practice or usage of the trade, any provision of the uniform commercial code or any other law, statute, requirement or rule, or any agreement, note, memo-randum or writing to the contrary:

 (a) Whenever an artist or craftsperson, his heirs or personal representatives, delivers or causes to be delivered a work of fine art, craft or a print of his own creation to an art merchant for the purpose of exhibition and/or sale on a commission,

fee or other basis of compensation, the delivery to and acceptance thereof by the art merchant establishes a consignor/consignee relationship as between such artist or craftsperson and such art merchant with respect to the said work, and:

(i) such consignee shall thereafter be deemed to be the agent of such consignor with respect to the said work;

(ii) such work is trust property in the hands of the consignee for the benefit of the consignor;

(iii) any proceeds from the sale of such work are trust funds in the hands of the consignee for the benefit of the consignor;

(iv) such work shall remain trust property notwithstanding its purchase by the consignee for his own account until the price is paid in full to the consignor; provided that, if such work is resold to a bona fide third party before the consignor has been paid in full, the resale proceeds are trust funds in the hands of the consignee for the benefit of the consignor to the extent necessary to pay any balance still due to the consignor and such trusteeship shall continue until the fiduciary obligation of the consignee with respect to such transaction is discharged in full; and

(v) no such trust property or trust funds shall be subject or subordinate to any claims, liens or security interest of any kind or nature whatsoever.

(b) Waiver of any provision of this section is absolutely void except that a consignor may lawfully waive the provisions of clause (iii) of paragraph (a) of this subdivision, if such waiver is clear, conspicuous, in writing and subscribed by the consignor, provided:

(i) no such waiver shall be valid with respect to the first two thousand five hundred dollars of gross proceeds of sales received in any twelve-month period commencing with the date of the execution of such waiver;

(ii) no such waiver shall be valid with respect to the proceeds of a work initially received on consignment but

subsequently purchased by the consignee directly or indirectly for his own account; and

(iii) no such waiver shall inure to the benefit of the consignee's creditors in any manner which might be inconsistent with the consignor's rights under this subdivision.

(c) proceeds from the sale of consigned works covered by this section shall be deemed to be revenue from the sale of tangible goods and not revenue from the provision of services to the consignor or others, except that the provisions of this paragraph shall not apply to proceeds from the sale of consigned works sold at public auction.

2. Nothing in this section shall be construed to have any effect upon any written or oral contract or arrangement in existence prior to September first, nineteen hundred sixty-nine or to any extensions or renewals thereof except by the mutual written consent of the parties thereto.

NORTH CAROLINA (ENACTED 1983)

§ 25C-2 Interest of art dealer who accepts works of fine art on consignment.

If an art dealer accepts a work of fine art on a fee, commission, or other compensation basis on consignment from the artist:

(1) The art dealer is, with respect to that work of fine art, the bailee of the artist;

(2) The work of fine art is bailment property in which the art dealer has no legal or equitable interest until the work is sold to a bona fide third party; and

(3) The proceeds of the sale of the work of fine art are bailment property in which the art dealer has no legal or equitable interest until the amount due the artist from the sale, minus the agreed commission, is paid.

§ 25C-3 Status of works of fine art subsequently purchased by art dealer for his own account.

Notwithstanding the subsequent purchase of a work of fine art by the art dealer directly or indirectly for the art dealer's own account, a work of fine art that is bailment property when initially accepted by the

art dealer remains bailment property until the purchase price minus the agreed upon commission, is paid in full to the artist.

§ 25C-4 Creditors of art dealer may not reach works of fine art on consignment with art dealer.

Property that is bailment property under this Article is not subject to the claims, liens, or security interests of the creditors of an art dealer.

§ 25C-5 Risk of loss; insurable interest.

Nothing in this Article shall affect any provision of law pertaining to the risk of loss between or among the parties to a consignment agreement under this Article or pertaining to the insurable interest of any such party.

OHIO (ENACTED 1984)

1339.71 Definitions

As used in sections 1339.71 to 1339.78 of the Revised Code:

(A) "Art dealer" means a person engaged in the business of selling works of art, other than a person exclusively engaged in the business of selling goods at public auction.

(B) "Artist" means the creator of a work of art.

(C) "On consignment" means delivered to an art dealer for the purpose of sale or exhibition, or both, to the public by the art dealer other than at a public auction.

(D) "Work of art" means an original art work that is any of the following:

 (1) A visual rendition including, but not limited to, a painting, drawing, sculpture, mosaic, or photograph;

 (2) A work of calligraphy;

 (3) A work of graphic art, including, but not limited to, an etching, lithograph, offset print, or silk screen;

 (4) A craft work in materials, including, but not limited to, clay, textile, fiber, wood, metal, plastic, or glass;

 (5) A work in mixed media, including, but not limited to, a collage or a work consisting of any combination of the items listed in divisions (D)(1) to (4) of this section.

1339.72 Consignment by Artist of His Work of Art to a Dealer; Effects; Trust

If an art dealer accepts a work of art, on a fee, commission, or other compensation basis, on consignment from the artist who created the work of art, the following consequences attach:

(A) The art dealer is, with respect to that work of art, the agent of the artist.

(B) The work of art is trust property and the art dealer is a trustee for the benefit of the artist until the work of art is sold to a bona fide third party or returned to the artist.

(C) The proceeds of the sale of the work of art are trust property and the art dealer is a trustee for the benefit of the artist until the amount due the artist from the sale is paid.

(D) The art dealer is strictly liable for the loss of, or damage to, the work of art while it is in the art dealer's possession or control. The value of the work of art is, for the purpose of this division, the value established in the written contract between the artist and art dealer entered into pursuant to section 1339.75 of the Revised Code.

1339.73 Continuation of Trust after Purchase by Dealer for Own Account

(A) If a work of art is trust property under section 1339.72 of the Revised Code when it is initially received by the art dealer, it remains trust property, notwithstanding the subsequent purchase of the work of art by the art dealer directly or indirectly for the art dealer's own account, until the purchase price specified pursuant to division (A)(3) of section 1339.75 of the Revised Code is paid in full to the artist.

(B) If an art dealer resells a work of art that he purchased for his own account to a bona fide third party before the artist has been paid in full, the work of art ceases to be trust property and the proceeds of the resale are trust funds in the possession or control of the art dealer for the benefit of the artist to the extent necessary to pay any balance still due to the artist. The trusteeship of the proceeds continues until the artist is paid in full under the contract entered into pursuant to section 1339.75 of the Revised Code.

154

1339.74 Not Subject to Claims of Dealer's Creditors

A work of art that is trust property under section 1339.72 or 1339.73 of the Revised Code is not subject to the claims, liens, or security interests of the creditors of the art dealer, notwithstanding Chapters 1301. to 1310. of the Revised Code.

1339.75 Written Contract Required of Dealer

(A) An art dealer shall not accept a work of art, on a fee, commission, or other compensation basis, on consignment from the artist who created the work of art unless, prior to or at the time of acceptance, the art dealer enters into a written contract with the artist that contains all of the following:

(1) The value of the work of art and whether it may be sold;

(2) The time within which the proceeds of the sale are to be paid to the artist, if the work of art is sold;

(3) The minimum price for the sale of the work of art;

(4) The fee or percentage of the sale price that is to be paid to the art dealer for displaying or selling the work of art.

(B) If an art dealer violates this section, a court, at the request of the artist, may void the obligation of the artist to that art dealer or to a person to whom the obligation is transferred, other than a holder in due course.

1339.76 Display Requires Consent of Artist and Notice to Viewers as to Artist's Identity

An art dealer who accepts a work of art, on a fee, commission, or other compensation basis, on consignment from the artist who created the work of art shall not use or display the work of art or a photograph of the work of art, or permit the use or display of the work of art or a photograph of the work of art, unless both of the following occur:

(1) Notice is given to users or viewers that the work of art is the work of the artist;

(2) The artist gives prior written consent to the particular use or display.

1339.77 Waiver of Statutory Provisions Void

Any portion of an agreement that waives any provision of sections 1339.71 to 1339.78 of the Revised Code is void.

1339.78 Special Damages for Certain Violations by Dealer

Any art dealer who violates section 1339.75 or 1339.76 of the Revised Code is liable to the artist for his reasonable attorney's fees and in an amount equal to the greater of either of the following:

(A) Fifty dollars;

(B) The actual damages, if any, including the incidental and consequential damages, sustained by the artist by reason of the violation.

OREGON (ENACTED 1981)

359.200. Definitions for ORS 359.200 to 359.255.

As used in ORS 359.200 to 359.255:

(1) "Art dealer" means an individual, partnership, firm, association or corporation, other than a public auctioneer, that undertakes to sell a work of fine art created by another.

(2) "Artist" means the creator of a work of fine art or, if the artist is deceased, the artist's personal representative, heirs or legatees.

(3) "Consignee" means an art dealer who receives and accepts a work of fine art from a consignor for the purpose of sale or exhibition, or both, to the public on a commission or fee or other basis of compensation.

(4) "Consignment" means delivery of a work of fine art to an art dealer for the purpose of sale or exhibition, or both, to the public by the art dealer at other than a public auction.

(5) "Consignor" means an artist or any person who delivers a work of fine art to an art dealer for the purpose of sale or exhibition, or both, to the public on a commission or fee or other basis of compensation.

(6) "Fine art" means:

 (a) An original work of visual art such as a painting, sculpture, drawing, mosaic or photograph;

 (b) A work of calligraphy;

 (c) A work of original graphic art such as an etching, lithograph, offset print, silk screen or other work of similar nature;

 (d) A craft work in materials including but not limited to clay, textile, fiber, wood, metal, plastic, glass or similar materials; or

(e) A work in mixed media such as a collage or any combination of the art media described in this subsection.

359.205. Delivery of art work to dealer as consignment; exception for direct sale work as trust property.

(1) Notwithstanding any custom, practice or usage of the trade to the contrary, whenever an artist delivers or causes to be delivered a work of the artist's own creation to an art dealer in this state for the purpose of exhibition or sale, or both, on a commission, fee or other basis of compensation, the delivery to and acceptance thereof by the art dealer constitutes a consignment unless the delivery to the art dealer is pursuant to an outright sale for which the artist receives or has received compensation for the work of fine art upon delivery.

(2) A work of fine art is trust property in the hands of the art dealer, who is trustee for the benefit of the artist until the work of fine art is sold to a bona fide third party.

(3) The proceeds of the sale of a work of fine art are trust property in the hands of the art dealer who is trustee for the benefit of the artist until the amount due the artist from the sale is paid. Nothing in this subsection requires a separate trust account for each artist.

(4) A work of fine art that is trust property when initially accepted by the art dealer remains trust property notwithstanding the subsequent purchase of the work of fine art by the art dealer directly or indirectly for the art dealer's own account, until the purchase price is paid in full to the artist.

(5) The trust relationship described in this section imposes no duty greater than the duties described in ORS 359.200 to 359.210, 359.220, 359.225, 359.250 and 359.255 and does not give rise to any general trust or fiduciary relationship.

359.210. Effect of treating art work delivery as consignment; name of purchaser to be supplied on demand; remedy.

(1) A consignment of a work of fine art has the following effect:

(a) The consignee, after the delivery of fine art, shall be considered to be the agent of the consignor for the purpose of

the exhibition or sale, or both, of the work of fine art within this state.

(b) The work of fine art, or the artist's portion of the proceeds from the sale of such work, shall not be subject to the claims of a creditor or consignee.

(c) A consignee is liable for the loss of or damage to the work of fine art while it is in the consignee's possession where such loss or damage is caused by the failure of the consignee to use the highest degree of care. For the purpose of this subsection, the value of the work of fine art is the value established in a written agreement between the consignor and consignee prior to the loss or damage or, if no written agreement regarding the value of the work of fine art exists, the artist's portion of the fair market value of the work of fine art.

(d) The consignee shall not be held liable for the loss of, or damage to the work of fine art if the artist fails to remove the work within a period of 30 days following the date agreed upon for removal of the work in the written contract between the artist and the consignee or, if no written agreement regarding a removal date exists, 30 days after notice to remove the work of fine art is sent by registered mail or by certified mail with return receipt to the artist at the artist's last-known address.

(2) Upon written demand from the consignor, the consignee shall furnish the consignor with the name and address of the purchaser of the consignor's work, and the date of purchase and the price paid for the work, for any sale totaling $100 or more.

(3) Failure to furnish the information specified under subsection (2) of this section by the consignor shall entitle the artist to obtain an injunction prohibiting such conduct and in addition, money damages in an amount equal to three times the artist's portion of the retail value of the work.

359.215. Consignment does not create rights in art dealer greater than those of artist.

A consignment of a work of fine art does not convey title to or create an estate in the work or grant a right to possession superior to that of

the consignor notwithstanding the power or authority of the consignee to transfer or convey to a third person all of the right, title and interest of the consignor in and to the work.

359.220. Artist and art dealer to execute consignment contract; contents; consent to display.

(1) An art dealer may accept a work of fine art, on a fee, commission or other compensation basis, on consignment from the artist who created the work of fine art only if prior to or at the time of acceptance the art dealer enters into a written contract with the artist establishing:

 (a) The retail value of the work of fine art;

 (b) The time within which the proceeds of the sale are to be paid to the artist, if the work of fine art is sold;

 (c) The minimum price for the sale of the work of fine art; and

 (d) The fee, commission or other compensation basis of the art dealer.

(2) An art dealer who accepts a work of fine art on a fee, commission or other compensation basis on consignment from the artist may use or display the work of fine art or a photograph of the work of fine art or permit the use or display of work or photograph only if:

 (a) The art dealer gives notice to users or viewers that the work of fine art is the work of the artist; and

 (b) The artist gives prior written consent to the particular use or display.

359.225. Payment of sale proceeds of consigned work; funds due artist not subject to claims of dealer's creditors.

The proceeds from a sale of a work of fine art on consignment shall be paid to the consignor within 30 days of receipt by the consignee unless the consignor expressly agrees otherwise in writing. If the sale of the work of fine art is on installment, the funds from the installment shall first be applied to pay any balance due the consignor on the sale, unless the consignor expressly agrees in writing that the proceeds on each installment shall be paid according to the percentage established by the consignment agreement. The artist's portion of funds received

on the sale of the work of fine art or on installment shall not be subject to the claims of a creditor of the consignee.

359.230. Contract provision waiving protections for artist is void.

Any provision of a contract or agreement whereby the consignor waives any of the provisions of ORS 359.200 to 359.255 is void.

359.235. ORS 359.200 to 359.240 not to affect prior transactions; effect of Uniform Commercial Code.

(1) Nothing in ORS 359.200 to 359.255 is intended to affect any written or oral contract or agreement in existence prior to November 1, 1981, unless the parties agree by mutual written consent that ORS 359.200 to 359.255 shall apply or the contract is extended or renewed after November 1, 1981.

(2) ORS 359.200 to 359.255 is applicable notwithstanding the absence of, or conflict with, any written agreement, receipt, note or memorandum entered into on or after November 1, 1981, between the consignor and the consignee concerning any matter covered by ORS 359.200 to 359.255. ORS 359.200 to 359.255 controls over any conflicting provisions of the Uniform Commercial Code.

359.240. Art dealer prohibited from diverting sale proceeds; penalty.

It shall be unlawful for a consignee willfully and knowingly to secret, withhold or appropriate a work of fine art or the proceeds from sale thereof for the consignee's own use or the use of any person other than the consignor, except pursuant to a bona fide sale or as otherwise consistent with the terms of consignment. Violation of this section is a Class C felony.

359.250. Liability of art dealer for violation of ORS 359.220.

(1) An art dealer violating ORS 359.220 is liable to the artist for $100 plus actual damages, including incidental damages sustained as a result of the violation.

(2) If an art dealer violates ORS 359.220, the artist's obligation for compensation to the art dealer is voidable by the artist.

359.255. Attorney fees.

In any action under any provision of ORS 359.200 to 359.255, the court may award reasonable attorney fees and costs to the prevailing party.

PENNSYLVANIA (ENACTED 1986)

§ 2122. Definitions

The following words and phrases when used in this act shall have the meanings given to them in this section unless the context clearly indicates otherwise:

"Art dealer." A person engaged in the business of selling crafts and works of fine art, other than a person exclusively engaged in the business of selling goods at public auction.

"Artist." An individual who is the creator of a craft or work of fine art.

"Bona fide purchaser." A person who makes a purchase in good faith without notice of any outstanding rights of others with respect to the object of the purchase.

"Commission." A fee, compensation or percentage of the actual selling price of a craft or work of fine art which has been agreed upon by the artist and an art dealer and to which the art dealer is entitled after completion of the sale of the craft or work of fine art to a third party.

"Consignee." A person who accepts a craft or work of fine art delivered to the person on consignment.

"Consignor." A person who delivers, or causes the delivery of, a craft or work of fine art to an art dealer on consignment.

"Craft." An artistic rendition, created using any medium, including, but not limited to, a collage and other works consisting of any combination of painting, drawing, sculpture, photography and manual creation in clay, textile, fiber, wood, metal, plastic, glass, stone, leather or similar materials.

"Fine art." An original work of visual or graphic art of recognized quality, created using any medium, including, but not limited to, a painting, drawing or sculpture.

"On consignment." Delivered into the possession and control of a

person in whom title to the delivered object does not vest but who, by agreement with the consignor, is authorized to convey the consignor's right, title and interest in the object to a third person.

§ 2123. Consignment

When an artist or other person delivers or causes the delivery of a craft or work of fine art to an art dealer, to be sold by the art dealer for a commission, the transfer to and acceptance by the art dealer of the craft or work of fine art shall be considered on consignment.

§ 2124. Property and proceeds

(a) Trust property.—A craft or work of fine art accepted on consignment is trust property being held by the consignee for the benefit of the consignor.

(b) Proceeds.—Any proceeds due the consignor from the sale of a craft or work of fine art on consignment are trust funds held by the consignee for the benefit of the consignor.

§ 2125. Sale of works

A craft or work of fine art initially received on consignment shall remain trust property under section 4, notwithstanding the subsequent purchase of the craft or work of fine art by the consignee, directly or indirectly, for the consignee's own account, until the terms of the purchase are completed. If the craft or work is resold to a third party who is a bona fide purchaser before the consignor has been paid in full, the work of fine art shall cease to be trust property, and the proceeds of the resale shall be trust funds under section 4 to the extent necessary to pay the balance due the consignor.

§ 2126. Property and funds not subject to claims, etc.

Property or funds which are held in trust under section 4 are not subject to the claims, liens or security interest of the creditors of an art dealer.

§ 2127. Receipt

An art dealer shall not accept a craft or work of fine art for a commission on consignment unless, before the time of acceptance, the

art dealer conveys to the consignor a written receipt describing the craft or work of fine art delivered to the art dealer and setting out the terms of the consignment agreement.

§ 2128. Liability for loss or damage
An art dealer who accepts a craft or work of fine art on consignment shall be liable in a civil action brought by the consignor for the loss of or damages to the craft or work of fine art.

§ 2129. Waiver of rights
A consignor may not waive his rights under this act unless the waiver is in writing.

§ 2130. Application of act
This act applies to crafts and works of art accepted on consignment on and after the effective date of this act.

TENNESSEE (ENACTED 1984)

47-25-1002 Definitions.
As used in this part, unless the context otherwise requires:
(1) "Art dealer" means a person engaged in the business of selling works of art, other than a person exclusively engaged in the business of selling goods at public auction;
(2) "Artist" means the person who creates a work of art, or, if such person is deceased, such person's heir, legatee, or personal representative;
(3) "Consignment" means that no title to, estate in, or right to possession of, the work of art, superior to that of the consignor shall vest in the consignee, notwithstanding the consignee's power or authority to transfer and convey to a third person all of the right, title, and interest of the consignor in and to such work of art;
(4) "Co-operative" means an association or group of artists which:
 (A) Engages in the business of selling only works of art which are produced or created by such artists;
 (B) Jointly owns, operates, and markets such business; and

(C) Accepts such works of art from its members on consignment;

(5) "Person" means an individual, partnership, corporation, association, or other group, however organized; and

(6) "Work of art" means an original art work which is:

(A) A visual rendition, including a painting, drawing, sculpture, mosaic, or photograph;

(B) A work of calligraphy;

(C) A work of graphic art, including an etching, lithograph, offset print, or silk screen;

(D) A craft work in materials, including clay, textile, fiber, wood, metal, plastic, or glass; or

(E) A work in mixed media, including a collage or a work consisting of any combination of subdivisions (6)(A)–(D).

47-25-1003 *What constitutes consignment.*

Notwithstanding any custom, practice, or usage of the trade to the contrary, whenever an artist delivers or causes to be delivered a work of art of the artist's own creation to an art dealer in this state for the purpose of exhibition or sale, or both, on a commission, fee, or other basis of compensation, the delivery to and acceptance of such work of art by the art dealer shall constitute a consignment, unless the delivery to the art dealer is pursuant to an outright sale for which the artist receives or has received full compensation for the work of art upon delivery.

47-25-1004 *Effect of consignment.*

A consignment of a work of art shall result in all of the following:

(1) The art dealer, after delivery of the work of art, shall constitute an agent of the artist for the purpose of sale or exhibition of the consigned work of art within the state of Tennessee;

(2) The work of art shall constitute property held in trust by the consignee for the benefit of the consignor and shall not be subject to claim by a creditor of the consignee;

(3) The consignee shall be responsible for the loss of, or damage to, the work of art; and

(4) The proceeds from the sale of the work of art shall constitute funds held in trust by the consignee for the benefit of the

consignor. Such proceeds shall first be applied to pay any balance due to the consignor, unless the consignor expressly agrees otherwise in writing.

47-25-1005 Nature of trust.

(a) A work of art received as a consignment shall remain trust property, notwithstanding the subsequent purchase thereof by the consignee directly or indirectly for the consignee's own account, until the price is paid in full to the consignor. If such work is thereafter resold to a bona fide purchaser before the consignor has been paid in full, the proceeds of the resale received by the consignee shall constitute funds held in trust for the benefit of the consignor to the extent necessary to pay any balance still due to the consignor, and such trusteeship shall continue until the fiduciary obligation of the consignee with respect to such transaction is discharged in full.

(b) No such trust property or trust funds shall be or become subject or subordinate to any claims, liens, or security interests of any kind or nature whatsoever, of the consignee's creditors, anything in the Uniform Commercial Code, § 47-2-326, or any other provision of the Uniform Commercial Code to the contrary notwithstanding.

47-25-1006 Waiver.

Any cooperative may contract with its members to waive liability for the loss of or damage to works of art consigned to such cooperative. Any other provision of a contract or an agreement whereby the consignor purports to waive any provision of this part is void.

TEXAS (ENACTED 1977)

Art. 9018. Artists' Consignment Act

Sec. 1. This Act may be cited as the Artists' Consignment Act.

Sec. 2. In this Act:

(1) "Art" means a painting, sculpture, drawing, work of graphic art, pottery, weaving, batik, macrame, quilt, or other commonly recognized art form.

(2) "Artist" means the creator of a work of art or, if he is deceased, his estate.

(3) "Art dealer" means a person engaged in the business of selling works of art.

(4) "Creditor" has the meaning given that term by Section 1.201, Business & Commerce Code.

(5) "Person" means an individual, partnership, corporation, or association.

Sec. 3. A work of art delivered to an art dealer for the purpose of exhibition or sale, and the proceeds from the sale of the work by the dealer, whether to the dealer on his own account or to a third person, are not subject to the claims, liens, or security interests of the creditors of the art dealer, notwithstanding any provision of the Business & Commerce Code.

WASHINGTON (ENACTED 1981)

18.110.010. Definitions

As used in this chapter, the following terms have the meanings indicated unless the context clearly requires otherwise.

(1) "Art dealer" means a person, partnership, firm, association, or corporation, other than a public auctioneer, which undertakes to sell a work of fine art created by another.

(2) "Artist" means the creator of a work of fine art.

(3) "On consignment" means delivered to an art dealer for the purpose of sale or exhibition, or both, to the public by the art dealer other than at a public auction.

(4) "Work of fine art" means an original art work which is:

(a) A visual rendition including a painting, drawing, sculpture, mosaic, or photograph;

(b) A work of calligraphy;

(c) A work of graphic art including an etching, lithograph, offset print, or silk screen;

(d) A craft work in materials including clay, textile, fiber, wood, metal, plastic, or glass; or

(e) A work in mixed media including a collage or a work con-

sisting of any combination of works included in this sub-section.

18.110.020. Rights—Duties—Liabilities

If an art dealer accepts a work of fine art on a fee, commission, or other compensation basis, on consignment from the artist:

(1) The art dealer is, with respect to that work of fine art, the agent of the artist.

(2) The work of fine art is trust property and the art dealer is trustee for the benefit of the artist until the work of fine art is sold to a bona fide third party.

(3) The proceeds of the sale of the work of fine art are trust property and the art dealer is trustee for the benefit of the artist until the amount due the artist from the sale is paid. These trust funds shall be paid to the artist within thirty days of receipt by the art dealer unless the parties expressly agree otherwise in writing. If the sale of the work of fine art is on installment, the funds from the installment shall first be applied to pay any balance due the artist on the sale, unless the artist expressly agrees in writing that the proceeds on each installment shall be paid according to a percentage established by the consignment agreement.

(4) The art dealer is strictly liable for the loss of or damage to the work of fine art while it is in the art dealer's possession. For the purpose of this subsection the value of the work of fine art is the value established in a written agreement between the artist and art dealer prior to the loss or damage or, if no written agreement regarding the value of the work of fine art exists, the fair market value of the work of fine art.

A work of fine art which is trust property when initially accepted by the art dealer remains trust property notwithstanding the subsequent purchase of the work of fine art by the art dealer directly or indirectly for the art dealer's own account until the purchase price is paid in full to the artist. No property which is trust property under this section is subject to the claims, liens, or security interests of the creditors of the art dealer.

18.110.030. Contract required—Provisions

(1) An art dealer may accept a work of fine art on a fee, commission, or other compensation basis, on consignment from the artist only if prior to or at the time of acceptance the art dealer enters into a written contract with the artist which states:

 (a) The value of the work of fine art;

 (b) The minimum price for the sale of the work of fine art; and

 (c) The fee, commission, or other compensation basis of the art dealer.

(2) An art dealer who accepts a work of fine art on a fee, commission, or other compensation basis, on consignment from the artist may use or display the work of fine art or a photograph of the work of fine art or permit the use or display of the work or photograph only if:

 (a) Notice is given to users or viewers that the work of fine art is the work of the artist; and

 (b) The artist gives prior written consent to the particular use or display.

(3) Any portion of a contract which waives any provision of this chapter is void.

18.110.040. Violations—Penalties—Attorney fees

An art dealer violating RCW 18.110.030 is liable to the artist for fifty dollars plus actual damages, including incidental and consequential damages, sustained as a result of the violation. If an art dealer violates RCW 18.110.030, the artist's obligation for compensation to the art dealer is voidable. In an action under this section the court may, in its discretion, award the artist reasonable attorney's fees.

18.110.900. Application of chapter

This chapter applies to any work of fine art accepted on consignment on or after July 26, 1981. If a work of fine art is accepted on consignment on or after July 26, 1981 under a contract made before that date, this section applies only to the extent that it does not conflict with the contract.

WISCONSIN (ENACTED 1979)

129.01. Definitions

In this chapter:

(1) "Art dealer" means a person engaged in the business of selling works of fine art, other than a person exclusively engaged in the business of selling goods at public auction.

(2) "Artist" means the creator of a work of fine art.

(3) "On consignment" means delivered to an art dealer for the purpose of sale or exhibition, or both, to the public by the art dealer other than at a public auction.

(4) "Work of fine art" means an original art work which is:

 (a) A visual rendition including, but not limited to, a painting, drawing, sculpture, mosaic or photograph.

 (b) A work of calligraphy.

 (c) A work of graphic art, including, but not limited to, an etching, lithograph, offset print or silk screen.

 (d) A craft work in materials, including but not limited to clay, textile, fiber, wood, metal, plastic or glass.

 (e) A work in mixed media, including, but not limited to, a collage or a work consisting of any combination of pars. (a) to (d).

129.02. Art dealer and artist; relationship

If an art dealer accepts a work of fine art, on a fee, commission or other compensation basis, on consignment from the artist who created the work of fine art:

(1) The art dealer is, with respect to that work of fine art, the agent of the artist.

(2) The work of fine art is trust property and the art dealer is trustee for the benefit of the artist until the work of fine art is sold to a bona fide 3rd party.

(3) The proceeds of the sale of the work of fine art are trust property and the art dealer is trustee for the benefit of the artist until the amount due the artist from the sale is paid.

(4) The art dealer is strictly liable for the loss of or damage to the work of fine art while it is in the art dealer's possession. The value

of the work of fine art is, for the purpose of this subsection, the value established in a written agreement between the artist and art dealer prior to the loss or damage or, if no written agreement regarding the value of the work of fine art exists, the fair market value of the work of fine art.

129.03. Trust property

(1) If a work of fine art is trust property under s. 129.02 when initially received by the art dealer it remains trust property notwithstanding the subsequent purchase of the work of fine art by the art dealer directly or indirectly for the art dealer's own account until the purchase price is paid in full to the artist.

(2) If the art dealer resells a work of fine art to which sub. (1) applies to a bona fide 3rd party before the artist has been paid in full, the work of fine art ceases to be trust property and the proceeds of the resale are trust funds in the hands of the art dealer for the benefit of the artist to the extent necessary to pay any balance still due to the artist. The trusteeship of the proceeds continues until the fiduciary obligation of the art dealer with respect to the transaction is discharged in full.

129.04. Trust property, art dealer's creditors

No property which is trust property under s. 129.02 or 129.03 is subject to the claims, liens or security interests of the creditors of the art dealer, notwithstanding chs. 401 to 411.

129.05. Art dealer required to obtain written contract

(1) An art dealer may accept a work of fine art, on a fee, commission or other compensation basis, on consignment from the artist who created the work of fine art only if prior to or at the time of acceptance the art dealer enters into a written contract with the artist establishing:

 (a) The value of the work of fine art;

 (b) The time within which the proceeds of the sale are to be paid to the artist, if the work of fine art is sold; and

 (c) The minimum price for the sale of the work of fine art.

(2) If an art dealer violates this section a court may, at the request

of the artist, void the obligation of the artist to that art dealer or to a person to whom the obligation is transferred, other than a holder in due course.

129.06. Art dealer; duties

An art dealer who accepts a work of fine art, on a fee, commission or other compensation basis, on consignment from the artist who created the work of fine art may use or display the work of fine art or a photograph of the work of fine art or permit the use or display of the work of fine art or a photograph of the work of fine art only if:

(1) Notice is given to users or viewers that the work of fine art is the work of the artist; and

(2) The artist gives prior written consent to the particular use or display.

129.07. Waiver voided

Any portion of an agreement which waives any provision of this chapter is void.

129.08. Penalty

Any art dealer who violates s. 129.05 or 129.06, is liable to the artist in an amount equal to:

(1) $50; and

(2) The actual damages, if any, including the incidental and consequential damages, sustained by the artist by reason of the violation and reasonable attorney fees.

●

Part III.

Appendix

A

The Standard Art Consignment Agreement

. .

\mathcal{T}he Artist (name, address, and telephone number):_____

and the Gallery (name, address, and telephone number): _____

hereby enter into the following Agreement:

1. *Agency; Purposes.* The Artist appoints the Gallery as agent for the works of art ("the Artworks") consigned under this Agreement, for the purposes of exhibition and sale. The Gallery shall not permit the Artworks to be used for any other purposes without the written consent of the Artist.

2. *Consignment.* The Artist hereby consigns to the Gallery, and the Gallery accepts on consignment, those Artworks listed on the attached Inventory Sheet which is a part of this Agreement. Additional Inventory Sheets may be incorporated into this Agreement at such time as both parties agree to the consignment of other works of art. All Inventory Sheets shall be signed by Artist and Gallery.

3. *Warranty.* The Artist hereby warrants that he/she created and

possesses unencumbered title to the Artworks, and that their descriptions are true and accurate.

4. *Duration of Consignment.* The Artist and the Gallery agree that the initial term of consignment for the Artworks is to be _____ (months), and that the Artist does not intend to request their return before the end of this term. Thereafter, consignment shall continue until the Artist requests the return of any or all of the Artworks or the Gallery requests that the Artist take back any or all of the Artworks with which request the other party shall comply promptly.

5. *Transportation Responsibilities.* Packing and shipping charges, insurance costs, other handling expenses, and risk of loss or damage incurred in the delivery of Artworks from the Artist to the Gallery, and in their return to the Artist, shall be the responsibility of the _____ (specify Gallery or Artist).

6. *Responsibility for Loss or Damage, Insurance Coverage.* The Gallery shall be responsible for the safekeeping of all consigned Artworks while they are in its custody. The Gallery shall be strictly liable to the Artist for their loss or damage (except for damage resulting from flaws inherent in the Artworks), to the full amount the Artist would have received from the Gallery if the Artworks had been sold. The Gallery shall provide the Artist with all relevant information about its insurance coverage for the Artworks if the Artist requests this information.

7. *Fiduciary Responsibilities.* Title to each of the Artworks remains in the Artist until the Artist has been paid the full amount owing him or her for the Artworks; title then passes directly to the purchaser. All proceeds from the sale of the Artworks shall be held in trust for the Artist. The Gallery shall pay all amounts due the Artist before any proceeds of sales can be made available to creditors of the Gallery.

8. *Notice of Consignment.* The Gallery shall give notice, by means of a clear and conspicuous sign in full public view, that certain works of art are being sold subject to a contract of consignment.

9. *Removal from Gallery.* The Gallery shall not tend out, remove from the premises, or sell on approval any of the Artworks, without first obtaining written permission from the Artist.

10. *Pricing; Gallery's Commission; Terms of Payment.* The Gallery shall sell the Artworks only at the Retail Price specified on the Inventory Sheet. The Gallery and the Artist agree that the Gallery's commission is to be____ percent of the Retail Price of the Artwork. Any change in the Retail Price, or in the Gallery's commission, must be agreed to in advance by the Artist and the Gallery. Payment to the Artist shall be made by the Gallery within____days after the date of sale of any of the Artworks. The Gallery assumes full risk for the failure to pay on the part of any purchaser to whom it has sold an Artwork.

11. *Promotion.* The Gallery shall use its best efforts to promote the sale of the Artworks. The Gallery agrees to provide adequate display of the Artworks, and to undertake other promotional activities on the Artist's behalf, as follows: _____

_____.

The Gallery and the Artist shall agree in advance on the division of artistic control and of financial responsibility for expenses incurred in the Gallery's exhibitions and other promotional activities undertaken on the Artist's behalf. The Gallery shall identify clearly all Artworks with the Artist's name, and the Artist's name shall be included on the bill of sale of each of the Artworks.

12. *Reproduction.* The Artist reserves all rights to the reproduction of the Artworks except as noted in writing to the contrary. The Gallery may arrange to have the Artworks photographed to publicize and promote the Artworks through means to be agreed to by both parties. In every instance of such use, the Artist shall be acknowledged as the creator and copyright owner of the Artwork. The Gallery shall include on each bill of sale of any Artwork the following legend: "All rights to reproduction of the work(s) of art identified herein are retained by the Artist."

13. *Accounting.* A statement of accounts for all sales of the Artworks shall be furnished by the Gallery to the Artist on a regular basis, in a form agreed to by both parties, as follows: _____

(specify frequency and manner of accounting). The Artist shall have the right to inventory his or her Artworks in the Gallery and

to inspect any books and records pertaining to sales of the Artworks.

14. *Additional Provisions.*

15. *Termination of Agreement.* Notwithstanding any other provision of this Agreement, this Agreement may be terminated at any time by either the Gallery or the Artist, by means of written notification of termination from either party to the other. In the event of the Artist's death, the estate of the Artist shall have the right to terminate the Agreement. Within thirty days of the notification of termination, all accounts shall be settled and all unsold Artworks shall be returned by the Gallery.

16. *Procedures for Modification.* Amendments to this Agreement must be signed by both Artist and Gallery and attached to this Agreement. Both parties must initial any deletions made on this form and any additional provisions written onto it.

17. *Miscellany.* This Agreement represents the entire agreement between the Artist and the Gallery. If any part of this Agreement is held to be illegal, void, or unenforceable for any reason, such holding shall not affect the validity and enforceability of any other part. A waiver of any breach of any of the provisions of this Agreement shall not be construed as a continuing waiver of other breaches of the same provision or other provisions hereof. This Agreement shall not be assigned, nor shall it inure to the benefit of the successors of the Gallery, whether by operation of law or otherwise, without the prior written consent of the Artist.

18. *Choice of Law.* This Agreement shall be governed by the law of the State of _____.

SIGNATURE OF ARTIST

SIGNATURE OF AUTHORIZED REPRESENTATIVE OF THE GALLERY

DATE

DATE

B

Inventory Sheet/Receipt
for Artworks on Consignment

· ·

INVENTORY NUMBER DESCRIPTION OF OBJECT RETAIL PRICE GALLERY COMMISSION %

Terms of payment: _____

THE GALLERY AGREES TO ACCEPT FULL RESPONSIBILITY FOR THE SAFE-
KEEPING OF THE ABOVE ARTWORKS WHILE THEY ARE IN ITS CUSTODY.

_____ _____
SIGNATURE OF ARTIST SIGNATURE OF AUTHORIZED REPRESENTATIVE OF GALLERY; TITLE

_____ _____
ARTIST'S ADDRESS DATE

179

C

Sample Consignment Sign for Gallery

The Artworks on display are being sold subject to a contract of consignment between the artist and the gallery.

D
Sample UCC Law

· ·

*T*he following copy of UCC S 2-326 is from the model statute that states consult to create their own laws. Although there are some variations among the states, the sample shown here is basically representative. The Purposes of Changes explain some of the considerations of the drafters of this model provision.

Sec. 2-326. Sale on Approval and Sale or Return; Consignment Sales and Rights of Creditors.

(1) Unless otherwise agreed, if delivered goods may be returned by the buyer even though they conform to the contract, the transaction is

 (a) a "sale on approval" if the goods are delivered primarily for use, and

 (b) a "sale or return" if the goods are delivered primarily for resale.

(2) Except as provided in subsection (3), goods held on approval are not subject to the claims of the buyer's creditors until acceptance; goods held on sale or return are subject to such claims while in the buyer's possession.

(3) Where goods are delivered to a person for sale and such person

maintains a place of business at which he deals in goods of the kind involved, under a name other than the name of the person making delivery, then with respect to claims of creditors of the person conducting the business the goods are deemed to be on sale or return. The provisions of this subsection are applicable even though an agreement purports to reserve title to the person making delivery until payment or resale or uses such words as "on consignment" or "on memorandum." However, this subsection is not applicable if the person making delivery

(a) complies with an applicable law providing for a consignor's interest or the like to be evidenced by a sign, or

(b) establishes that the person conducting the business is generally known by his creditors to be substantially engaged in selling the goods of others, or

(c) complies with the filing provisions of the Article on Secured Transactions (Article 9).

(4) Any "or return" term of a contract for sale is to be treated as a separate contract for sale within the statute of frauds section of this Article (Section 2-201) and as contradicting the sale aspect of the contract within the provisions of this Article on parol or extrinsic evidence (Section 2-202).

Purposes of Changes: To make it clear that:

1. A "sale on approval" or "sale or return" is distinct from other types of transactions with which they have frequently been confused. The type of "sale on approval," "on trial" or "on satisfaction" dealt with involves a contract under which the seller undertakes a particular business risk to satisfy his prospective buyer with the appearance or performance of the goods in question. The goods are delivered to the proposed purchaser but they remain the property of the seller until the buyer accepts them. The price has already been agreed. The buyer's willingness to receive and test the goods is the consideration for the seller's engagement to deliver and sell. The type of "sale or return" involved herein is a sale to a merchant whose unwillingness to buy is overcome only by the seller's engagement to take back the goods (or any commercial unit of goods) in lieu of payment if

they fail to be resold. These two transactions are so strongly delineated in practice and in general understanding that every presumption runs against a delivery to a consumer being a "sale or return" and against a delivery to a merchant for resale being a "sale on approval."

The right to return the goods for failure to conform to the contract does not make the transaction a "sale on approval" or "sale or return" and has nothing to do with this and the following section. The present section is not concerned with remedies for breach of contract. It deals instead with a power given by the contract to turn back the goods even though they are wholly as warranted.

This section nevertheless presupposes that a contract for sale is contemplated by the parties although that contract may be of the peculiar character here described.

Where the buyer's obligation as a buyer is conditioned not on his personal approval but on the article's passing a described objective test, the risk of loss by casualty pending the test is properly the seller's and proper return is at his expense. On the point of "satisfaction" as meaning "reasonable satisfaction" where an industrial machine is involved, this Article takes no position.

2. Pursuant to the general policies of the UCC which require good faith not only between the parties to the sales contract, but as against interested third parties, subsection (3) resolves all reasonable doubts as to the nature of the transaction in favor of the general creditors of the buyer. As against such creditors words such as "on consignment" or "on memorandum", with or without words of reservation of title in the seller, are disregarded when the buyer has a place of business at which he deals in goods of the kind involved. A necessary exception is made where the buyer is known to be engaged primarily in selling the goods of others or is selling under a relevant sign law, or the seller complies with the filing provisions of UCC Article 9 as if his interest were a security interest. However, there is no intent in this Section to narrow the protection afforded to third parties in any jurisdiction which has a selling Factors Act. The purpose of the exception is merely to limit the effect of the present

subsection itself, in the absence of any such Factors Act, to cases in which creditors of the buyer may reasonably be deemed to have been misled by the secret reservation.

3. Subsection (4) resolves a conflict in the pre-existing case law by recognition that an "or return" provision is so definitely at odds with any ordinary contract for sale of goods that where written agreements are involved it must be contained in a written memorandum. The "or return" aspect of a sales contract must be treated as a separate contract under the Statute of Frauds section and as contradicting the sale insofar as questions of parol or extrinsic evidence are concerned.

●

E
Organizations for
Artists and Galleries
· ·

𝓝umerous organizations exist to serve artists and galleries. A brief list of leading organizations appears here. You can take the next step and contact the appropriate organization to ask if an affiliated or similar group exists in your own area.

Alliance of Artists' Communities, 2325 E. Burnside Street, Suite 201, Portland, OR 97214

American Association of Museums, 1575 Eye Street, Suite 400, Washington, DC 20005

American Craft Council, 72 Spring Street, New York, NY 10012

Americans for the Arts, 1 East 53rd Street, New York, NY 10022

Art Dealers Association of America, Inc., 575 Madison Avenue, New York, NY 10022

Art Dealers Association of California, 718 North La Cienaga Boulevard, Los Angeles, CA 90069

The Artists Foundation, 8 Park Plaza, Boston, MA 02116

Boston Visual Artists Union, Inc., P.O. Box 399, Newton, MA 02160

California Lawyers for the Arts, Inc., Fort Mason Center, Building C, Room 255, San Francisco, CA 94123, or 1549 11th Street, Suite 200, Santa Monica, CA 90401

The Center for the Visual Arts, City Center Plaza, 1333 Broadway, Oakland, CA 94612

Chicago Artists' Coalition, 5 West Grand Avenue, Chicago, IL 60610

International Sculpture Center, 1050 17th Street NW, Washington, DC 20036

Lawyers for the Creative Arts, 213 West Institute Place, Chicago, IL 60610

National Artists Equity Association, Inc., P.O. Box 28068 Central Station, Washington, DC 20038

National Assembly of Local Arts Agencies, 927 15th Street NW, Washington, DC 20005

National Assembly of State Art Agencies, 1029 Vermont Avenue NW, 2nd Floor, Washington, DC 20005

National Association of Artists Organizations (NAAO), 918 F Street, NW, Washington, DC 20004

National Association of Women Artists (NAWA), 41 Union Square W, New York, NY 10003

National Endowment for the Arts, Visual Arts, 2401 E Street NW, Washington, DC 20506

New York Artists Equity Association, Inc., 498 Broome Street, New York, NY 10013

New York Foundation for the Arts, 155 6th Avenue, 14th Floor, New York, NY 10013

New York State Council on the Arts, 915 Broadway, New York, NY 10010

NOVA (New Organization for the Visual Arts), 1290 Euclid Avenue, Cleveland, OH 44115

Volunteer Lawyers for the Arts, 1 East 53rd Street, New York, NY 10022

Washington Area Lawyers for the Arts, 733 15th Street NW, Suite 700, Washington, DC 20005. (As of August, 1998: 815 15th Street NW, Suite 900, Washington, DC 20005)

●

Selected Bibliography

· ·

Barnes, Molly. *How to Get Hung.* Boston: Charles E. Tuttle Co., 1994.

Caplin, Lee Evan. *The Business of Art.* Englewood Cliffs, N.J.: Prentice-Hall, Inc., 1989.

Crawford, Tad. *Business and Legal Forms for Fine Artists.* New York: Allworth Press, 1995.

Crawford, Tad. *Legal Guide for the Visual Artist.* New York: Allworth Press, 1998.

Doherty, Stephen M. *Business Letters for Artists.* New York: Watson-Guptill, 1993.

DuBoff, Leonard D. *The Art Business Encyclopedia.* New York: Allworth Press, 1994.

DuBoff, Leonard D. *The Law (In Plain English)® for Galleries.* New York: Allworth Press, 1999.

Feldman, Franklin, Stephen E. Weil, and Susan Duke Biederman. *Art Law: Rights and Liabilities of Creators and Collectors.* 2 vols. Boston: Little, Brown and Company, 1986. Supp. 1993.

Goodman, Calvin, and Goodman, Florence. *Art Marketing Handbook.* Los Angeles: Gee Tee Bee, 1991.

Grant, Daniel. *The Artist's Resource Handbook.* New York: Allworth Press, 1997.

————. *The Business of Being an Artist*. New York: Allworth Press, 1996.

————. *How to Start and Succeed as an Artist*. New York: Allworth Press, 1997.

Hadden, Peggy. *The Artist's Guide to New Markets*. New York: Allworth Press, 1998.

Lerner, Ralph E., and Judith Bresler. *Art Law: The Guide for Collectors, Investors, Dealers, and Artists*. New York: Practicing Law Institute, 1998.

Michels, Caroll. *How to Survive and Prosper as an Artist*. New York: Henry Holt and Co., 1998.

Norwick, Kenneth P., and Jerry Simon Chasen, with Henry R. Kaufman. *The Rights of Authors and Artists*. New York: Bantam Books, 1992.

Smith, Constance. *Art Marketing Sourcebook for the Fine Artist*. Renaissance, CA: Art Network Press, 1995.

————. *Art Marketing 101*. Renaissance, CA: Art Network Press, 1997.

Snyder, Jill. *Caring for Your Art*. New York: Allworth Press, 1996.

Victoroff, Gregory T., ed. *The Visual Artist's Business and Legal Guide*. Englewood Cliffs, NJ: Prentice-Hall, 1995.

Vitali, Julius. *The Fine Artist's Guide to Marketing and Self-Promotion*. New York: Allworth Press, 1996.

●

About the Authors

. .

.

TAD CRAWFORD has served as Chairman of the Board of the Foundation for the Community of Artists, General Counsel for the Graphic Artists Guild, and legislative counsel for artists' groups fighting for artists' rights. He is the author of *Legal Guide for the Visual Artist, Business and Legal Forms for Fine Artists,* and many other books for creative professionals as well as *The Secret Life of Money.* A regular columnist for *Communication Arts* magazine, he has been a faculty member at the School of Visual Arts in New York City and a frequent lecturer on successful business practices for artists.

SUSAN MELLON served as a director of Artist/Craftsman's Information Service of Washington, D.C., and was active within that organization in the development of the model consignment agreement used in this pamphlet. Her other activities in the art field have included the management of a not-for-profit craft gallery in Connecticut, and her own work as a craftsman-jeweler.

LAURA MANKIN, '99 at Columbia School of Law, has a special interest in arts law.

DANIEL GRANT is a contributing editor of *American Artist* magazine and the former editor of *Art and Artists*. His articles and essays have appeared in such publications as *Art in America*, *ARTnews*, *Christian Science Monitor* and the *New York Times*. He is also the author of other acclaimed books: *The Business of Being an Artist*, *The Artist's Resource Handbook*, *The Writers Resource Handbook,* and *How to Start and Succeed as an Artist* (all published by Allworth Press). He lives in Amherst, Massachusetts.

●

Index

Books from Allworth Press

Legal Guide for the Visual Artist, Third Edition
by Tad Crawford (softcover, 8½ × 11, 256 pages, $19.95)

Business and Legal Forms for Crafts
by Tad Crawford (softcover, 8½ × 11, 144 pages, $19.95)

Business and Legal Forms for Fine Artists, Revised Edition
by Tad Crawford (softcover, 8½ × 11, 144 pages, $16.95)

The Business of Being an Artist
by Daniel Grant (softcover, 6 × 9, 272 pages, $18.95)

The Artist's Resource Handbook
by Daniel Grant (softcover, 6 × 9, 248 pages, $18.95)

How to Start and Succeed as an Artist
by Daniel Grant (softcover, 6 × 9, 240 pages, $18.95)

**The Artist's Guide to New Markets: Opportunities to Show and
Sell Art Beyond Galleries**
by Peggy Hadden (softcover, 5½ × 8½, 224 pages, $18.95)

Licensing Art & Design, Revised Edition
by Caryn R. Leland (softcover, 128 pages, $16.95)

**Caring for Your Art: A Guide for Artists, Collectors, Galleries,
and Art Institutions,** Revised Edition *by Jill Snyder, Illustrations by
Joseph Montague* (softcover, 6 × 9, 192 pages, $16.95)

The Fine Artist's Guide to Marketing and Self-Promotion
by Julius Vitali (softcover, 6 × 9, 224 pages, $18.95)

Fine Art Publicity: The Complete Guide for Galleries and Artists
by Susan Abbott and Barbara Webb (softcover, 8½ × 11, 190 pages, $22.95)

Artists Communities *by the Alliance of Artists' Communities*
(softcover, 6½ × 10, 224 pages, $16.95)

Please write to request our free catalog. To order by credit card, call 1-
800-491-2808 or send a check or money order to Allworth Press, 10 East
23rd Street, Suite 210, New York, NY 10010. Include $5 for shipping and
handling for the first book ordered and $1 for each additional book or
$10 plus $1 for each additional book if ordering from Canada. New York
State residents must add sales tax.

If you would like to see our complete catalog on the World Wide Web,
you can find us at: ***www.allworth.com***